Cover: The 2007 Pentagram
design for the Doomsday
Clock, adapted by designer
James Goggin

This book's endpapers
feature original cover art
commissioned for *Bulletin
of the Atomic Scientists*.

Front endpapers: Milton
Glaser, March-April
2008; Ario Mashayekhi,
September-October 2007;
Martyl, May-June 2007

The Doomsday Clock at 75

Robert K. Elder J.C. Gabel

1947
7 minutes to
midnight

2022
100 seconds to
midnight

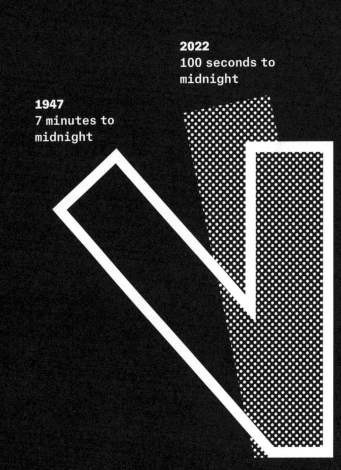

Hat & Beard Press

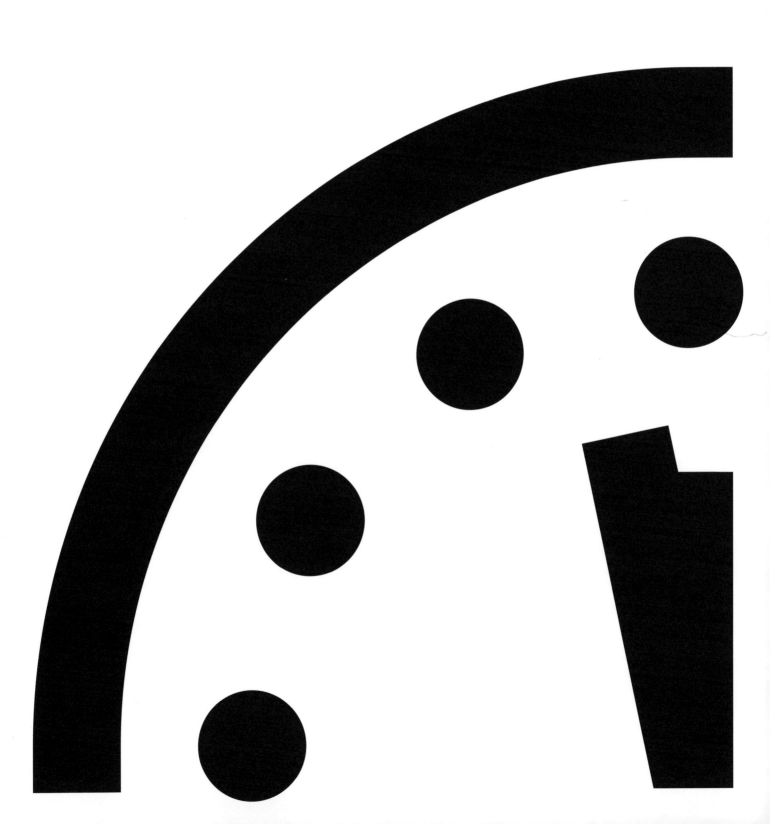

Contents

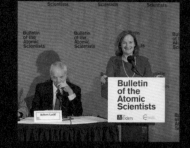

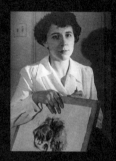

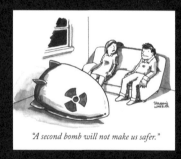

"A second bomb will not make us safer."

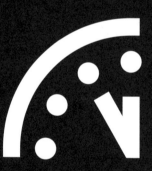

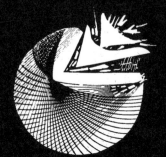

Throughout
Interstitial Illustrations
Martyl, Rainey Bennett,
and William Dempster

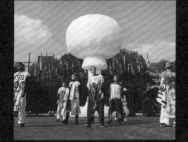

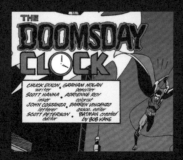

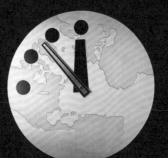

The Doomsday Clock has become a powerful, worldwide symbol with a rich history. In this book, we'll explore how the Clock was created and how it resonates through cultures.

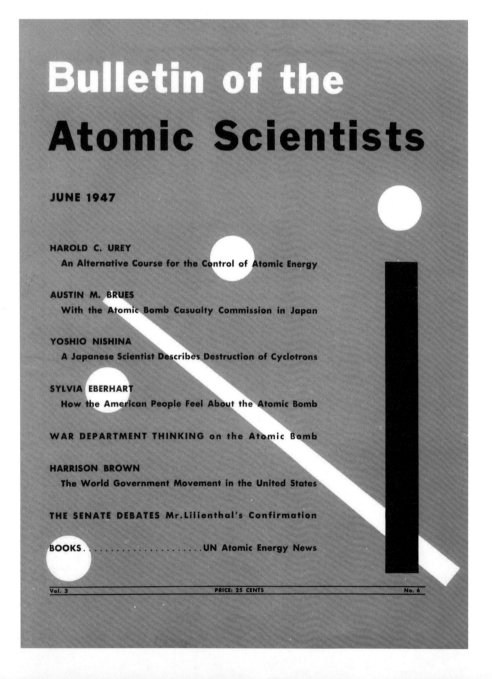

Bulletin of the Atomic Scientists

JUNE 1947

HAROLD C. UREY
 An Alternative Course for the Control of Atomic Energy

AUSTIN M. BRUES
 With the Atomic Bomb Casualty Commission in Japan

YOSHIO NISHINA
 A Japanese Scientist Describes Destruction of Cyclotrons

SYLVIA EBERHART
 How the American People Feel About the Atomic Bomb

WAR DEPARTMENT THINKING on the Atomic Bomb

HARRISON BROWN
 The World Government Movement in the United States

THE SENATE DEBATES Mr. Lilienthal's Confirmation

BOOKS. UN Atomic Energy News

Vol. 3 PRICE: 25 CENTS No. 6

The original Clock was the creation of the artist Martyl Langsdorf. Called to produce an illustration for the *Bulletin*'s first magazine cover in 1947, she created a universally compelling image of rare power.

Introduction

By Robert K. Elder
and J.C. Gabel

The Doomsday Clock is many things all at once: It's a metaphor, it's a logo, it's a brand, and it's one of the most recognizable symbols of the past 100 years.

Chicago landscape artist Martyl Suzanne Schweig Langsdorf, who went by the single name Martyl professionally, created the Doomsday Clock design for the June 1947 cover of the *Bulletin of the Atomic Scientists*, published by the non-profit behind the iconic Doomsday Clock.

The Clock sits at the crossroads of science and art, and therefore communicates an immediacy that few other forms can. As designer Michael Bierut says, the Clock is "the most powerful piece of information design of the 20th century."

The Doomsday Clock has permeated not only the media landscape, but also culture itself. As you'll see in the pages ahead, more than a dozen musicians, including The Who, The Clash, and Smashing Pumpkins have written songs about it.

The Clock has appeared in countless novels, comic books, movies, and TV shows. Even the Clock's shorthand, which is the way we tell the time (for example, our most recent shorthand is "It is 100 seconds to midnight"), has been adopted into the global vernacular. Even as this book went to press, UK Prime Minister Boris Johnson appropriated the metaphor and compared the climate crisis to a James Bond movie. He said "... humanity has long since run down the clock on climate change. It's one minute to midnight on that doomsday clock and we need to act now." (Editor's note: He got the time wrong.)

When it first appeared, Martyl's Clock was simply called "the Clock" or the

Note to the Reader

The Bulletin of the Atomic Scientists is the name of the organization, as well as the publication. When referring to the magazine, we use italics, such as the *Bulletin* or *Bulletin of the Atomic Scientists*. It's also worth noting that the original name of the publication was the *Bulletin of the Atomic Scientists of Chicago*, though "of Chicago" was dropped beginning with the seventh issue on March 16, 1946. The *Bulletin* spent its first year and a half as a newsletter before relaunching in June 1947 as a magazine.

"Bulletin's Clock." Eventually, the name evolved into the Doomsday Clock.

There were other permutations. In 1917, American poet Vachel Lindsay wrote, "The fatal hour is striking in all the doomsday clocks."

J. Robert Oppenheimer used a metaphorical "atomic clock" in the pages of the *Bulletin* in 1953, writing that "the prevailing view is that we are probably faced with a long period of cold war in which conflict, tension, and armaments are to be with us. The trouble then is just this: during this period the atomic clock ticks faster and faster. We may anticipate a state of affairs in which two great powers will each be in a position to put an end to the civilization and life of the other, though not without risking its own. We may be likened to two scorpions in a bottle, each capable of killing the other, but only at the risk of his own life."

But colloquially, some had been calling the Bulletin's most recognizable symbol "the Doomsday Clock"—including the *New York Times*, *Washington Post*, and *Irish Times*—in 1968. Bulletin co-founder Eugene Rabinowitch adopted the name more formally in 1972. It's also worth noting that the term "doomsday clock" was only added to the premier historical record of the English language, the *Oxford English Dictionary*, in June 2021.

While researching this book, Kennette Benedict—the Bulletin's executive director and publisher from 2005 to 2015—told us why the Doomsday Clock has such staying power.

"The Clock isn't in any language," she said. "It has become universal around the globe.

Everyone understands what it means to be coming close to midnight. You don't really need to translate from English into Japanese, or Farsi, or Chinese or … And so this lends universality to the Clock, which is important in the popular imagination."

And sometimes, that popular imagination takes over.

"One unobtrusive indicator of how popular the Clock is in the imaginations of people is how many people have tried to essentially steal it. That's a polite way of saying that everyone wants to use it—because it is so powerful," Benedict said. "People understand that and want to use it, not understanding that we actually have the trademark."

And so, throughout the Doomsday Clock's 75 years, the Bulletin has worked to preserve its integrity and its scientific mission to educate and inform the public.

This is why, in part, we wanted to explore this powerful symbol and how it has impacted culture, politics, and global policy—and how it's helped shape discussions and strategies around nuclear risk, climate change, and disruptive technologies.

In the chapters ahead, you'll learn more about each of these facets, including an introduction by current Bulletin president and CEO Rachel Bronson to what the Clock stands for now and how it has changed over time.

You'll also see how the time on the Clock has changed over the years, and how different artists have interpreted the Clock through their work.

It's a symbol of danger, of hope, of caution, and of our responsibility to one another.

Right: Despite its ominous name, the Doomsday Clock is meant to inspire hope and action. James DeMonaco, a 22-year-old art and design student at the Art Institute of California, San Francisco, got the message loud and clear. A course about the history of war introduced DeMonaco to the *Bulletin*, and he became fascinated with the Clock. In contrast to the horror of the subject he was studying, the Clock had the potential to present a more optimistic outlook.

As part of the final exam for his class, he decided to interpret the Clock along these lines and solicited his friends on campus to serve as models. The final illustration shows how the Clock can spur action, which was precisely DeMonaco's goal: "I hope to encourage people to do more, to stand up for what they believe in. Your planet needs it, your children need it, we all really need it."

Bulletin of the Atomic Scientists, November–December, 2008

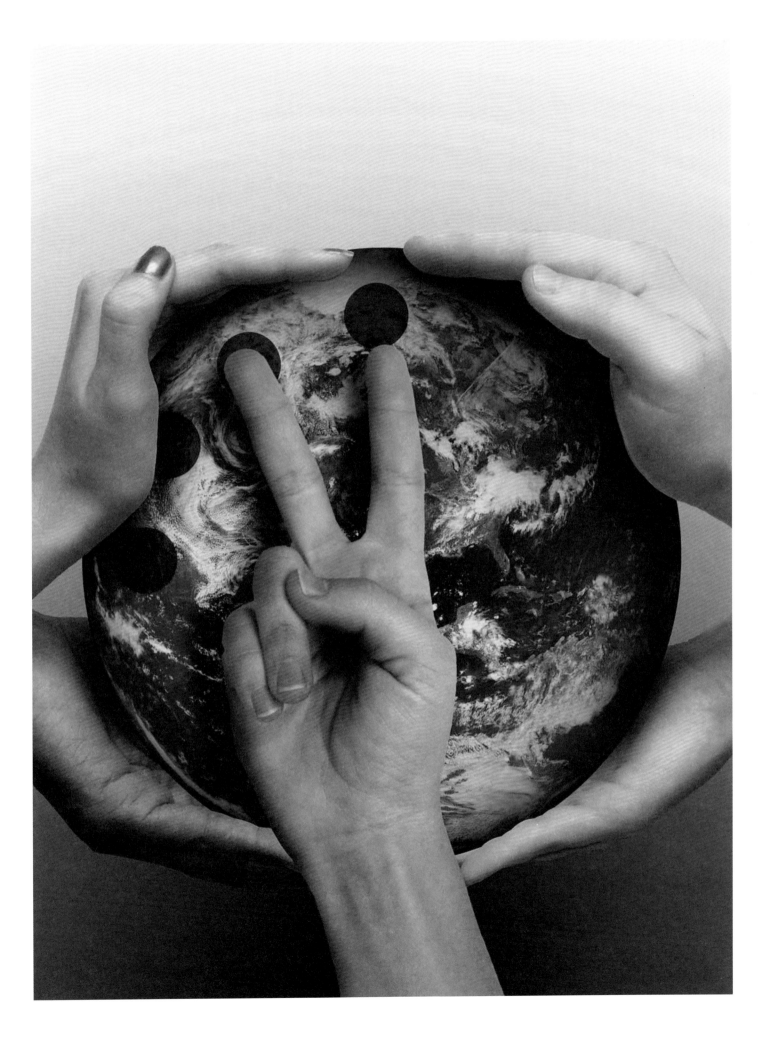

Through the decades, the Doomsday Clock—and what it means—has evolved with the times as humanity faces new existential threats.

The Doomsday Clock at 75: The Evolution of a Symbol

By Rachel Bronson,
President and CEO,
Bulletin of the
Atomic Scientists

When is a clock not a clock? When it's a metaphor.

That's what the Doomsday Clock has been for 75 years: a metaphor for humanity's proximity to self-destruction as the minute hand creeps closer to midnight. But what the metaphor represents has changed over time.

The *Bulletin of the Atomic Scientists* was founded in 1945 by Manhattan Project scientists who "could not remain aloof to the consequences of their work" after nuclear bombs devastated the Japanese cities of Hiroshima and Nagasaki. Its mission is to equip the public, policy makers, and scientists with the information needed to reduce human-made threats to our existence.

The Clock was created by Chicago-based landscape painter Martyl Langsdorf, who was known professionally by her first name. Her husband, Alexander Langsdorf Jr., was one of the *Bulletin*'s early founders and, when the publication

transitioned from a newsletter to a magazine format in June 1947, Martyl was tapped to design the cover. Her Clock design was meant to convey concerns by experts that public engagement and activism were necessary to manage newly-evolved and wildly destructive weaponry. The Clock was set at seven minutes to midnight to communicate the urgency of the situation and the need for action.

Initially, the Doomsday Clock time was solely focused on the specter of nuclear annihilation. Eugene Rabinowitch, the founding co-editor of the *Bulletin*, wrote about the necessity of the organization's mission "to awaken the public to the full understanding of the horrendous reality of nuclear weapons, and of their far-reaching implications for the future of mankind; to warn of the inevitability of other nations acquiring nuclear weapons within a few years ..."

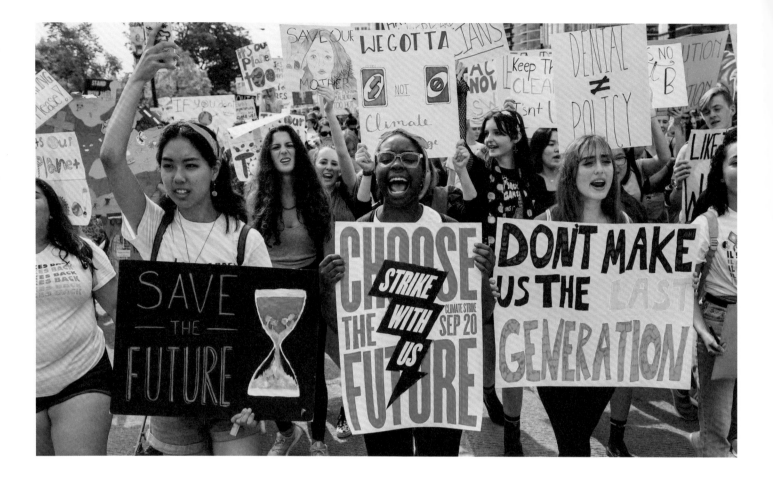

Rabinowitch also warned that the atom bomb would be "only the first of many dangerous presents from the Pandora's box of modern science."

It's this Pandora's box that the *Bulletin* tracks now. Each year, the Science and Security Board assesses nuclear risk and climate change—along with the threat multiplier of disruptive technologies—to set the time.

We've had help, too. Dozens of Nobel laureates have lent their expertise and amplified our mission via our Board of Sponsors, a body founded by Albert Einstein and chaired by Robert J. Oppenheimer. Since the 1940s, cultural luminaries such as Stephen Hawking, Ruth Adams, Andrei Sakharov, Arthur C. Clarke, Dorothy Hodgkin, Freeman Dyson, Masatoshi Koshiba, and others have served on the board. And contributors whose bylines have appeared in the

Bulletin include John F. Kennedy, Richard Nixon, Christine Todd Whitman, and US Secretary of Defense William J. Perry, to name a few.

Over time, the Clock hands have moved toward and away from midnight as geopolitical realities and technological advancement have evolved. When they were created, nuclear weapons were the only human-made threat with the potential to one day end life on Earth as we know it. But the scientists who created the atomic bomb understood that science was advancing rapidly and that other technologies would soon emerge that required serious and high-level engagement by scientists, political leaders, and the public. Accordingly, humans' ability to change the climate began pushing onto the *Bulletin*'s agenda in the late 1950s and early 1960s. New biological threats, along with advancements in artificial intelligence and new disruptive

technologies soon followed. Each began to figure increasingly in the *Bulletin*'s pages and coverage. Our 1978 cover story asked whether mankind was changing the climate, and the answer was, definitively, yes.

By 2007, it was no longer possible to answer whether humanity was becoming safer or was at greater risk without factoring climate into the setting of the Doomsday Clock. In one of the most controversial decisions the *Bulletin* has taken, it moved the Clock from seven to five minutes to midnight in 2007, largely as a clarion call for greater attention to the growing climate crisis. With that move, the *Bulletin* made clear the Clock was not about nuclear weapons alone. It was fundamentally about existential risk.

Today, the need to manage the Pandora's box of modern science, as Rabinowitch put it, guides our activities, our near-daily publications, and our yearly Clock setting and statement. Our annual Clock statement has made clear over the last few years that we see particular disruptive technologies as threat multipliers. Advances in cybersecurity and artificial intelligence are increasing the risks associated with nuclear stability. Certain advances in geoengineering threaten the balance of our ecosystems, and new forms of bioengineering increase the potential for lab leaks and pandemics, as well as for new vaccines and disease cures.

The *Bulletin* was founded by scientists who foresaw the promise and peril of all science has to offer. They, and we, understand such advancements bring huge risks and huge rewards. They understood, and we understand, that unless we take the risks seriously and manage them politically, we will forego the benefits of science, to our considerable disservice and possible destruction.

As I write this, the Doomsday Clock is set at 100 seconds to midnight, the closest to midnight it has ever been, but we've turned the hands back before and surely we can do it again. The Doomsday Clock is a call to action, urging citizens everywhere to work toward moving the hands away from midnight. And it is a challenge for our decision makers to do better, to reject complacency in the face of challenge. Setting the Clock each year is meant to inspire agency, and in doing so, carry a message of hope.

That's what inspires me about this 75th anniversary of the Doomsday Clock. It challenges us to remember that we have the ability to reduce these seemingly insurmountable threats. It reminds us of our responsibility to the planet and future generations. It tells us we can beat the odds. And, most important, it reminds us that the situation is urgent, even if that has been true over a long period of time. Vigilance in the presence of almost immutable threats is terribly difficult to sustain, but it is what is required.

The Doomsday Clock's brutal simplicity provides an entry point for people around the world to grapple with some of the most technically and politically complicated issues confronting humankind. The science can be alienating, forcing people to recognize what they don't know and distancing them from the conversation about how to manage it. The Clock welcomes ordinary citizens—grassroots advocates, teachers, religious leaders, local political representatives—those who are most needed to influence our national leaders. It does so in a way that only an artist could have imagined. Martyl's brilliance was to make the inaccessible accessible. In doing so, she accomplished what the scientists hoped she would, but what they were unable to do themselves. She connected.

The pages of this book are filled with examples of how artists and cultural icons have used the Clock to convey their hopes and fears and engage a broader audience to inspire political action. That it is still being used today, 75 years later, tells us at least two important things. The first is that the Doomsday Clock is a powerful symbol that continues to speak to people worldwide. And the second: We still have a lot of work to do.

In 2008, writer J.C. Gabel met
Martyl at her house in Schaumburg,
Illinois. It changed his life.

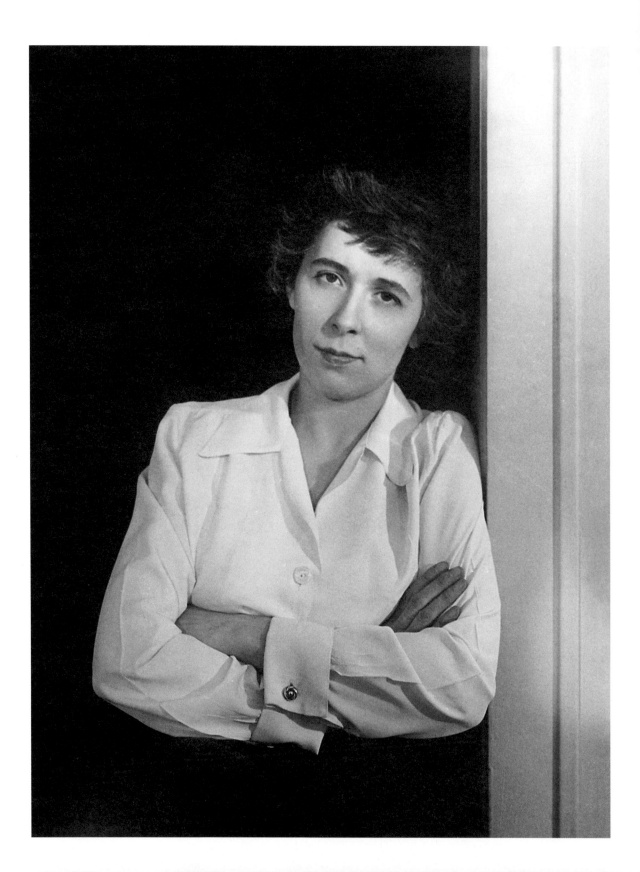

Martyl at home
in Hyde Park,
Chicago, 1950s

Martyl and I

By J.C. Gabel

If on a Winter's Night, a Traveler
I remember first meeting artist Martyl Langsdorf because it was what one might call a happy accident. A photographer friend and I had been researching the Schweikher House in Schaumburg, Illinois, for a magazine article, where I would write the story and he would photograph the house. It was to be a profile of the home and studio of architect Paul Schweikher.

Martyl, a life-long artist, was the home's present occupant, and from minute-one was more interesting than the house itself. This was unusual yet inviting.

Paul Schweikher, who designed and built the house, was born and raised in Colorado. He studied architecture in and around Chicago in the 1920s (and opened his studio practice in 1934); until, in 1953, he took a dean's position at Yale University's School of Architecture, at which point he moved his family to New Haven, Connecticut. He later went to teach at Carnegie Mellon University in Pittsburgh, and finished his career in academia, before reinventing himself, once more, in the hills of Sedona, Arizona, where he built his (now, sadly, demolished) mountainside home to ride out his twilight years.

Schweikher had originally acquired the roughly 7-plus acres of land in what was then the sleepy town of Roselle, amid the Depression-era 1930s—which was mostly German farms—northwest of Chicago. Working for some local farmers, he redesigned and converted a barn to serve more than one purpose, and that other purpose happened to be exporting bootleg liquor, so the legend goes. Regardless, Schweikher was gifted the property, which later was sold to Bob Atcher, an early performer on WGN, who sang country and western songs, before becoming Schaumburg's first mayor.

Schweikher acquired the land in 1936 but didn't begin construction until 1938. He brought in landscape architect Franz Lipp, who helped him create what he then began calling "South Willow."

Martyl and her scientist husband Alexander Langsdorf Jr. met the Schweikher family and bought the home from them directly almost by accident, having met through mutual friends from the Art Institute.

After looking at over 100 homes, Martyl once told me, she finally found one that suited them, "a gem on the prairie."

Martyl fell in love with Schweikher's Japanese-styled Modernism, which, off Meacham Road back then, must have looked like something out of H.G. Wells' *The Time Machine*.

The Langsdorfs moved in with their two daughters, Suzanne and Alexandra, from Hyde Park, where Alex had been working on the then top-secret Manhattan Project.

By this time, Alex was working at Argonne National Laboratory in the forest preserve suburb of Lemont, Illinois, 20 miles southwest of Chicago. After the War, many of the scientists who were recruited to move to Chicago to work on the Bomb scattered out into Illinois suburbia to work for the federal government or for private industries.

Soon Schaumburg rose up next to Roselle and eclipsed it in size; companies like Motorola set up their US operations there, opposite the third largest indoor mall in America, called Woodfield.

Meet Me in St. Louis

Alex and Martyl were married on New Year's Eve, 1941, in St. Louis, just weeks after the Japanese attacked Pearl Harbor, and (finally) thrust the United States into WWII.

"The Manhattan Project had been organized in Chicago," Martyl said in her official oral history for the Art Institute of Chicago, which was recorded by Betty Blum in 2007. "All the famous physicists and chemists from all over the world were there." She didn't know it at the time, but the Langsdorfs had stayed an extra year in St. Louis so Alex could build the cyclotron at Washington University. "This was all top secret at the time," she said.

"I'd met my husband-to-be through family," Martyl said. "My family knew the Langsdorfs, who themselves were prominent St. Louis natives. My mother Amiee was a well-known artist, my father Martin was a well-known photographer in the city."

Alex's father, meanwhile, was the dean of engineering and architecture at Washington University, and Elsie Langsdorf, Alex's mother, was a well-known suffragette.

After another fateful year in St. Louis, the Langsdorfs moved to Chicago so Alex could continue his work on the Manhattan Project, under the tutelage of Enrico Fermi.

Hyde Park, in the heady 1940s, was (and still is) a bastion of intellectual rigor on the city's South Side, an island on the land, butting up against Lake Michigan, anchored by the University of Chicago. This area, it should be noted, was also the staging grounds for the 1893 World's Fair, The White City.

The university campus was always a research hub for the sciences, but by 1942, the Manhattan Project scientists, under the direction of Fermi, would build and test the first nuclear reactor under Stagg Field, an outdoor football stadium, without anyone above ground knowing what was taking place until years later.

In 1945, after the atomic bombs were dropped on Hiroshima and Nagasaki, some of the secretive Manhattan Project was made public, and with it, the undeniable anxiety about this new Atomic Age was brought to the fore. Civilization itself had been threatened directly—and its aftereffects can still be felt today.

"My husband was in a group of 70 scientists who wrote a letter and signed a petition to President Truman," Martyl said. The scientists were pleading with Truman not to use The Bomb on the

Schweikher-Langsdorf Home & Studio, Schaumburg, IL, 1946.

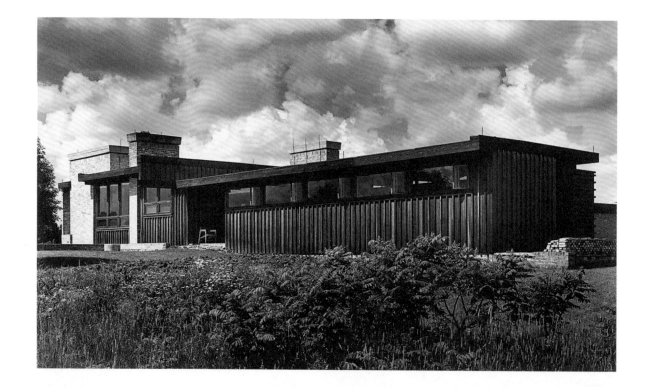

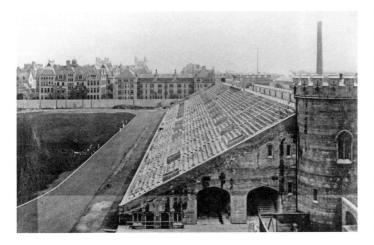
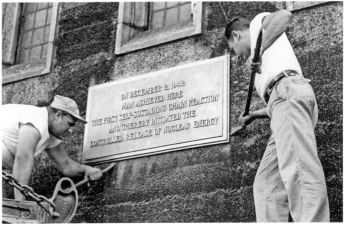
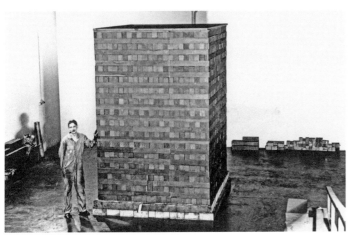

Stagg Field, University of Chicago (top left) and Chicago Pile-1, the first artificial nuclear reactor, under construction (bottom row), 1942

Japanese people. "There are some stories that say [Truman] never received it," Martyl said, "that it was interrupted by the then Secretary of State."

This group of 70 scientists dissenting against the use of nuclear weapons organically morphed into the Bulletin of the Atomic Scientists, under the leadership of University of Chicago science professor Eugene Rabinowitch.

A Symbol of Our Time

The atmosphere of brilliant people gathered in Hyde Park at that time around the University of Chicago was formidable. "The Committee on Social Thought," Martyl said, "[co-founded] by Robert Hutchins, brought all sorts of interesting people [to the city]. That era has never been duplicated. There has never been that many geniuses in one place again."

After the war, Martyl said, "Alex and I made a list of all our close friends who had won Nobel Prizes, and there were something like 17."

After the two atomic bombs were dropped, the social consciousness of what to do next coalesced around Rabinowitch. Originally from St. Petersburg, Russia, he had come to the US as a refugee to help the war effort against the fascism raging in Europe. "He knew Latin, he knew Greek, he knew three or four romance languages," Martyl said.

Rabinowitch, and fellow professor, Hy Goldsmith, were both writers and scientists. This was the basis for the *Bulletin of the Atomic Scientists*: They wanted to inform the public of the dangers of nuclear weapons. They also believed that nuclear power should not be in the hands of the army, but instead civilians.

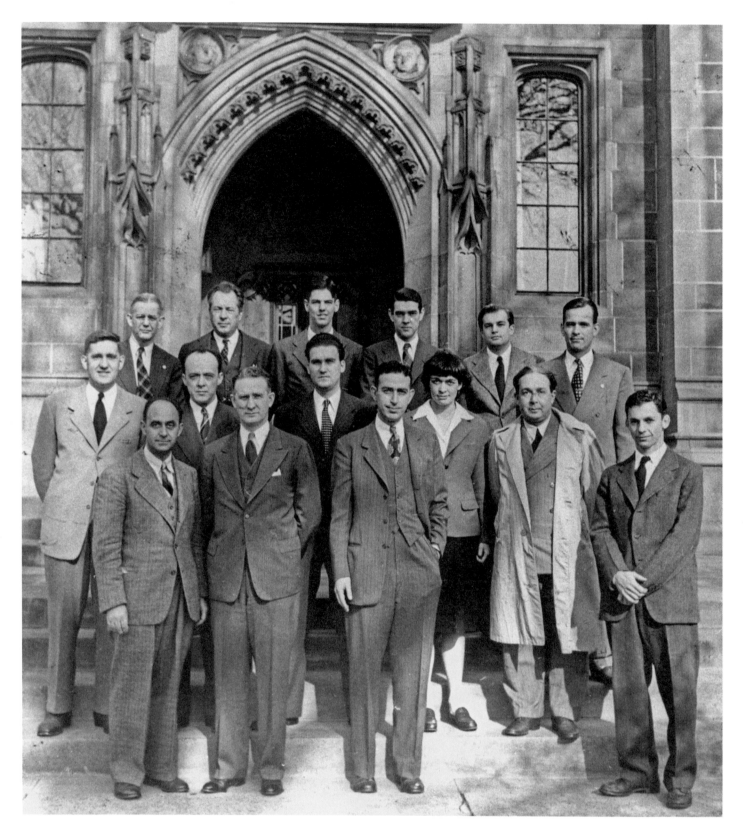

Reunion of atomic scientists in 1946 on the 4th anniversary of the first controlled nuclear fission chain reaction, December 2, 1942. Pictured in front of Bernard A. Eckhart Hall at the University of Chicago, from left (3rd row): Norman Hilberry; Samuel Allison; Thomas Brill; Robert G. Nobles; Warren Nyer; Marvin Wilkening; (2nd row): Harold Agnew; William Sturm; Harold Lichtenberger; Leona W. Marshall; Leo Szilard; (1st row): Enrico Fermi; Walter H. Zinn; Albert Wattenberg; Herbert L. Anderson.

J. C. Gabel

Martyl Langsdorf, *Sunset*, 2000

A digital Doomsday Clock (sponsored by Timex) provides the countdown for a bomb in Springfield in *The Simpsons Movie* (2007).

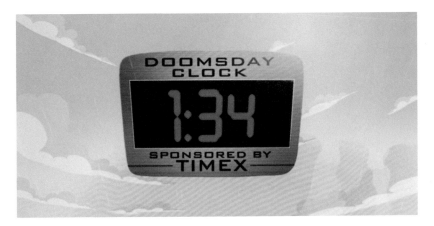

"They came to me and wanted to put out this pamphlet in magazine form," Martyl said. "Being the so-called resident artist in the scientific community, they asked me to do the first cover for the magazine-to-be."

Knowing the parameters of a monthly publication schedule, Martyl created the Doomsday Clock as the symbol for our time, which could be super-imposed on each cover with a different color palette, each month. "It's a phenomenon in itself," Martyl said, "the Clock has a life of its own now. It's amazing. You do things in your youth ... you never know what comes back."

After Martyl and I became good friends, following the publication of our story about her home, it was clear that although she was extremely proud of the visual contribution to history via the Doomsday Clock, in a way it was also a double-edged sword: over time more people knew her for the Clock than for her eight decades of painting as a fine artist.

"It's going to be in one of the first paragraphs of my obituary," she would always jokingly opine. And sure enough, at the time of her passing, in 2013 at the age of 96, all the obituaries did mention this fact early on. Still, Martyl's adeptness and her love of pop culture—in particular, *The Simpsons*—helped her appreciate how this iconic symbol she helped create had made its way into the songs of bands like The Who, The Clash, Bright Eyes, Iron Maiden, and Smashing Pumpkins; films like *Dr. Strangelove*; and, more recently, internet memes. She loved the influence this symbol had on society outside of the scientific community as much as within it.

Once the Bulletin of the Atomic Scientists started to include climate change among its existential threats to society, the Doomsday Clock, already a symbol denoting the time till we reach mutually assured destruction, Martyl saw how its power could also promote climate change awareness. More recently, after the rise of Trumpism,

the Bulletin added misinformation to their list of existential threats to the planet.

"I chose the clock face because of the urgency and the time of essence," Martyl said. "I have fooled around trying to do something literal—I started with a clock, the hands and numbers. And it gradually got into something simpler, something graphically good-looking." Martyl used to do spot illustrations for the inside of the magazine, as well, "to break up the monotony of text," she said.

Some years later, in the 1980s, she ran into Chicago journalist Jamie Kalven, who was then working for the *Bulletin*. He said, "I'm in this meeting, and they don't know what to do. They don't know where to take the *Bulletin*." Martyl knew what to do, instinctively. "It was obvious to me," she said, "you put the clock on an image of the world." "Oh my god," Kalven said, "that's fantastic."

Child Prodigy Beginnings

Martyl Suzanne Schweig was born in 1917 in St. Louis, Missouri. Her name, she always said, had been invented by her mother, after her father, whose name was Martin. "She made it up," she said. It stuck.

Aimee Schwieg, Martyl's mother, was a trailblazing woman in her time. She traveled to the coastal resort town of Provincetown, Massachusetts, where experimental art colonies were set up during the summer months. The Ash Can School, built up under the instruction and teachings of Robert Henri, was at the forefront of art education and training around the turn of the 20th century.

Aimee had a front-seat view of this community, learning the essentials of painting colors, and Martyl, soon after, was tagging along with her, in the summertime. "We studied with artist and teacher Charles Hawthorne, who had formed the first art colony in Cape Cod," she said.

A signed reproduction of the premiere issue of the *Bulletin* cover from 1947, which featured the first iteration of the Doomsday Clock.

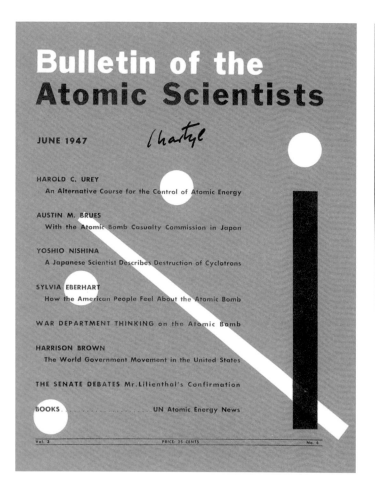

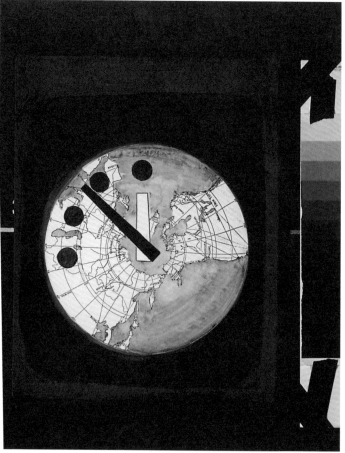

Martyl always told me that she felt she had been born a painter. But she also harbored other ambitions and was a bit of a child prodigy.

"I was going to be the world's greatest violinist," Martyl said. "When I was three years old, I used to pick up sticks, and played with them as if it was a violin. I did study the violin and the piano. I was going to be a musician."

But the calling to a career in fine art always bubbled under the surface. Her mother started her own experimental art colony, St. Genevieve, outside St. Louis, where Martyl was able to continue her painting studies. "We looked like sisters for a long time," Martyl said. "Sometimes we passed as sisters. It was fun. I was born old, with rings under my eyes, and she was youthful."

Aimee brought in artists Fred Conway, Jesse Ricky, Joe Jones, and Thomas Hart Benton, all of whom were friends of the family, to instruct students.

"The Bentons were friends of my parents," Martyl said, "so we'd go to Kansas City and visit them. I have great recollections of the Bentons. Tom was so full of life. He was so much fun, but he did tell me such rubbish frequently."

For instance, he told Martyl not to go to Paris. "You'll be corrupted, you'll be ruined," he told her. Benton, Martyl said, was down on French painters more generally. He had a disdain for Impressionism, which was big at that time.

Martyl went on to paint some murals during the Works Progress Administration (WPA) years, before the war; in fact, she was a supervisor in St. Louis for the WPA art projects. Although Martyl would paint cityscapes, it was landscape painting that became her area of expertise. She did some figurative painting in the 1930s, and at an early exhibition, received a call from none other than George Gershwin himself, who was in St. Louis performing. He had read about Martyl in the newspaper.

"I was 18 years old, and I had my first exhibition," Martyl said.

Gershwin was staying in St. Louis at the Coronado Hotel, which was one of the fancy hotels near the symphony. "I got this telephone call," Martyl said. "I'm living at home so he found out where to find me. But I didn't believe it was him on the phone. I thought it was my college friends," pulling a prank.

In 1989, the *Bulletin* was looking for a way to update the Clock. "It was obvious to me," recalled Martyl. "You put the clock on an image of the world."

"Hello, I'm George Gershwin," he said. "Yeah," Martyl said, "and I'm the Queen of Sheba. Who is this? 'George Gershwin,' he said, 'I'm in town for the rehearsal, and you have an exhibition that I'd like to see. How can I see it?' Well, I remember it was on a Saturday. The building was closed. I remember there was a Doubleday Bookstore on the first floor; it was on Maryland Avenue. Somehow, I got the building opened and showed him the work. He chose the drawing that he liked the best, which I had kept in my studio. Also in that exhibition, fortuitously, there was a drawing, and it was called *Gershwin Chord in Trees*."

After seeing the work, Gershwin took Martyl back to his hotel and played all the music that he was going to play the next day, a symphony for one. "That was some experience," she said at 89.

In college, Martyl was a part of a playwriting class at Washington University. "In the class," Martyl said, "was a sallow-looking young man named Tom Williams. He wasn't enrolled in the school, full time; the professor, William Glasgow Bruce Carson, must have known he was a talent and let him sit in on the class.

"The exam at the end of the year was to write a play. So we all wrote a play. Williams wrote a play. I remember he read it out loud," she said. "I remember doing my zoology homework during his reading because it was so dull, and he had this whiny voice. I paid no attention to it ... at the time. I remember him wearing a brown suit the whole year that turned sort of purple and shiny, because he never changed it."

Then the exams came back.

"The young man that won the first prize became the editor of the *Kansas City Star*. The second prize went to me," Martyl said, "and the third prize went to Tennessee Williams, then known as Thomas Lanier Williams."

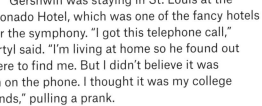

An Annotated History of the Doomsday Clock

In 2007, Martyl provided some annotations on a memo she had written in the 1980s about the creation of the Doomsday Clock. Here, we reproduce her original remembrance with those additional comments (in color), plus some historical footnotes from the editors (in black).

Except for J. Robert Oppenheimer, I was the only artist any of those scientists ever knew. It seems like I still am on account of the Clock.

Hyman H. Goldsmith (1907–1949) was physicist and the coordinator of information at Chicago's Metallurgical Lab. He and Eugene Rabinowitch served as co-editors of the *Bulletin* until Goldsmith's untimely death in a swimming accident.

Creativity in art and science are the same. I once painted cyclotrons and radio oscillators. They were unusual shapes and just wonderful objects. I exhibited them in New York. The reviewer said I had this unusual originality. I wrote him, "If I invented these, I would've won the Nobel Prize a long time ago." But scientists hated it. They didn't want anyone taking liberties with their work.

The Container Corporation of America (CCA), a leading American packaging company, had a huge influence on 20th century American art and design with its forward-thinking commissions of avant-garde artists and designers like A. M. Cassandre, Herbert Bayer, László Moholy-Nagy, and Fernand Léger.

It was just a good idea, and the fact that it survived—and became even more important—is one of the nicer things that's happened in my life.

The Bulletin of the Atomic Scientists is the name of the organization, as well as the publication. When referring to the magazine, we use italics, such as the *Bulletin* or *Bulletin of the Atomic Scientists*.

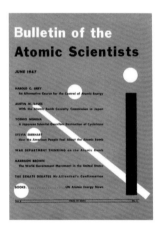
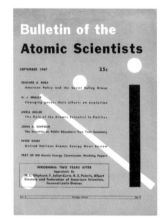
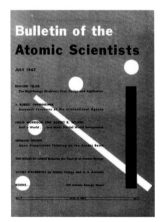
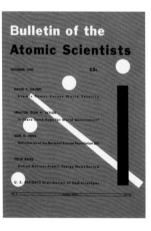

Bulletin of the Atomic Scientists covers, 1947

In 1943, I came to Chicago from Saint Louis with my husband Alexander Langsdorf Jr., who was invited to join the Manhattan Project by Enrico Fermi. We were able to get Edward Teller's apartment when the Tellers moved to Los Angeles.

The publication known as the *Bulletin of the Atomic Scientists* came into being as a pamphlet in December 1945. It was published as a direct response by concerned scientists to the social implications of the Bomb. Since I knew most of the scientists—famous and not-so-famous—and was friends with H.H. Goldsmith, a founder of the Bulletin, he asked for my help in designing the publication for a magazine format with a suitable cover. There was no money available for different monthly covers or any artwork at all. By this time I had had numerous exhibitions of my drawings and paintings around the United States, so Goldsmith thought me the logical one to help launch the *Bulletin* as a full-fledged magazine.

There followed some sketches and ideas; the most significant of all was a sketch of a clock, which I made on the 8 by 11-inch back of a bound copy of Beethoven's Piano Sonatas. I visualized the cover by drawing a Clock in white paint on the black binding of the sonatas. It was a rather realistic clock, but it was the idea of using a clock to signify urgency. My idea was to repeat the clock every month on a different color background—the first color being bright orange to catch the eye.

I had a friend, Egbert Jacobson, chief of design for the Container Corporation of America. I got his advice one evening at his house on how to graphically carry out my idea of superimposing a clock, a table of contents, and other pertinent information on the cover with style and clarity. His suggestions and know-how were very helpful in designing the simplest possible form for a repeat cover. The June 1947 issue was the subsequent result, and the Clock became the logo of the *Bulletin*. We moved the Clock's hands forwards and backwards as the times indicated.

Goldsmith was delighted with my results, as were the rest of the board as far as I knew. The same design ran on the cover for decades, only the contents and color changing. I also drew the end pieces and illustrations for articles from 1947 until sometime in the 1970s.

Many years later, Eugene Rabinowitch, a founder and editor of the *Bulletin*, confessed to me that he never knew that Goldsmith asked me to design the cover. Rabinowitch lived in Urbana, Illinois, and there were gaps in the exact sequence of events. He confessed having thought the idea of a Clock was so brilliant that it surely must've come from Edward Teller.

Therein is the true birth of the Bulletin Clock.

Edward Teller (1908–2003) was a theoretical physicist often referred to as "the father of the hydrogen bomb" and an advocate for nuclear energy in the civilian sector.

My husband never wanted to work at Los Alamos. Other scientists found it to be an intriguing scientific pursuit. Everyone draws their own line, and he felt differently. The research, yes. But he refused to go where the bombs were made.

It was a panicky time. My husband was recruited for speaking tours around Chicago. Nobody knew anything. It's hard to believe today that the word "atom" was alien. The scientists, however, wanted to inform the public. So they went on the rubber chicken circuit— Rotary Clubs, Better Business Bureaus, etc. The groups would say, "We'll give you 20 minutes to tell us about atomic energy." It's insane, but they tried.

That I can't take credit for. It was a wonderful idea, and it fit with the urgency theme. I originally set the Clock at seven minutes to midnight simply because it looked good.

The editor wanted some illustrated relief on the page so they'd send me stories to illustrate. My friends did it, too. It was all done gratis; there was never any money. They did it because I asked them.

Martyl broke ground as a visionary artist, not just of her time, but beyond it. As both a painter and as designer of the Doomsday Clock, Martyl established herself at the nexus of Chicago's midcentury art and design scene.

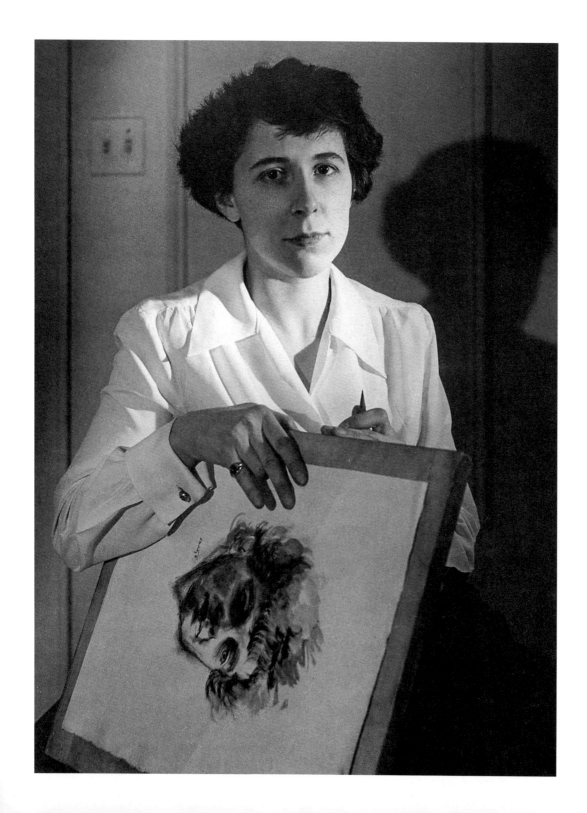

Martyl at home in Hyde Park, Chicago, 1950s

Martyl and the Doomsday Clock in Midcentury Chicago

By Maggie Taft,
Art Historian and
Founding Director,
Writing Space
(Chicago, IL)

In 2007, Printworks Gallery in Chicago hosted "Martyl: Inspired by Location," an exhibition of the artist's drawings and paintings on paper. Most of the work in the show was made during Martyl's time in the American West and Southwest, where she traveled frequently throughout her life. Drawings of the open sky and old growth trees and paintings of rock formations and the ocean have a clear connection to America's western landscapes. How might the Doomsday Clock also have a relationship with place? Though it has no representational ties to the skyscrapers, city grid, or lakefront of Chicago, where Martyl lived when she made it, the striking design for the *Bulletin of the Atomic Scientists* nevertheless resonated and had a relationship with Chicago's broader midcentury art scene.

"Moving to Chicago was like a liberation," Martyl recollected in 2007, 64 years after leaving her hometown of St. Louis with her new husband, atomic researcher Alexander Langsdorf Jr. "We moved to Hyde Park by the University of Chicago; and so, with the elevated, I could go any place."[1]

During the 1940s, the train could take her to visit her friend Peter Pollock at the South Side Community Art Center, where he had served as Director from 1939 to 1942, or his eponymous gallery on Chicago's Near North Side. She would ride it to the Loop to see the contemporary European art on view at Alice Roullier's gallery and the Arts Club of Chicago, where she also admired the interiors designed by recent émigré architect Ludwig Mies van der Rohe. (Inspired by Mies's designs, Martyl would use the same

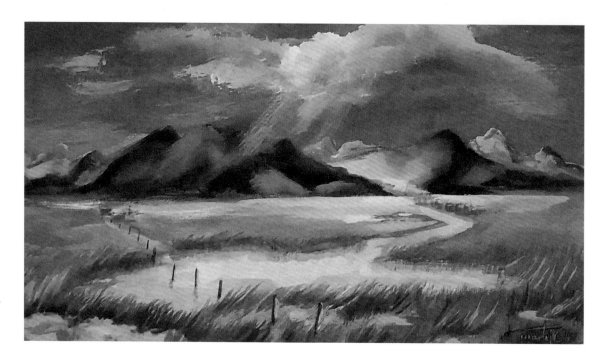

Martyl Langsdorf, *Western Slope*, 1940. Gouache on paper

black varnish on the wood floor of her Woodlawn home as Mies used in all his apartments.[2]) The train made it easy for her to visit her friend Katherine Kuh at the Art Institute of Chicago (AIC), where Kuh ran the museum's Gallery of Art Interpretation (a pioneering experiment in museum education that sought to give the public tools for appreciating modern art), and then became its inaugural curator of modern painting and sculpture. Once in the Loop, Martyl could walk north to the Gold Coast and see work by local artists at Charles Feingarten Gallery and Associated American Artists Gallery. They were just two of the Chicago spaces that would display her work.

After arriving in Chicago in 1943, Martyl consistently showed at spaces around the city. In 1944, she had an exhibit at the Renaissance Society, a kunsthalle located on the University of Chicago campus, where her paintings hung alongside textiles designed by German émigré weaver Marli Ehrman. And Pokrass Gallery, located in the home of a wealthy Hyde Park woman, showed her work next to paintings by Felix Ruvolo. Martyl's work was regularly included and awarded prizes in the Art Institute's annual Chicago and Vicinity exhibitions. And

she was invited to participate in the museum's pioneering collaboration with network television for a program in which a handful of Chicago artists were invited to select and discuss favorite pieces in the museum's collection and then do an artmaking demo. (Martyl's picks included Auguste Renoir's *Jugglers at the Circus Fernando*, a Fernand Léger canvas, a Giovanni Bellini portrait, and an African mask.) While intended to increase visibility for the museum by expanding its public to a nascent television audience, Martyl remembered that the program was most beneficial for publicizing the featured artists like herself.

Martyl's experience as an artist in mid-century Chicago was unusual. Most of her peers bemoaned the few opportunities available to local artists: There was the Art Institute with its "Chicago Room" and its annual exhibitions highlighting the work of local and American artists ("There wasn't anything else,"[3] Martyl would say of museum opportunities); a few galleries (as Martyl would remember, "You could count them on one hand"[4]); and only a small circle of critics (according to Martyl, just "three" [5]). Though the creative culture was not as "provincial" as she believed it to be, her assessment

of its mainstream spaces was apt.[6] Chicago's society art scene was circumscribed by a handful of institutions and a few powerful collectors and curators, many of whom—including collectors Joe Shapiro and Florene May Schoenborn, and AIC curators Hans Huth (Decorative Arts), Frederick Sweet (American Art), Harold Joachim (Prints and Drawings), and Dan Rich (Chief Curator, Director of Fine Arts)—Martyl counted as friends.

Some of Martyl's success in Chicago may have been due to her social network, but that was not the only reason for it. Her work balanced competing strands of Chicago's midcentury art scene and responded to its preoccupations. Though the Doomsday Clock falls outside of Martyl's primary oeuvre, consisting particularly of landscapes, the iconic design is illustrative in both respects.

"I chose the clock face because of the urgency and that time [was] of the essence," Martyl would say of her concept for the Clock.[7] As the self-described "resident artist" in Chicago's scientific community, she was approached by a

group of scientists and civilian activists to turn their pamphlet about the existential dangers of atomic power into a magazine that might reach a broader audience.[8] "I fooled around trying to do something literal, and then take [sic] away," she said. "That's the way I work." This was how Martyl conceptualized abstraction in her painting process more broadly. She would begin with representation and chip away at it to get at something essential— "an abstract," she would call it, as though a painting were a précis.[9] With the Doomsday Clock, Martyl began with the familiar form of a clock and then eliminated the hands and numbers to produce a simplified graphic.

In Martyl's paintings, such as those shown at the Renaissance Society in 1944, this approach to abstraction resulted in canvases that use a peculiar, elevated vantage, unblended color, and a flurry of brushstrokes to capture rural landscapes and small-town scenes. Paintings like these offered an antidote to Chicago's bifurcated, institutional interwar arts scene in which modernists, supported by critic C.J. Bulliet of the *Chicago Evening Post*

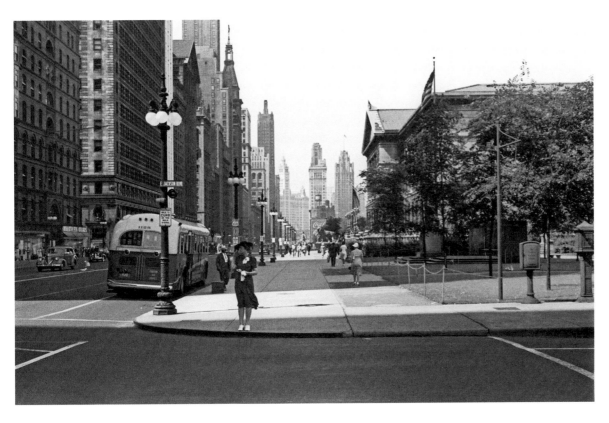

Michigan Avenue, Chicago, Illinois, with the Art Institute of Chicago on the right, 1940

and later the *Chicago Daily News*, were pitted against anti-modernists, led by the *Chicago Tribune*'s outspoken critic Eleanor Jewett; while Bulliet celebrated the originality and individualism of modernism, Jewett derided it as brutal, ugly, and immoral. Martyl's paintings offered pretty landscapes of the sort Jewett enjoyed *and* the distinctive viewpoint favored by the modernists. ("Martyl Work Bridges Two Concepts of Art," the *Chicago Tribune* would proclaim in a headline.[10]) As H.W. Janson, author of the canonical art history textbook *History of Art* and a friend of Martyl's, once wrote, "The house of modernity has many rooms. I'm grateful that Martyl has chosen one towards the garden, rather than the overcrowded discotheque."[11] While her work took up the techniques and the lessons of modernism, he suggested, it was more tranquil than most. Though the Doomsday Clock is far from tranquil in its message, its design issued from an approach

to art making that Martyl used in her practice more widely and that reconciled ongoing critical debates in Chicago's art world.

The Doomsday Clock also offered an apropos response to the challenge of representing the atomic bomb. As the nation wrestled with the ethics of the bomb's deployment, this topic concerned Americans across the country. But it was particularly potent in Chicago, where the bomb had been invented by scientists, Martyl's husband among them.[12] The local press was full of discussions about how to understand the magnitude of the bomb's destruction. For example, the *Chicago Daily News* and the *Chicago Tribune* published illustrations showing what would have been the scope of devastation had it been dropped in Chicago.[13]

Such questions of representation also concerned artists and art critics. Bulliet, for example, argued that artists had historically

Comparative nuclear strike map showing the effects on New York and surrounding area, *Bulletin of the Atomic Scientists*, April 1950

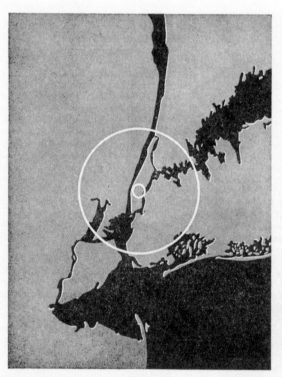 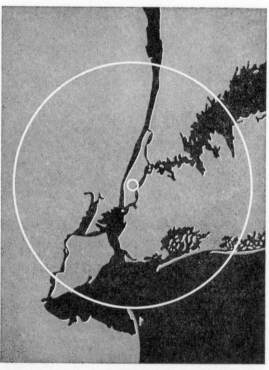

Fig. 1 Fig. 2

EFFECTS OF *present uranium bomb* (small circle, each map) and *proposed hydrogen bomb,* 1,000 times more powerful (large circle) on New York and surrounding area. Figure 1 shows areas of severe destruction by blast; Figure 2, areas within which flash burns would be lethal.*

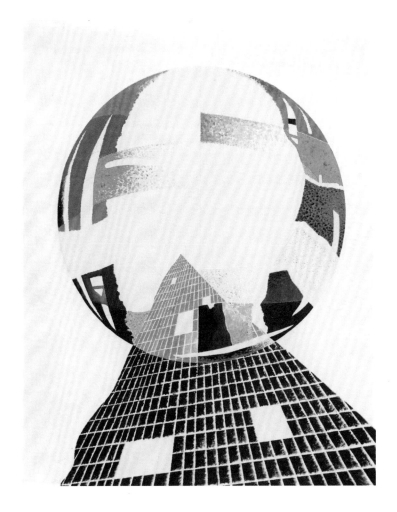

László Moholy-Nagy, *Nuclear I, CH*,
1945. Oil and graphite on canvas

borne the responsibility of humanizing war, of showing civilians its casualties and horrors so that they could better comprehend its weight. But, Bulliet wondered, how could any representation ever make something so immense as the atomic bomb graspable?[14] Chicago-based artists, like László Moholy-Nagy, director of Chicago's Institute of Design (previously the New Bauhaus), took up the challenge. In two paintings—*Nuclear I, CH* and *Nuclear II*—completed shortly before his death in 1946, Moholy used some of the hallmarks of early 20th century European abstraction—hovering forms, passages of primary color—to try to represent the enormity of this unprecedented invention. In *Nuclear I, CH*, a floating orb sits atop a grid that recedes into the background, as though to suggest a city overtaken by the power of this new nuclear energy. By contrast, Martyl's Doomsday Clock offered a very different answer to Bulliet's question. Instead of representing the destructive capacity of the atomic age, the Clock suggests its threat, picturing our proximity to devastation instead of the devastation itself. It's like a monster movie in which the monster never appears, and the creature is more frightening for it. The destruction, her design suggests, cannot be contained in an image but is instead to be conjured by a collective imagination. It is an inspired response to the challenge of representing the enormity of atomic power, and a direct response to a question circulating in Chicago's postwar art scene.

1 "Oral History of Martyl Langsdorf," Interviewed by Betty J. Blum (The Art Institute of Chicago, 2007), 72.

2 Ibid, 146.

3 Ibid, 74.

4 Ibid, 74.

5 Ibid, 133.

6 Ibid, 133.

7 Ibid, 124.

8 Ibid, 123.

9 Ibid, 124.

10 *Chicago Tribune*, February 5, 1957.

11 H.W. Janson quoted in "Oral History of Martyl Langsdorf," 135.

12 Art historian Timothy J. Garvey offers a cogent assessment of this local discussion in "László Moholy-Nagy and Atomic Ambivalence in Postwar Chicago," *American Art* Vol. 14, no. 3 (Autumn 2000), 23-39.

13 "What One Bomb Could Smash," *Chicago Daily News*, August 7, 1945; "Damage Compared," *Chicago Tribune*, August 7, 1945; "Bomb Destruction," *Chicago Tribune*, August 8, 1945.

14 C.J. Bulliet, "Atomic Bomb a Headache for Our War Artists," *Chicago Daily News*, August 18, 1945.

May 15, 1946

November 1947

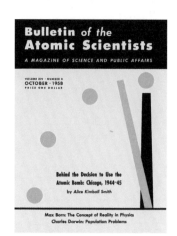
October 1958

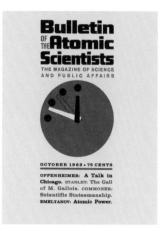
October 1963

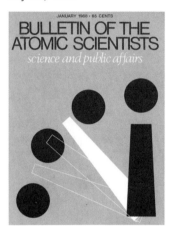
January 1968

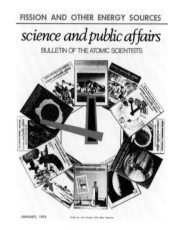
January 1974

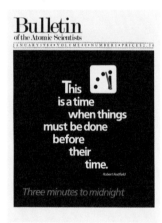
June 1977

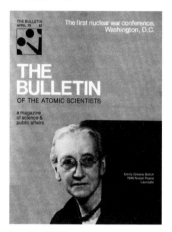
April 1979

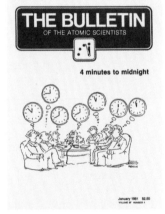
January 1981

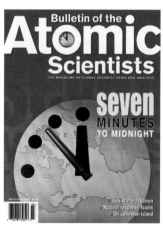
January 1984

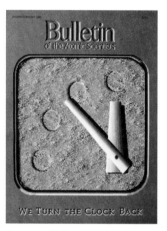
January/February 1988

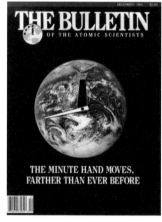
December 1991

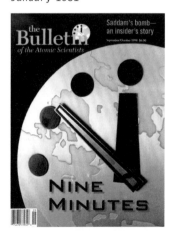
September/October 1998

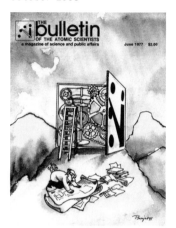
March/April 2002

January/February 2007

November 2019

The Doomsday Clock and the Bulletin

Since its inception on the June 1947 cover, Martyl's Clock has evolved with the *Bulletin*'s design and the magazine's increasingly global concerns.

James Goggin,
Partner and
Design Director,
Practise

As you may or may not know, The Bulletin of the Atomic Scientists (organization) started with the *Bulletin of the Atomic Scientists* (publication). And the *Bulletin* in turn begat the *Bulletin*'s clock. Of course, before the Doomsday Clock, the *Bulletin* was a literal bulletin: A dry six-page all-text newsletter. While this section of the book starts with a spread of those anonymous-looking pamphlets, things escalate rapidly—graphically—from there.

Martyl's commissioned artwork for the June 1947 issue changed everything. The warning-sign orange cover set the time from which we now gauge our global security every year, starting at an ominous yet hopeful seven minutes to midnight. The scientific calculation behind that Clock setting? "Simply because it looked good," Martyl later admitted. A correct calculation, as it turned out.

What started as an arresting yet economical repeating motif—just colors changing from issue to issue—naturally evolved over time, through design movements and trends, the Clock moving between foreground and background. Although it sometimes remained as feature illustration, in general the Clock gradually shrunk, often embedded in the masthead yet always omnipresent.

By 1963 the icon had become iconic, and this status clearly gave designers license to shift the Clock's shape into a playful modular system: A field containing multitudes, from Arabic script to data charts to photography. The cover designs continued to morph through late '60s "international style" modernism to less abstract topical news magazine territory by the late '70s. The early-to-mid 1980s saw a more *New Yorker*-style cartoon blip followed by a surprisingly (if slightly late) punk collage tack (circa '84–'87), before a segue back to legit news mag aesthetics as they headed into the 1990s.

The artistic lineage from Martyl onwards was apparently AWOL through the early 2000s, but a revival of sorts was sparked with the 2007 Pentagram redesign featuring specially commissioned covers by the likes of designer Milton "I Heart NY" Glaser. May/June '07 saw a glorious return by Martyl herself, with a dramatic abstract Clock landscape.

This graphic archive across the next 30 pages provides a concise yet broad range of histories. The *Bulletin* captured numerous 20th century art and design zeitgeists and, in parallel, the story is told of increasingly global concerns: Not just the nuclear threat (as if that isn't already enough), but increasingly the organization's expanded remit of climate change and disruptive technologies (from drones to misinformation), with the latter issues presciently showing up earlier than you might expect.

BULLETIN of the
ATOMIC SCIENTISTS of CHICAGO

| VOL. 1 | DECEMBER 10, 1945 | 360 | NO. 1 |

PEARL HARBOR ANNIVERSARY and the MOSCOW CONFERENCE

On this fourth anniversary of the Pearl Harbor attack, American public opinion seems to be much more concerned with assessing the responsibility for the disaster which occurred four years ago, than with preventing a future "Pearl Harbor" on a continental scale, which may occur four years from now. Three thousand Americans — mostly members of our Armed Forces — lost their lives in the Japanese sneak attack. Thirty million Americans — civilians, women, and children — may be doomed to perish if a sneak attack on our cities by atomic bombs ever comes to pass. This catastrophe will be inevitable if we do not succeed in banishing war from the world. Our own better preparedness could have saved Pearl Harbor — but in a world of atomic bombs, preparedness can only give us the power to retaliate — to smash in our turn the cities of the nation which attacked us.

On the anniversary of Pearl Harbor, The Atomic Scientists of Chicago appeal to the American people to work unceasingly for the establishment of international control of atomic weapons, as a first step towards permanent peace. Let us realize that all we can gain in wealth, economic security, or improved health, will be useless if our nation is to live in continuous dread of sudden annihilation.

We are convinced that no insuperable technical difficulties stand in the way of an efficient international control of atomic power. In a consultation of scientists of all countries, the technical methods of control could be worked out; it will be up to the statesmen to bring about the necessary political understanding.

Right now, the Senate Committee on atomic energy, under the chairmanship of Senator MacMahon, is holding hearings, in which the most qualified experts are testifying. These hearings are perhaps the most important thing happening in the world today. How Congress makes up its mind in this matter and whether the American people will support or oppose the administration's atomic power policy, will have more effect on the future of this country and of the world than the civil wars in China or Iran, or the fate of Palestine or Bulgaria.

Scientists have repeatedly advocated immediate consultations with Russia on the subject of atomic power. We are therefore gratified by the announcement that the subject is to be discussed at Moscow by the foreign secretaries of the three big nations. However, we are worried lest these negotiations be endangered by combining them with an attempt to settle various other political differences between the Allies. The problem of atomic power requires a fresh approach and should not be encumbered by the burden of past and present conflicts and misunderstandings. We fervently hope that all three big nations are aware that an agreement on atomic power controls must be reached if our civilization is to survive.

Our readiness to submit our own atomic power development to control and inspection by an international body, and to restore full and free publication of all research results in the field of atomic studies, should be conditioned only by the readiness of other nations to assume the same responsibilities and submit to the same controls, and should not depend on any concessions in other controversial issues of world politics. We can afford compromises, disagreements, or delays in other fields — but not in this one, where our very survival is at stake.

* This statement was released on December 7 at a press conference held by H. C. Urey and members of the Executive Committee of the A.S.C.

THE ATOMIC SCIENTISTS OF CHICAGO

The Atomic Scientists of Chicago is an organization of the scientific employees of the Metallurgical Laboratory of the University of Chicago, founded on September 26, 1945 after informal discussions which began as early as June. The present constitution was adopted on October 30, 1945. The constitution defines the aims of the organization as:

1. To explore, clarify and formulate the opinion and responsibilities of scientists in regard to the problems brought about by the release of nuclear energy, and

2. To educate the public to a full understanding of the scientific, technological and social problems arising from the release of nuclear energy.

Any past or present scientific employee of the Manhattan Project is eligible for membership. There are at present 200 members who have signed a Declaration of Intent embodying the above aims. General meetings are held at least twice a month. The A. S. C. is now incorporated as a nonprofit corporation in the state of Illinois.

The present Executive Committee, elected on November 7, consists of J. A. Simpson, Jr., chairman, Austin Brues, Francis L. Friedman, Arthur H. Jaffey, Robert L. Moon, J. J. Nickson, E. Rabinowitch. Alternates to Executive Committee: A. Wattenberg, R. Adams, L. I. Katzin, M. Freedman.

The Advisory Committee is composed of: Thorfin Hogness, chairman, Kenneth C. Cole, Farrington Daniels, James Franck, Robert S. Mulliken, Glenn T. Seaborg, Harold C. Urey and Walter H. Zinn.

The Executive Committee has made the following appointments: H. H. Goldsmith, secretary to the Execututive Committee; L. C. Furney, treasurer; Mrs. R. Adams, secretary. Mrs. Adams can be reached at our temporary office, room 508, Social Science Building, University of Chicago, 1126 East 59th St., Chicago 37 — telephone Midway 0800, extension 1168.

December 10, 1945

December 24, 1945

January 10, 1946

February 1, 1946

February 15, 1946

May 15, 1946

June 1, 1946

July 1, 1946

August 1, 1946

September 1, 1946

October 1, 1946

November 1, 1946

December 1, 1946

January 1947

February 1947

March 1947

April–May 1947

June 1947

July 1947

August 1947

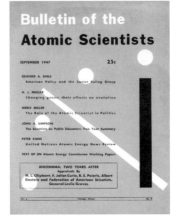
September 1947

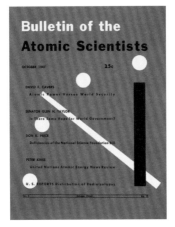
October 1947

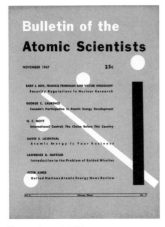
November 1947

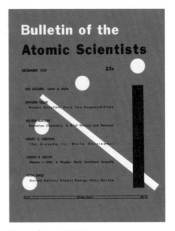
December 1947

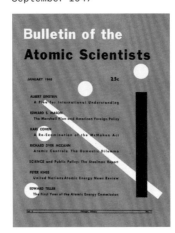
January 1948

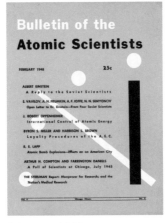
February 1948

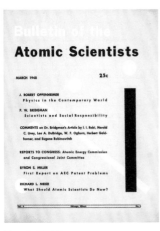
March 1948

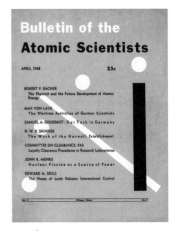
April 1948

May 1948

January 1949

February 1949

March 1949

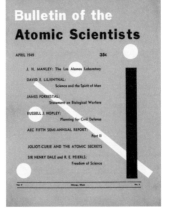
April 1949

DECEMBER, 1949
Vol. 5 • No. 12

Bulletin of the

Atomic Scientists

50c

"This is the time when things must be done before their time."
ROBERT REDFIELD

Featured in this Issue: **AEC Investigation: The Verdict**

United Nations News • **AEC, Congress, and Scientists**

Military Importance of the Atomic Bomb

December 1949

Bulletin of the Atomic Scientists

A MAGAZINE OF SCIENCE AND PUBLIC AFFAIRS

VOLUME XII · NUMBER 1
JANUARY · 1956
PRICE FIFTY CENTS

TENTH ANNIVERSARY YEAR

E. Rabinowitch: Ten Years That Changed the World

H. J. Morgenthau: Is Atomic War Really Impossible?

January 1956

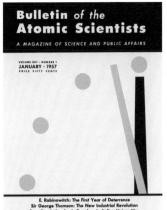

Bulletin *of the* **Atomic Scientists**
A MAGAZINE OF SCIENCE AND PUBLIC AFFAIRS

VOLUME XIII · NUMBER 1
JANUARY · 1957
PRICE FIFTY CENTS

E. Rabinowitch: The First Year of Deterrence
Sir George Thomson: The New Industrial Revolution
Enzo Boeri: Academic Freedom in Italian Universities

January 1957

Bulletin *of the* **Atomic Scientists**
A MAGAZINE OF SCIENCE AND PUBLIC AFFAIRS

VOLUME XIII · NUMBER 2
FEBRUARY · 1957
PRICE FIFTY CENTS

Chester Bowles: A New Approach to Foreign Aid
Bernard Brodie: Nuclear Weapons and Changing Strategic Outlooks
Arthur S. Barron: Why Do Scientists Read Science Fiction?

February 1957

Bulletin *of the* **Atomic Scientists**
A MAGAZINE OF SCIENCE AND PUBLIC AFFAIRS

VOLUME XIII · NUMBER 3
MARCH · 1957
PRICE FIFTY CENTS

Lee A. DuBridge: Science—The Endless Adventure
William H. Stead: The Sun and Foreign Policy

March 1957

Bulletin *of the* **Atomic Scientists**
A MAGAZINE OF SCIENCE AND PUBLIC AFFAIRS

VOLUME XIII · NUMBER 5
MAY · 1957
PRICE FIFTY CENTS

Ivan D. London: Toward A Realistic Appraisal of Soviet Science
Thomas Nelson: Nuclear Technology—An Economic Catalyst

May 1957

Bulletin *of the* **Atomic Scientists**
A MAGAZINE OF SCIENCE AND PUBLIC AFFAIRS

VOLUME XIV · NUMBER 1
JANUARY · 1958
PRICE ONE DOLLAR

Special Issue

RADIATION AND MAN

January 1958

Bulletin *of the* **Atomic Scientists**
A MAGAZINE OF SCIENCE AND PUBLIC AFFAIRS

VOLUME XIV · NUMBER 3
MARCH · 1958
PRICE FIFTY CENTS

Jay Orear: Detection of Nuclear Weapons Testing
IGY, SATELLITES, AND SPACE TRAVEL: Articles by Lloyd V. Berkner,
H. S. W. Massey, and James B. Edson

March 1958

Bulletin *of the* **Atomic Scientists**
A MAGAZINE OF SCIENCE AND PUBLIC AFFAIRS

VOLUME XIV · NUMBER 8
OCTOBER · 1958
PRICE ONE DOLLAR

Behind the Decision to Use the
Atomic Bomb: Chicago, 1944-45

by Alice Kimball Smith

Max Born: The Concept of Reality in Physics
Charles Darwin: Population Problems

October 1958

Bulletin *of the* **Atomic Scientists**
A MAGAZINE OF SCIENCE AND PUBLIC AFFAIRS

VOLUME XIV · NUMBER 10
DECEMBER · 1958
PRICE FIFTY CENTS

Third Pugwash Conference: Papers by A. V. Topchiev,
Harrison Brown, and Alvin M. Weinberg
Hans A. Bethe reviews *Brighter Than a Thousand Suns*

December 1958

Bulletin *of the* **Atomic Scientists**
A MAGAZINE OF SCIENCE AND PUBLIC AFFAIRS

VOLUME XV · NUMBER 1
JANUARY · 1959
PRICE FIFTY CENTS

E. K. Fedorov: Controlled Cessation of Atomic Weapons Tests
Herman Kahn: How Many Can Be Saved?
Sir John Cockcroft: Peaceful Uses of Atomic Energy
David R. Inglis: The Fourth-Country Problem—Let's Stop at Three

January 1959

Bulletin *of the* **Atomic Scientists**
A MAGAZINE OF SCIENCE AND PUBLIC AFFAIRS

VOLUME XV · NUMBER 2
FEBRUARY · 1959
PRICE FIFTY CENTS

SCIENCE AND ART

Articles by Rainey Bennett, Marston Morse, Everett McNear,
Eugene Rabinowitch, H. W. Janson, Lancelot L. Whyte, Carl Holty,
John Rader Platt, John Nef, Martin Kamen and Beka Doherty

February 1959

Bulletin *of the* **Atomic Scientists**
A MAGAZINE OF SCIENCE AND PUBLIC AFFAIRS

VOLUME XVI · NUMBER 1
JANUARY · 1960
PRICE SIXTY CENTS

Editorial: The Dawn of a New Decade
J. Robert Oppenheimer: In the Keeping of Unreason
Eugene Staley: Scientific Developments and Foreign Policy

January 1960

Bulletin *of the* **Atomic Scientists**
A MAGAZINE OF SCIENCE AND PUBLIC AFFAIRS

VOLUME XVI · NUMBER 3
MARCH · 1960
PRICE SIXTY CENTS

Leo Szilard: To Stop or Not to Stop
Harold Brown: Detection of Underground Nuclear Explosions
Roger Hilsman: Planning for National Security

March 1960

Bulletin *of the* **Atomic Scientists**
A MAGAZINE OF SCIENCE AND PUBLIC AFFAIRS

VOLUME XVI · NUMBER 9
NOVEMBER · 1960
PRICE SIXTY CENTS

An Interview with John Kennedy
Richard Nixon: The Scientific Revolution
Eugene Rabinowitch: Defenders or Avengers?

November 1960

Bulletin *of the* **Atomic Scientists**
A MAGAZINE OF SCIENCE AND PUBLIC AFFAIRS

VOLUME XVII · NUMBERS 5-6
MAY-JUNE · 1961
PRICE ONE DOLLAR

Special Issue

SPACE EXPLORATION

May-June 1961

Science and Public Affairs

Bulletin *of the* **Atomic Scientists**
A MAGAZINE OF SCIENCE AND PUBLIC AFFAIRS

VOLUME XVII · NUMBER 8
OCTOBER · 1961
PRICE SEVENTY-FIVE CENTS

Man and His Habitat
Taming Trees · Wastebasket of the Earth · Minerals: Supply and Demand

October 1961

Science and Public Affairs

Bulletin *of the* **Atomic Scientists**

January 1962
seventy-five cents

Eugene Rabinowitch: New Year's Thoughts

January 1962

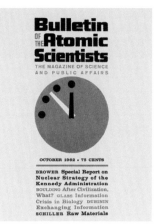

October 1962

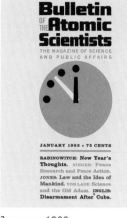

January 1963

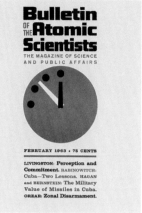

February 1963

April 1963

May 1963

October 1963

November 1963

December 1963

January 1964

February 1964

March 1964

April 1964

October 1964

December 1964

November 1965

December 1965

Bulletin OF THE Atomic Scientists

THE MAGAZINE OF SCIENCE AND PUBLIC AFFAIRS

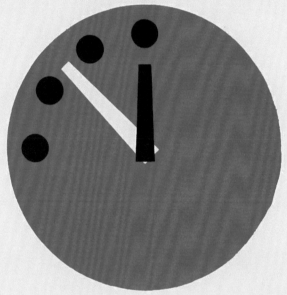

SEPTEMBER 1962 • 75 CENTS

NEW HOPE FOR DISARMAMENT LOUIS SOHN Variations on a Theme IGOR GLAGOLEV Is Disarmament Practical? HANS BETHE Disarmament and Strategy ROGER FISHER **Responding to Violations**

September 1962

JANUARY 1968 · 85 CENTS

BULLETIN OF THE ATOMIC SCIENTISTS

science and public affairs

January 1968

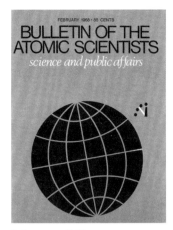

February 1968

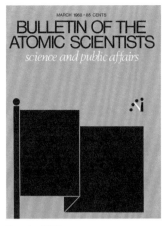

March 1968

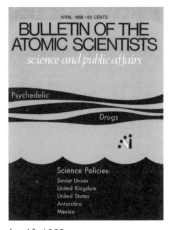

April 1968

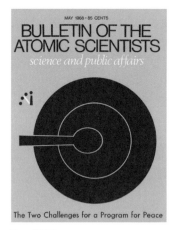

May 1968

June 1968

September 1968

October 1968

November 1968

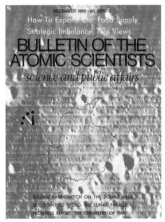

December 1968

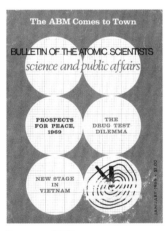

January 1969

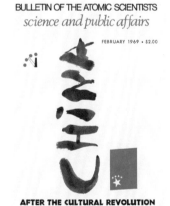

February 1969

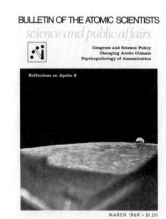

March 1969

April 1969

May 1969

June 1969

September 1969

November 1969

December 1969

January 1970

February 1970

April 1970

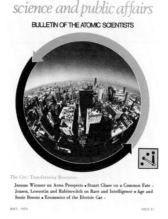

May 1970

June 1970

October 1970

May 1973

June 1973

September 1973

November 1973

December 1973

January 1974

March 1974

April 1974

science and public affairs
BULLETIN OF THE ATOMIC SCIENTISTS

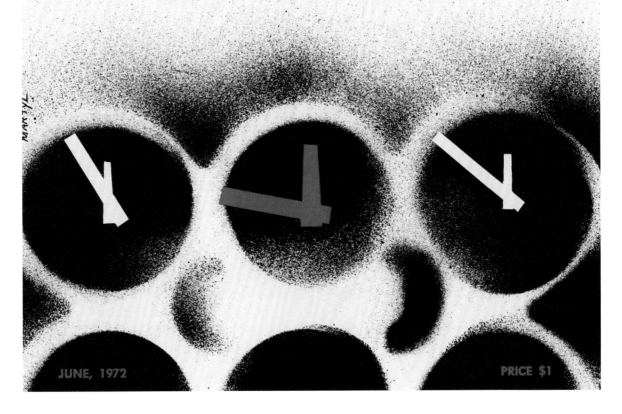

We Turn the Clock Back

JUNE, 1972

PRICE $1

June 1972

the bulletin
OF THE ATOMIC SCIENTISTS
a magazine of science and public affairs

June 1977 $2.00

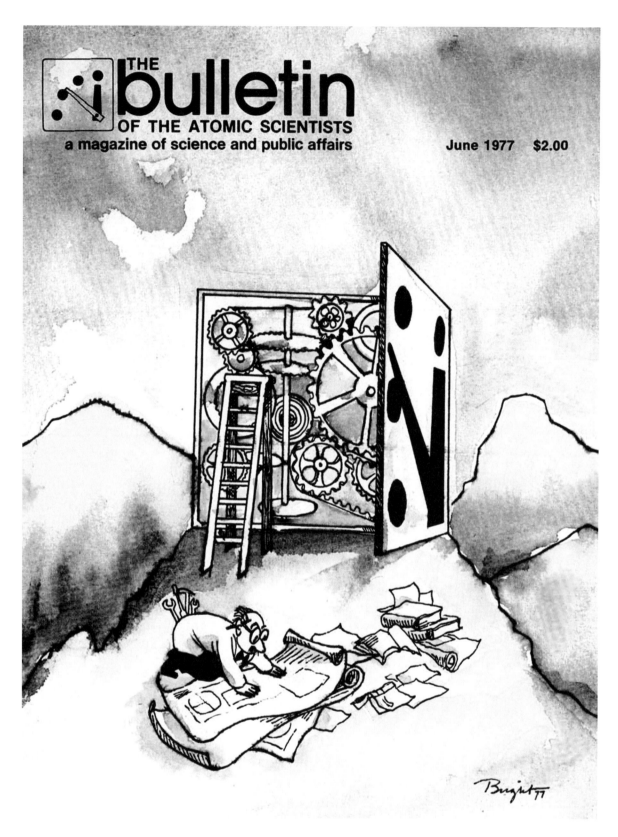

June 1977

May 1974

June 1974

September 1974

December 1974

March 1975

April 1975

May 1975

September 1975

December 1975

January 1976

May 1976

June 1976

November 1976

December 1976

February 1978

April 1978

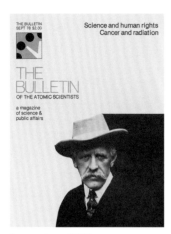

Science and human rights
Cancer and radiation

September 1978

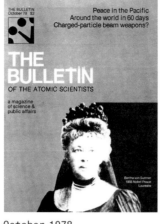

Peace in the Pacific
Around the world in 60 days
Charged-particle beam weapons?

October 1978

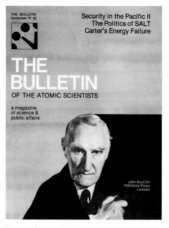

Security in the Pacific II
The Politics of SALT
Carter's Energy Failure

November 1978

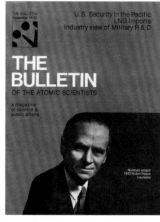

U.S. Security in the Pacific
LNG Imports
Industry view of Military R & D

December 1978

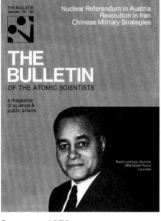

Nuclear Referendum in Austria
Revolution in Iran
Chinese Military Strategies

January 1979

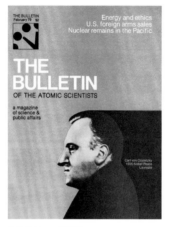

Energy and ethics
U.S. foreign arms sales
Nuclear remains in the Pacific

February 1979

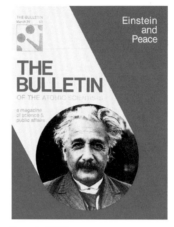

Einstein
and
Peace

March 1979

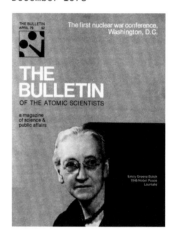

The first nuclear war conference,
Washington, D.C.

April 1979

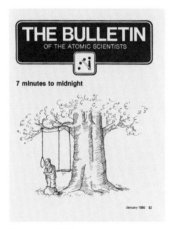

7 minutes to midnight

January 1980

The Clock stands still
From the Russian past to the Soviet present
How to make up your mind about the bomb

January 1982

The miners' canary
Last roundup for NATO?

February 1982

The pursuit of power: New nuclear strategy?
a historian reflects

April 1982

Studies on human evolution
The evidence for 'Yellow Rain'
Soviet religious practices

May 1982

The freeze and
the United Nations

World arsenals 1982

June 1982

Women and national security
At issue: nuclear modernization in Europe
A talk with Louis Harris

August/September 1982

Election 1982

October 1982

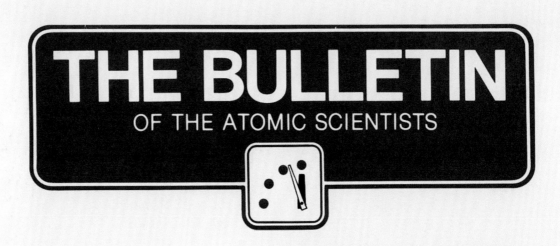

THE BULLETIN
OF THE ATOMIC SCIENTISTS

4 minutes to midnight

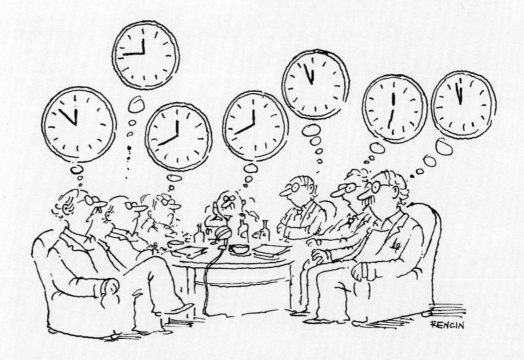

January 1981 $2.50
VOLUME **37** NUMBER **1**

January 1981

Bulletin
of the Atomic Scientists
JANUARY 1984 • VOLUME 40 • NUMBER 1 • PRICE $2.50

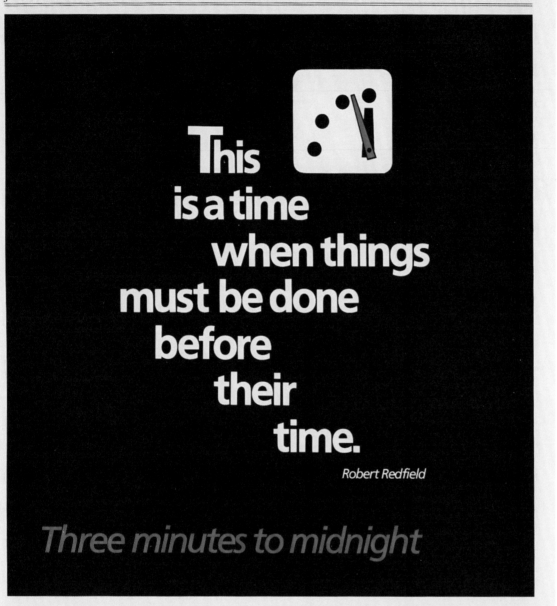

January 1984

January 1983

April 1983

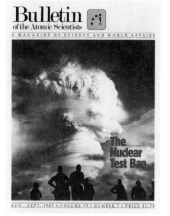

August–September 1983

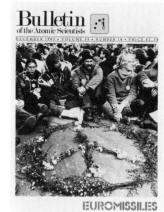

December 1983

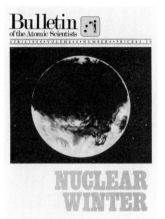

April 1984

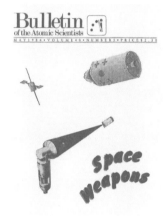

May 1984

August–September 1984

December 1984

January 1985

August 1985

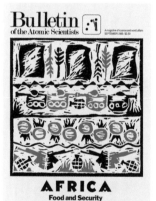

September 1985

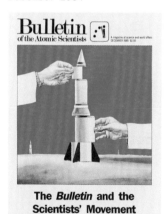

December 1985

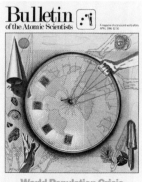

April 1986

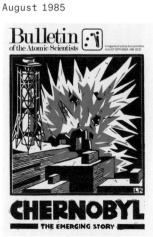

August/September 1986

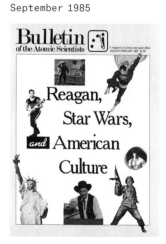

January/February 1987

March 1987

September 1987

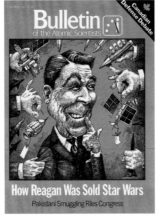

October 1987

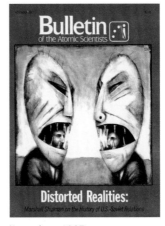

November 1987

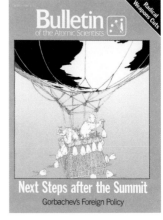

March 1988

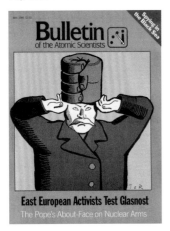

May 1988

June 1988

July/August 1988

September 1988

October 1988

November 1988

December 1988

January/February 1989

May 1989

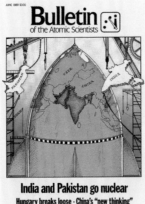

June 1989

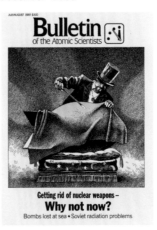

July/August 1989

September 1989

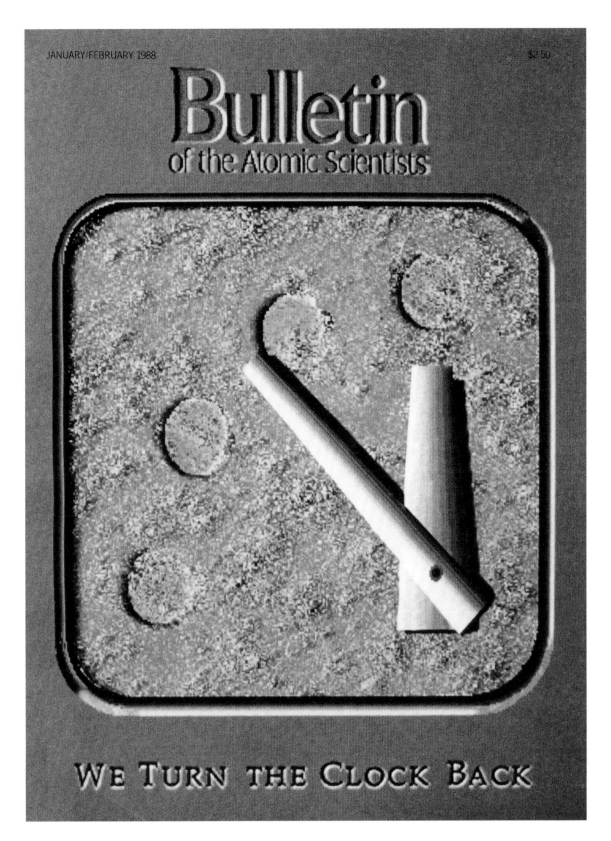

JANUARY/FEBRUARY 1988 $2.50

Bulletin
of the Atomic Scientists

WE TURN THE CLOCK BACK

January/February 1988

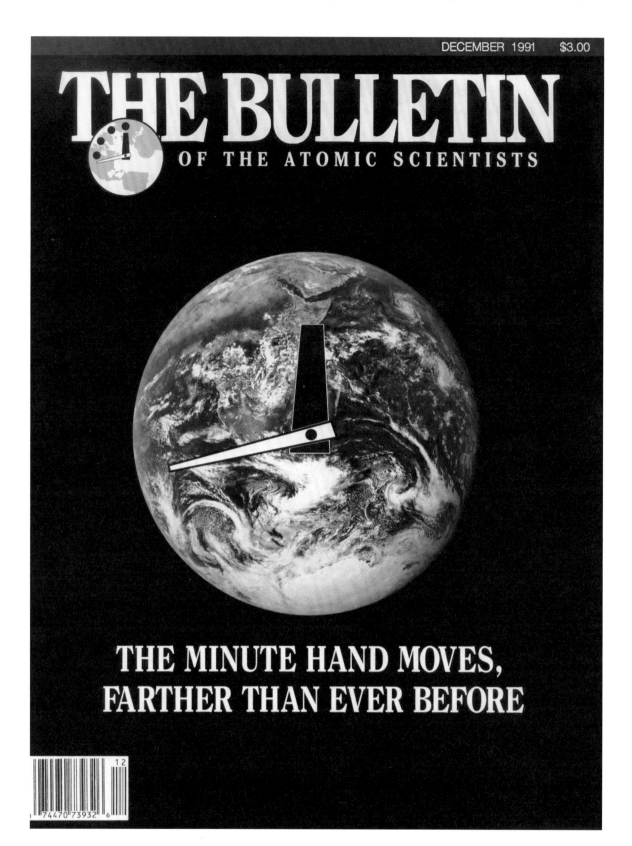

October 1989

March 1990

April 1990

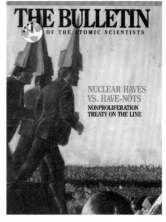

July/August 1990

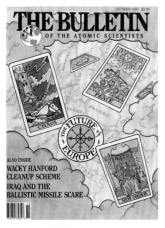

October 1990

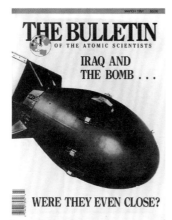

March 1991

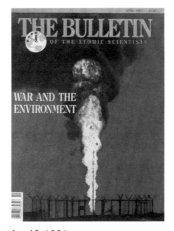

April 1991

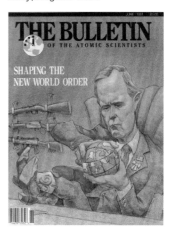

June 1991

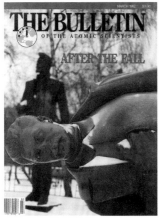

March 1992

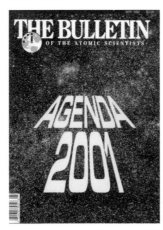

May 1992

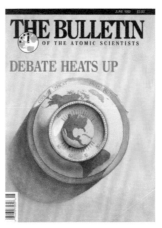

June 1992

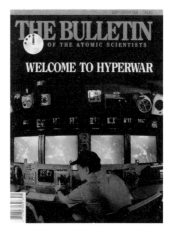

September 1992

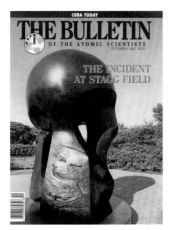

December 1992

November 1993

September/October 1995

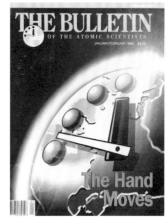

January/February 1996

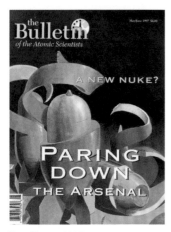
May/June 1997

July/August 1997

November/December 1997

May/June 1998

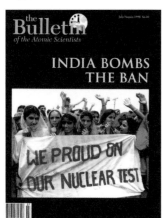
July/August 1998

November/December 1998

January/February 1999

May/June 1999

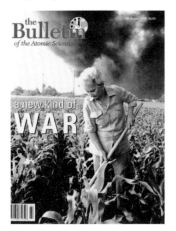
July/August 1999

September/October 1999

November/December 1999

January/February 2000

May/June 2000

July/August 2000

September/October 2000

November/December 2000

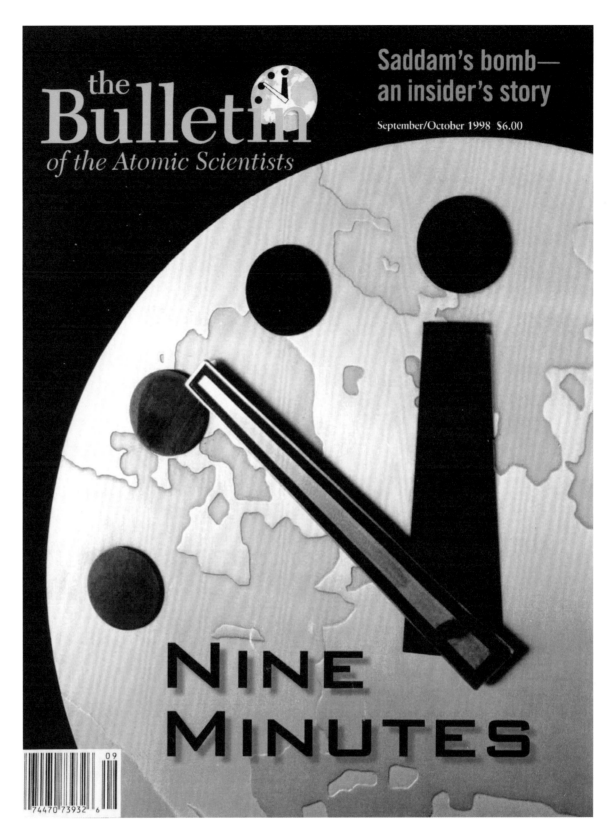

the
Bulletin
of the Atomic Scientists

**Saddam's bomb—
an insider's story**

September/October 1998 $6.00

NINE
MINUTES

74470 73932 6 09

September/October 1998

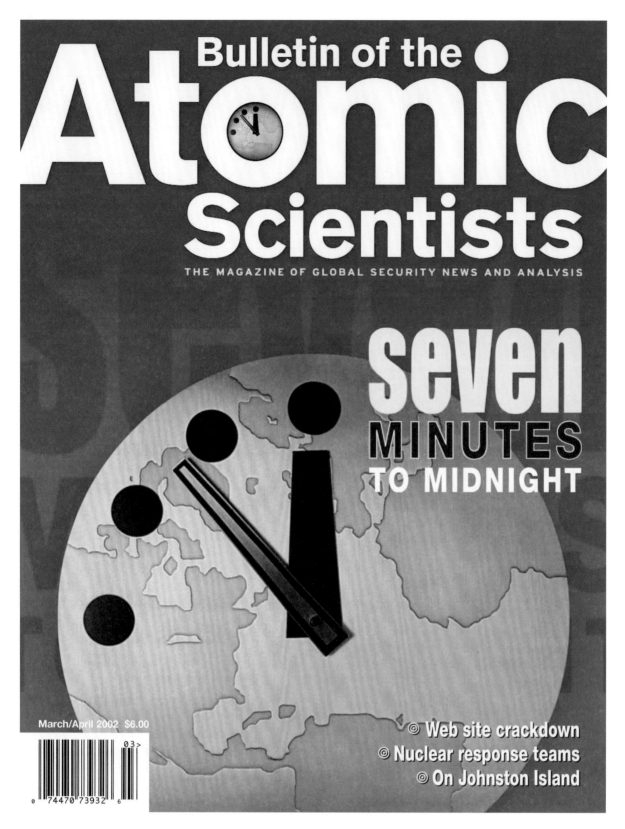

Bulletin of the Atomic

Atomic

Scientists

THE MAGAZINE OF GLOBAL SECURITY NEWS AND ANALYSIS

Seven
MINUTES
TO MIDNIGHT

March/April 2002 $6.00

◎ Web site crackdown
◎ Nuclear response teams
◎ On Johnston Island

74470 73932

03>

March/April 2002

January/February 2001

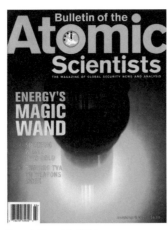

March/April 2001

May/June 2001

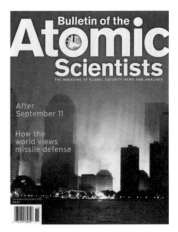

November/December 2001

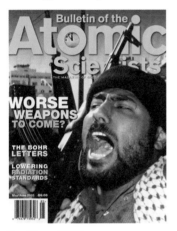

May/June 2002

September/October 2002

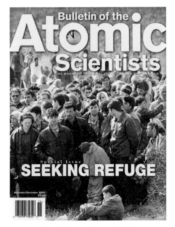

November/December 2002

January/February 2003

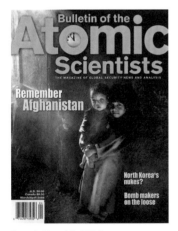

March/April 2003

September/October 2003

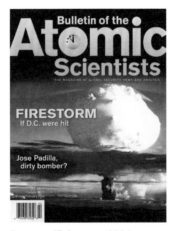

January/February 2004

July/August 2004

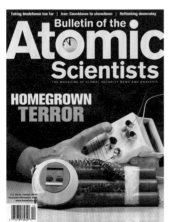

November/December 2004

March/April 2005

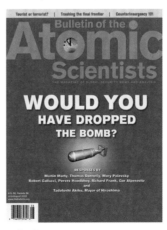

July/August 2005

November/December 2005

Bulletin of the Atomic Scientists

North Korea's nuclear neurosis
BY JACQUES E. C. HYMANS

Preserving our atomic heritage
BY RICHARD RHODES

Engineering evolution
INTERVIEW WITH DREW ENDY

May/June 2007

Bulletin of the Atomic Scientists

SPECIAL REPORT:
Plans for new nukes

Wernher von Braun: Space warrior
BY MICHAEL J. NEUFELD

Misreading Russia
BY VLADIMIR DVORKIN

WINNER
2007 National Magazine Award for General Excellence

July/August 2007

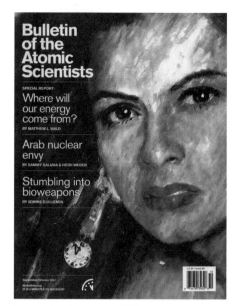

Bulletin of the Atomic Scientists

SPECIAL REPORT:
Where will our energy come from?
BY MATTHEW L. WALD

Arab nuclear envy
BY SAMMY SALAMA & HEIDI WEBER

Stumbling into bioweapons
BY JEANNE GUILLEMIN

September/October 2007

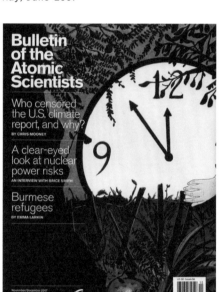

Bulletin of the Atomic Scientists

Who censored the U.S. climate report, and why?
BY CHRIS MOONEY

A clear-eyed look at nuclear power risks
AN INTERVIEW WITH BRICE SMITH

Burmese refugees
BY EMMA LARKIN

November/December 2007

Bulletin of the Atomic Scientists

Making nuclear energy work
BY ROBERT ROSNER

Curtains for Kyoto
BY GWYN PRINS & STEVE RAYNER

Dusting off disarmament
BY J. PETER SCOBLIC

Just before the bomb
AN INTERVIEW WITH PETER SELLARS

March/April 2008

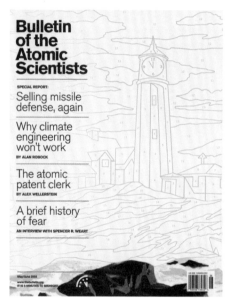

Bulletin of the Atomic Scientists

SPECIAL REPORT:
Selling missile defense, again

Why climate engineering won't work
BY ALAN ROBOCK

The atomic patent clerk
BY ALEX WELLERSTEIN

A brief history of fear
AN INTERVIEW WITH SPENCER R. WEART

May/June 2008

Bulletin of the Atomic Scientists

Films that bombed
BY JOSEPH MASCO

Carbon credit crunch
BY DAVID GREISING

Home on the (nuclear) range
BY NATHAN HODGE & SHARON WEINBERGER

The plant detective
AN INTERVIEW WITH JACQUELINE FLETCHER

July/August 2008

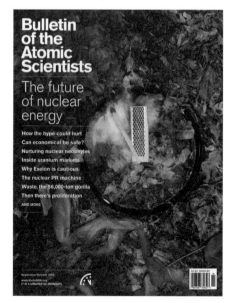

Bulletin of the Atomic Scientists

The future of nuclear energy

How the hype could hurt
Can economical be safe?
Nurturing nuclear neophytes
Inside uranium markets
Why Exelon is cautious
The nuclear PR machine
Waste, the 56,000-ton gorilla
Then there's proliferation
AND MORE

September/October 2008

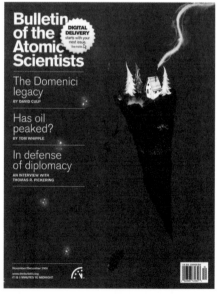

Bulletin of the Atomic Scientists

DIGITAL DELIVERY starts with your next issue. See inside

The Domenici legacy
BY DAVID CULP

Has oil peaked?
BY TOM WHIPPLE

In defense of diplomacy
AN INTERVIEW WITH THOMAS R. PICKERING

November/December 2008

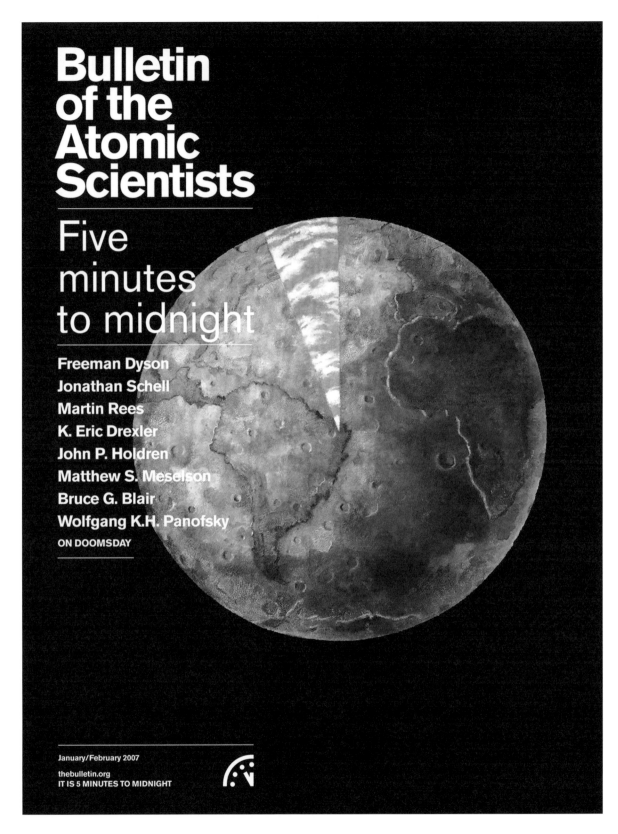

Bulletin of the Atomic Scientists

Five minutes to midnight

Freeman Dyson
Jonathan Schell
Martin Rees
K. Eric Drexler
John P. Holdren
Matthew S. Meselson
Bruce G. Blair
Wolfgang K.H. Panofsky

ON DOOMSDAY

January/February 2007

thebulletin.org
IT IS 5 MINUTES TO MIDNIGHT

January/February 2007

Now, then, and the future:
The *Bulletin* turns

Bulletin of the Atomic Scientists

DECEMBER 2020

IT IS 100 SECONDS
TO MIDNIGHT

December 2020

July 2018

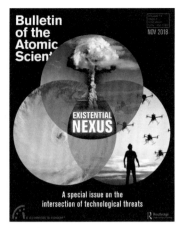

November 2018

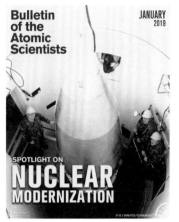

January 2019

March 2019

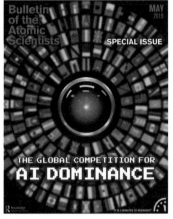

May 2019

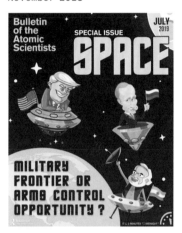

July 2019

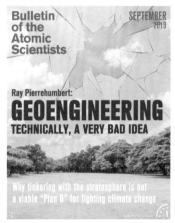

September 2019

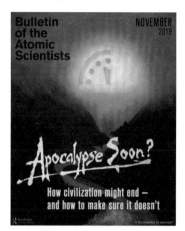

November 2019

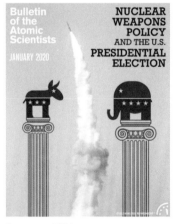

January 2020

March 2020

May 2020

September 2020

January 2021

March 2021

May 2021

July 2021

Editorial cartoons played an important role in the Bulletin's history, both for satirical purposes and translating the emotions of complex ideas.

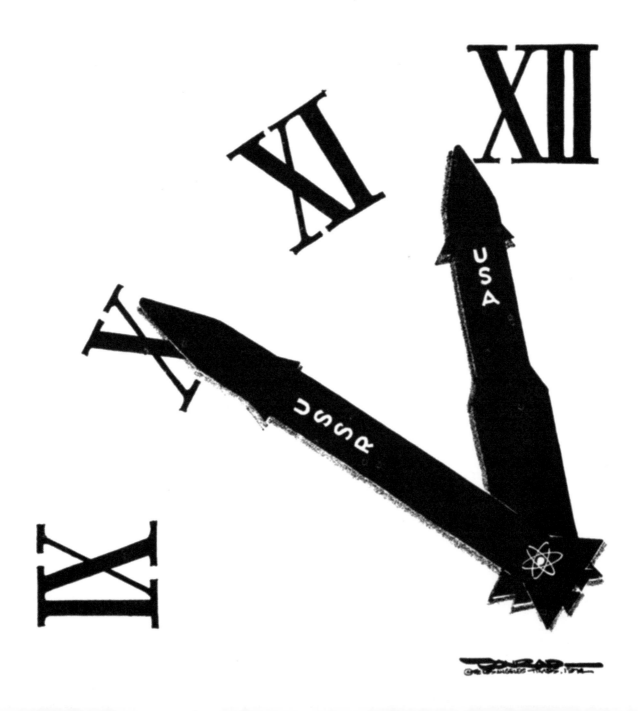

Doomsday Clock Cartoons

By Robert K. Elder

Single-panel cartoons were a longtime part of the Bulletin's print magazine, sometimes featuring the Doomsday Clock, but more often illuminating the issues of the day.

What started as *New Yorker*-style interstitial graphics by Martyl, Rainey Bennett, and William Dempster evolved into interior comics, then—in the 1980s—full cartoon covers.

Also in this section: Cartoons about the Doomsday Clock, that appeared in other publications.

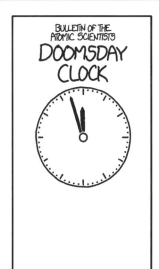 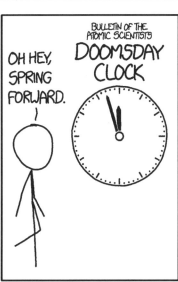 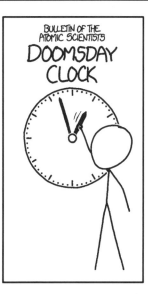

XKCD, xkcd.com, 2016

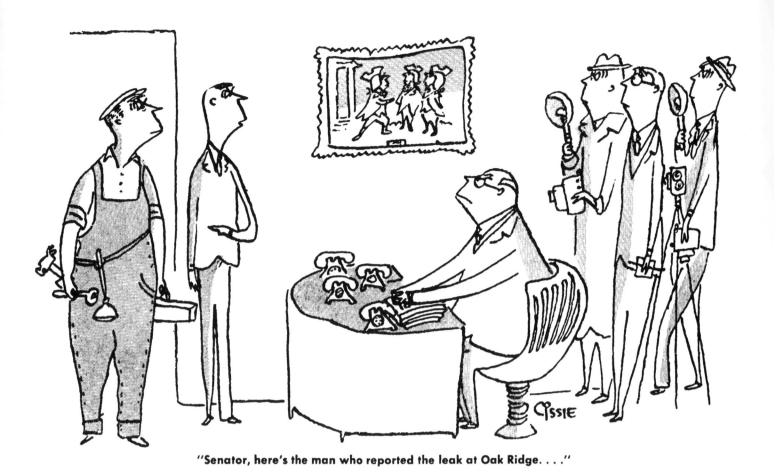

"Senator, here's the man who reported the leak at Oak Ridge...."

Cissie, *Bulletin of the Atomic Scientists*, 1951

Martyl, 1950

Glimpse at Doomsday

Daniel R. Fitzpatrick, 1954

Uncredited, 1972

Paule Loring, *Providence Evening Bulletin*, 1952

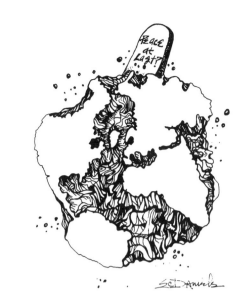

SC Daniels, 1975

Daniel R. Fitzpatrick, *St. Louis Dispatch*, 1955

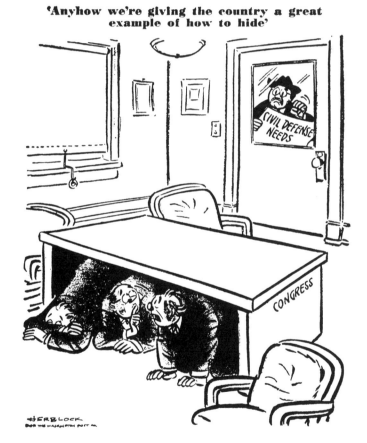

Herbert Lawrence Block, *Washington Post*, 1954

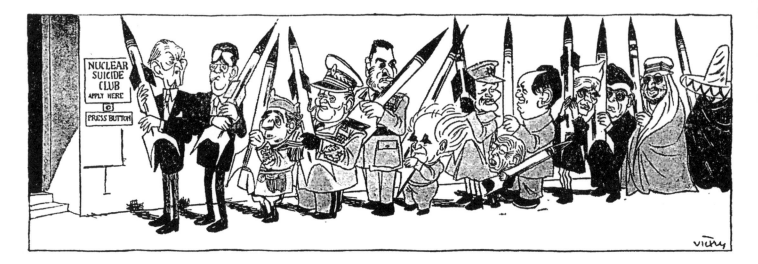

Victor "Vicky" Weisz, 1961

"The opinions expressed by the following congressmen do not necessarily reflect those of their constituents."

Rex May, 1982

Uncredited, 1992

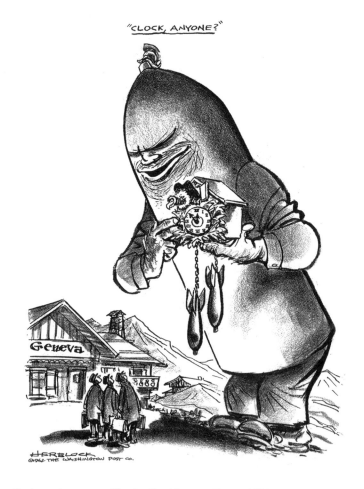

Herbert Lawrence Block, *Washington Post*, 1962

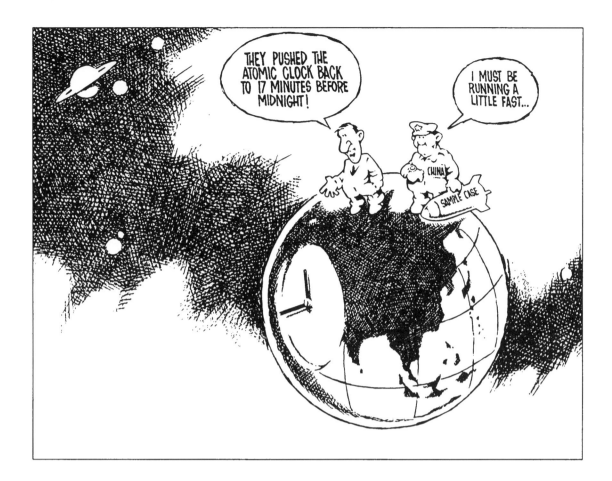

Tom Meyer, *San Francisco Chronicle*, 1991

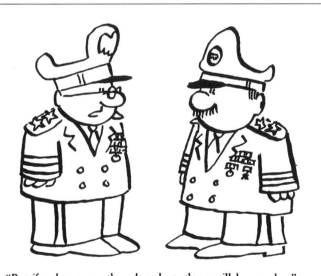

"But if nukes are outlawed, only outlaws will have nukes."

Rex May, 1984

Paul Valerry, 1988

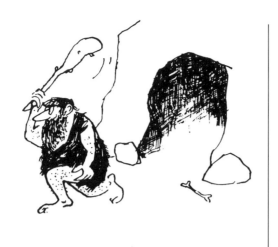

"I'm just as scared of peace as you are!"

Uncredited, 1966

Al Ross, 1980

Rainey Bennett, 1956

Paul Valerry, 1984

TROPICAL RAINFOREST IS BEING CLEARED AWAY NOW TO CREATE A MAGNIFICENT NEW HOTEL THAT WILL BE THE SITE OF THE NEXT ENVIRONMENTAL SUMMIT.

Harley Schwadron, 1992

Igor Smirnov, 1993

Mike Thompson, *St. Louis Sun*, 1992

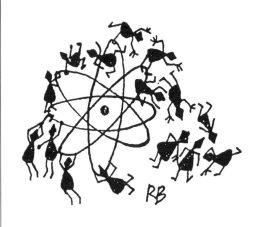

Rainey Bennett, 1956

Uncredited, 1967

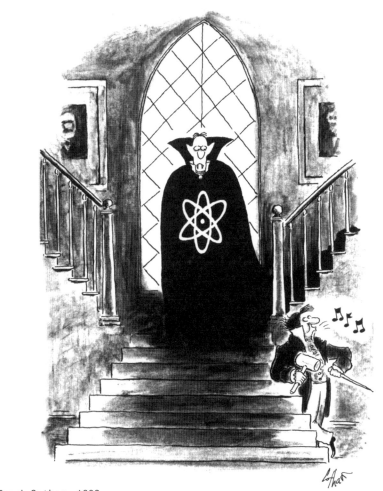

Frank Cotham, 1993

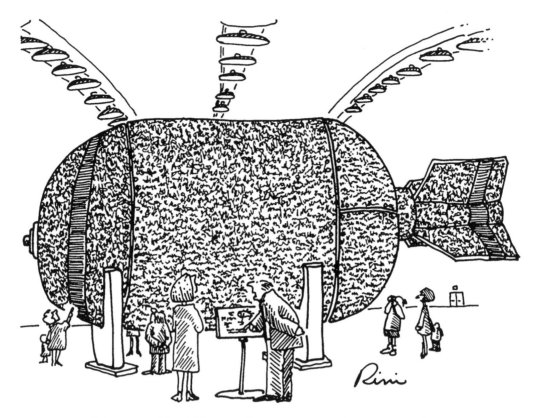

"Apparently, this one has everyone's name on it."

J.P. Rini, 2003

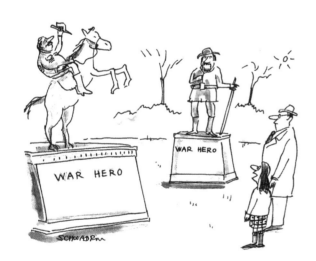

"How come there aren't any peace heroes?"

Harley Schwadron, 1999

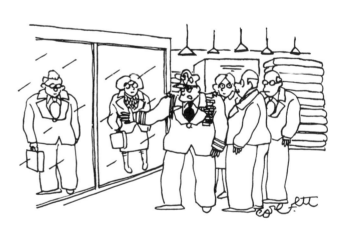

"This is where we stockpile experts, in case of emergency."

Jack Corbett, 2001

Tjeerd Royaards, 2019

"A second bomb will not make us safer."

Shannon Wheeler, *New Yorker*, 2018

Doomsday Clock.

Kieron Dwyer, 2020

Mike Luckovich, *Atlanta Journal-Constitution*, 2021

In 2007, the Bulletin approached
Pentagram, the design consulting
firm, looking for a new logo.
Partner Michael Bierut told them
they already had one.

Pentagram designers
Michael Bierut and
Armin Vit redesigned
the Doomsday Clock in
2007, when the set-
ting was 5 minutes to
midnight.

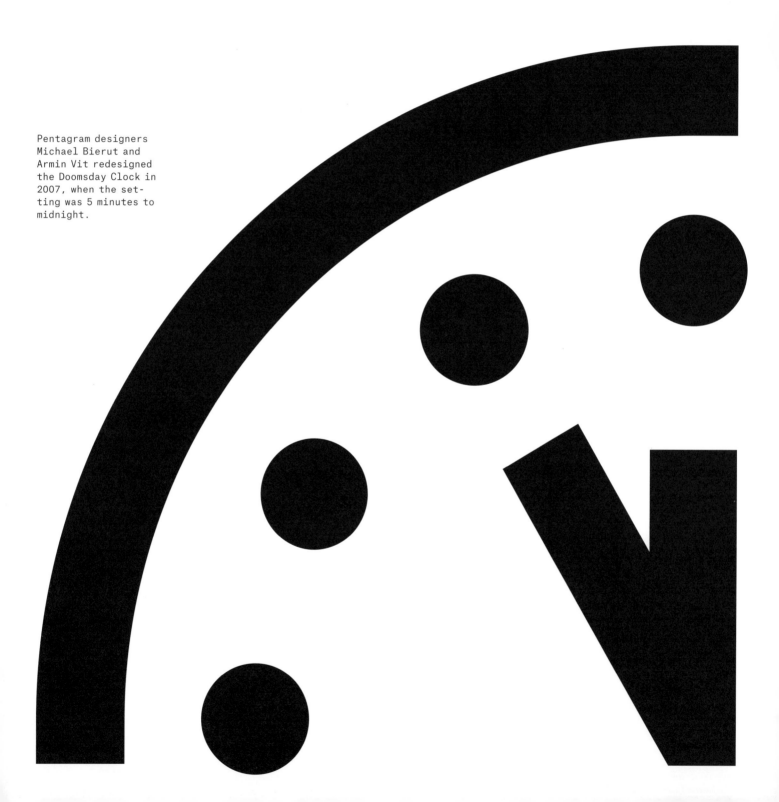

Redesigning the Doomsday Clock

By Michael Bierut,
Partner, Pentagram

The most powerful piece of information design*
of the 20th century was created by a landscape
painter. In 1943, the nuclear physicist Alexander
Langsdorf Jr. was called to Chicago to join hun-
dreds of scientists in a secret wartime project:
the race to develop an atomic bomb. Their
work on the Manhattan Project made possible
the bombs that were dropped on Hiroshima
and Nagasaki and ended World War II. But
Langsdorf, like many of his colleagues, greeted
the subsequent peace with profound unease.
What were the implications of the fact that the
human race had invented the means to render
itself extinct?

To bring this question to a broader audi-
ence, Langsdorf and his fellow scientists
began circulating a mimeographed newsletter
called the *Bulletin of the Atomic Scientists*. In
June 1947, the newsletter became a magazine.
Langsdorf's wife, Martyl, was an artist whose
landscapes were exhibited in Chicago galleries.
She volunteered to create the first cover. There
wasn't much room for an illustration, and the
budget permitted only two colors. But she found
a solution. The Doomsday Clock was born.

Since then, arguments about nuclear
proliferation have been complicated and con-
tentious. The Doomsday Clock translates them
into a brutally simple visual analogy, merging

the looming approach of midnight with the drama
of a ticking time bomb. Appropriately for an orga-
nization led by scientists, the Clock sidesteps over-
wrought imagery of mushroom clouds in favor
of an instrument of measurement. Martyl set the
minute hand at seven to midnight on that first
cover "simply because it looked good."

Two years later, the Soviets tested their own
nuclear device. The arms race was officially on. To
emphasize the seriousness of these circumstances,
the Clock was moved to three minutes to midnight.
It has been moved many times since. What a re-
markable, clear, concise piece of communication!

In 2007, the organization came to my
design consulting firm, Pentagram, looking for
a logo. We told them they already had one. The
designer Armin Vit and I suggested that the
Doomsday Clock be adopted as the organization's
logo. Its non-specific neutrality has permitted
the Bulletin to integrate data on bioterrorism and
climate change into the yearly scientific assess-
ment, which has led to more than 20 changes
to the position of the Clock's hands over the past
75 years. That began a relationship between
Pentagram and the Bulletin of the Atomic Scientists
that still continues.

Each year, we publish the report that accom-
panies the announcement of the Clock's position.
And each year, we hope we turn back time.

Excerpted from
Michael Bierut's
2015 book, *How To*
(HarperCollins)

It is five minutes to midnight.

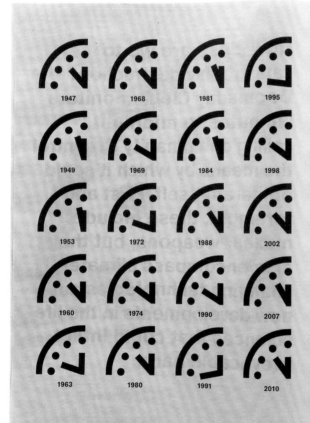

1947 1968 1981 1995

1949 1969 1984 1998

1953 1972 1988 2002

1960 1974 1990 2007

1963 1980 1991 2010

In 1947, the Bulletin first displayed the Doomsday Clock on the cover of the print magazine to convey, through a simple design, a sense of urgency and peril posed by nuclear weapons. The minute hand of the Clock has moved 19 times since, based on a global risk assessment by the Bulletin's Science and Security Board in consultation with other experts, and the Board of Sponsors, which currently includes 19 Nobel Laureates.

1947 As the Bulletin evolves from a newsletter into a magazine, the Clock appears on the cover for the first time. It symbolizes the urgency of the nuclear dangers that the Bulletin's founders – and the broader scientific community – are trying to convey to the public and political leaders around the world.
It is seven minutes to midnight.

1949 The Soviet Union denies it, but in the fall, President Harry Truman tells the American public that the Soviets tested their first nuclear device, officially starting the arms race. "We do not advise Americans that doomsday is near and that they can expect atomic bombs to start falling on their heads a month or year from now," the Bulletin explains. "But we think they have reason to be deeply alarmed and to be prepared for grave decisions."
It is three minutes to midnight.

1953 After much debate, the United States decides to pursue the hydrogen bomb, a weapon far more powerful than any atomic bomb. In October 1952, the United States tests its first thermonuclear device, obliterating a Pacific Ocean islet in the process; nine months later, the Soviets test an H-bomb of their own. "The hands of the Clock of Doom have moved again," the Bulletin announces. "Only a few more swings of the pendulum, and, from Moscow to Chicago, atomic explosions will strike midnight for Western civilization."
It is two minutes to midnight.

1960 Political actions belie the tough talk of "massive retaliation." For the first time, the United States and Soviet Union appear eager to avoid direct confrontation in regional conflicts such as the 1956 Egyptian-Israeli dispute. Joint projects that build trust and constructive dialogue between third parties also quell diplomatic hostilities. Scientists initiate many of these measures, helping establish the International Geophysical Year, a series of coordinated, worldwide scientific observations, and the Pugwash Conferences, which allow Soviet and American scientists to interact.
It is seven minutes to midnight.

1963 After a decade of almost non-stop nuclear tests, the United States and Soviet Union sign the Partial Test Ban Treaty, which ends all atmospheric nuclear testing. While it does not outlaw underground testing, the treaty represents progress in at least slowing the arms race. It also signals awareness among the Soviets and Americans that they need to work together to prevent nuclear annihilation.
It is twelve minutes to midnight.

1968 Regional wars rage. U.S. involvement in Vietnam intensifies, India and Pakistan battle in 1965, and Israel and its Arab neighbors renew hostilities in 1967. Worse yet, France and China develop nuclear weapons to assert themselves as global players. "There is little reason to feel sanguine about the future of our society on the world scale," the Bulletin laments. "There is a mass revulsion against war, yes; but no sign of conscious intellectual leadership in a rebellion against the deadly heritage of international anarchy."
It is seven minutes to midnight.

1969 Nearly all of the world's nations (come together to sign the Nuclear Non-Proliferation Treaty. The deal is simple – the nuclear weapon states vow to help the treaty's non-nuclear weapon signatories develop nuclear power if they promise to forego producing nuclear weapons. The nuclear weapon states also pledge to abolish their own arsenals when political conditions allow for it. Although Israel, India, and Pakistan refuse to sign the treaty, the Bulletin is cautiously optimistic: "The great powers have made the first step. They must proceed without delay to the next one – the dismantling, gradually, of their own oversized military establishments."
It is ten minutes to midnight.

1972 The United States and Soviet Union attempt to curb the race for nuclear superiority by signing the Strategic Arms Limitation Treaty (SALT) and the Anti-Ballistic Missile (ABM) Treaty. The two treaties foster a nuclear parity of sorts. SALT limits the number of ballistic missile launchers either country can possess, and the ABM Treaty stops an arms race in defensive weaponry from developing.
It is twelve minutes to midnight.

1974 South Asia gets the Bomb, as India tests its first nuclear device. And any gains in previous arms control agreements seem like a mirage. The United States and Soviet Union appear to be modernizing their nuclear forces, not reducing them. Thanks to the deployment of multiple independently targetable reentry vehicles (MIRV), both countries can now load their intercontinental ballistic missiles with more nuclear warheads than before.
It is nine minutes to midnight.

1980 Thirty-five years after the start of the nuclear age and after some promising disarmament gains, the United States and the Soviet Union still view nuclear weapons as an integral component of their national security. This stalled progress discourages the Bulletin: "[The Soviet Union and United States have] been behaving like what may best be described as 'nucleoholics' – drunks who continue to insist that the drink being consumed is positively the last one," but who can always find a good excuse for 'just one more round.'"
It is seven minutes to midnight.

1981 The Soviet invasion of Afghanistan hardens the U.S. nuclear posture. Before he leaves office, President Jimmy Carter pulls the United States from the Olympic Games in Moscow and considers ways in which the United States could win a nuclear war. The rhetoric only intensifies with the election of Ronald Reagan as president. Reagan scraps any talk of arms control and proposes that the best way to end the Cold War is for the United States to win it.
It is four minutes to midnight.

1984 U.S.-Soviet relations reach their iciest point in decades. Dialogue between the two superpowers virtually stops. "Every channel of communications has been constricted or shut down; every form of contact has been attenuated or cut off. And arms control negotiations have been reduced to a species of propaganda," a concerned Bulletin informs readers. The United States seems to flout the few arms control agreements in place by seeking an expensive, space-based anti-ballistic missile capability, raising worries that a new arms race will begin.
It is three minutes to midnight.

1988 The United States and Soviet Union sign the historic Intermediate-Range Nuclear Forces Treaty, the first agreement to actually ban a whole category of nuclear weapons. The leadership shown by President Ronald Reagan and Soviet Premier Mikhail Gorbachev makes the treaty a reality, but public opposition to U.S. nuclear weapons in Western Europe inspires it. For years, such intermediate-range missiles had kept Western Europe in the crosshairs of the two superpowers.
It is six minutes to midnight.

1990 As one Eastern European country after another (Poland, Czechoslovakia, Hungary, Romania) frees itself from Soviet control, Soviet General Secretary Mikhail Gorbachev refuses to intervene, halting the ideological battle for Europe and significantly diminishing the risk of all-out nuclear war. In late 1989, the Berlin Wall falls, symbolically ending the Cold War. "Forty-four years after Winston Churchill's 'Iron Curtain' speech, the myth of monolithic communism has been shattered for all to see," the Bulletin proclaims.
It is ten minutes to midnight.

1991 With the Cold War officially over, the United States and Russia begin making deep cuts to their nuclear arsenals. The Strategic Arms Reduction Treaty greatly reduces the number of strategic nuclear weapons deployed by the two former adversaries. Better still, a series of unilateral initiatives remove most of the intercontinental ballistic missiles and bombers in both countries from hair-trigger alert. "The illusion that tens of thousands of nuclear weapons are a guarantee of national security has been stripped away," the Bulletin declares.
It is seventeen minutes to midnight.

1995 Hopes for a large post-Cold War peace dividend and a renouncing of nuclear weapons fade. Particularly in the United States, hard-liners seem reluctant to soften their rhetoric or actions, as they claim that a resurgent Russia could provide as much of a threat as the Soviet Union. Such talk slows the rollback in global nuclear forces; more than 40,000 nuclear weapons remain worldwide. There is also concern that terrorists could exploit poorly secured nuclear facilities in the former Soviet Union.
It is fourteen minutes to midnight.

1998 India and Pakistan stage nuclear weapons tests only three weeks apart. "The tests are a symptom of the failure of the international community to fully commit itself to control the spread of nuclear weapons – and to work toward substantial reductions in the numbers of these weapons," a dismayed Bulletin reports. Russia and the United States continue to serve as poor examples to the rest of the world. Together, they still maintain 7,000 warheads ready to fire at each other within 15 minutes.
It is nine minutes to midnight.

2002 Concerns regarding a nuclear terrorist attack underscore the enormous amount of unsecured – and sometimes unaccounted for – weapon-grade nuclear materials located throughout the world. Meanwhile, the United States expresses a desire to design new nuclear weapons, with an emphasis on those able to destroy hardened and deeply buried targets. It also rejects a series of arms control treaties and announces it will withdraw from the Anti-Ballistic Missile Treaty.
It is seven minutes to midnight.

2007 The world stands at the brink of a second nuclear age. The United States and Russia remain ready to stage a nuclear attack within minutes, North Korea conducts a nuclear test, and many in the international community worry that Iran plans to acquire the Bomb. Climate change also presents a dire challenge to humanity. Damage to ecosystems is already taking place; flooding, destructive storms, increased drought, and polar ice melt are causing loss of life and property.
It is five minutes to midnight.

2010 A new spirit of international cooperation and negotiation gives hope that our leaders will act to rid the world of nuclear weapons. Governments are also proposing collaborative action on global warming. By shifting the hard back by only one minute, we emphasize how much needs to be accomplished as we affirm the new initiative that the United States, Russia, the European Union, India, China, Brazil, and others are deploying on nuclear security and on climate change. With 23,000 nuclear weapons in the world, the potential for use, inadvertent launches, accidents, and proliferation remains high. Scientists also believe that humanity has less than a decade to avoid the worst damage resulting from greenhouse gas emissions before Earth cascades into irreversible climate disaster. History shows that progress toward disarmament and environmental protection occurs when citizens are engaged and express their concerns to policy makers.
It is six minutes to midnight.

By Robert K. Elder

In 2007, the *Bulletin*'s art director Joy Olivia Miller (2004–2008) worked with Kennette Benedict, the Bulletin's executive director and publisher (2005–2015) to find a firm to redesign the Doomsday Clock and bring it back in alignment with Martyl's original vision.

Miller remembers visiting "three or four different big-name agencies in New York, all of whom were pitching us on the opportunity to help us reimagine the Clock."

"It was Pentagram who just 'got it,' and they were the last firm we went to see. When Michael Bierut and Armin Vit walked into the conference room, we didn't have to explain why these issues matter or that the Clock was powerful. He and Armin just knew they wanted to help. And, they did."

Miller said that one of the best things to come out of that collaboration is often overlooked.

"Pentagram—and specifically Vit—were the ones who had the idea to attach the tagline to the design," Miller said.

Vit was inspired to use the specific phrasing— "It is XX minutes to midnight"—after hearing the time announced one morning on his way into work when he was listening to NPR.

"He advised us to go very statement-of-fact for our tagline," Miller said. "He liked the indisputableness with how NPR announced, 'It is seven a.m. I'm Steve Inskeep, and this is Morning Edition.'"

Vit realized what weakened/weakens the Clock is when its meaning is over-explained, Miller said. "The Doomsday Clock is powerful as is, full-stop. A forthright statement about its time—as set by the Science and Security Board—supports that brand messaging," she said.

Pentagram was also instrumental in the strategy to stop treating the Doomsday Clock as a physical object that tourists could come see.

"The new cleaned up/stripped down interpretation set us up to take the next step and to make the Clock a powerful symbol on its own again," Miller said.

Turn back the Clock.

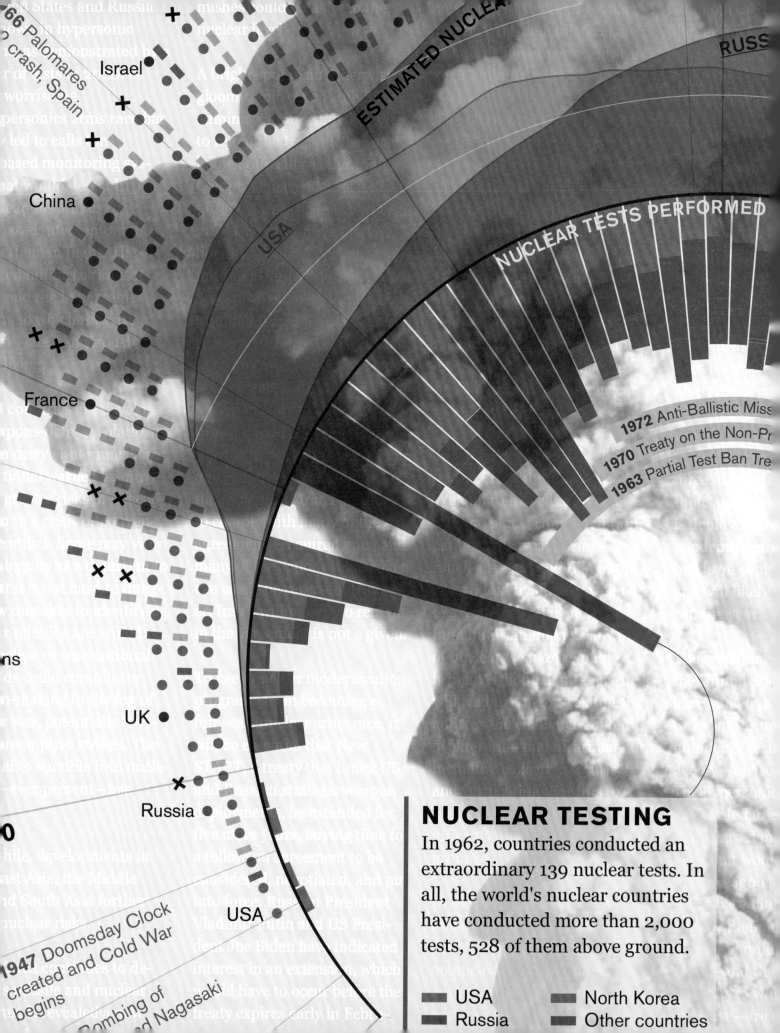

ESTIMATED NUCLEAR

NUCLEAR TESTS PERFORMED

USA

RUSS

Israel

China

France

UK

Russia

USA

1972 Anti-Ballistic Miss
1970 Treaty on the Non-Pr
1963 Partial Test Ban Tre

1947 Doomsday Clock created and Cold War begins

NUCLEAR TESTING

In 1962, countries conducted an extraordinary 139 nuclear tests. In all, the world's nuclear countries have conducted more than 2,000 tests, 528 of them above ground.

USA North Korea
Russia Other countries

Art and Data

A series of data visualizations by Pentagram partner Giorgia Lupi and her team offers a detailed look into the information that goes into setting the Doomsday Clock. These visualizations go beyond the symbol of the Clock to examine the issues that have brought the planet to the brink.

By Kurt Koepfle, Pentagram

In 2021, Pentagram partner Giorgia Lupi and her team created a series of data visualizations to accompany the announcement of the Doomsday Clock's position. It was the first time the report incorporated additional visual information on the human-made threats to our planet, and the infographics provided a detailed introduction to the issues at hand.

The Doomsday Clock is a strong, simple icon that dramatically conveys how close the world is to destruction. The new visualizations go beyond the symbol to provide more granular information about what has brought the planet to the brink. The Bulletin has reset the minute hand on the Clock 24 times since its debut in 1947. Every time it is adjusted, the group is flooded with questions about the symbol and why the hands have been moved. For the 2021 announcement, the Bulletin wanted to offer an idea of the amount of information and discussion that actually goes into the decision to reposition the Clock.

The Clock is most closely associated with nuclear risk, but its purview has included climate change since 2007 and now also encompasses disruptive technologies. The designers developed visualizations for each of these topics, reinforcing the Bulletin's wider focus. The infographics were not created to aid in the decision making of the group, but rather are meant to illustrate everything that goes into it. The Pentagram team was invited to listen in on the deliberations of the Bulletin scientists, advisors, and policy leaders to gather information and hear the considerations that lead to updating the Clock.

Design by Pentagram: Giorgia Lupi, Sarah Kay Miller, Phil Cox, Ting Fang Cheng, Talia Cotton

The dense visualizations have been layered with qualitative and quantitative data that provide depth of detail and build a comprehensive narrative of the issue and its impact on the world. The events of 2020 are highlighted, but set within the context of the past, to offer a larger look at the history that has led to the present moment.

For the designers, this meant going beyond simple bar charts and timelines to create something more dynamic and impactful. Each visualization utilizes a different form and has its own distinct color palette (red and orange for the infographic on nuclear risk; blue and green for the diagram on climate), but they all visually tie together as a group. The designs incorporate circular forms that echo the shape of the Clock and that reinforce the cyclical, time-based nature of the underlying issues, which are not always so linear. The Doomsday Clock itself appears on each in the corner, as part of the Bulletin's logo.

To make the visualizations more memorable, the backgrounds feature a collage of imagery and the hint of text, which was drawn from the discussions of the advisory panel and suggests the amount of analysis that went into the decision.

Climate change is the focus of the second visualization, "A Warming Planet," which is presented as a flowing linear timeline. The section representing 2020—one of the warmest years on record—has been enlarged as though under a magnifying glass, zooming in on the effects of environmental disasters such as wildfires and hurricanes, as well as the reduction of carbon dioxide emissions due to the economic slowdown caused by the COVID-19 pandemic. Looking forward, the timeline projects rising temperatures and sea levels through 2100 and beyond.

The disruptive technology visualization focuses on the COVID-19 pandemic, which has generated what the World Health Organization (WHO) calls an "infodemic" of misinformation that undermines the public trust and society's ability to address major threats of all kinds. Here, data sets on declining faith in institutions, varying opinions on the WHO, and slipping confidence in vaccination are depicted in a series of bar graphs that swell like waves of infection. In the background, a chart depicts the explosion of cases worldwide over the past year.

The complete set of data visualizations can be accessed via the *Bulletin of the Atomic Scientists* website, where visitors can also read new articles and download the yearly Doomsday Clock statement.

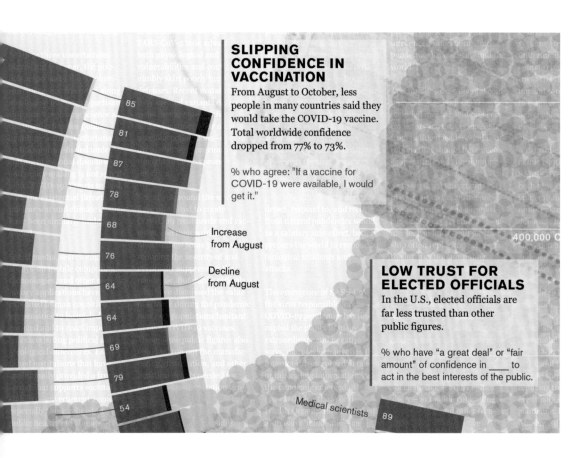

SLIPPING CONFIDENCE IN VACCINATION

From August to October, less people in many countries said they would take the COVID-19 vaccine. Total worldwide confidence dropped from 77% to 73%.

% who agree: "If a vaccine for COVID-19 were available, I would get it."

Increase from August

Decline from August

400,000 C

LOW TRUST FOR ELECTED OFFICIALS

In the U.S., elected officials are far less trusted than other public figures.

% who have "a great deal" or "fair amount" of confidence in ____ to act in the best interests of the public.

Medical scientists 89

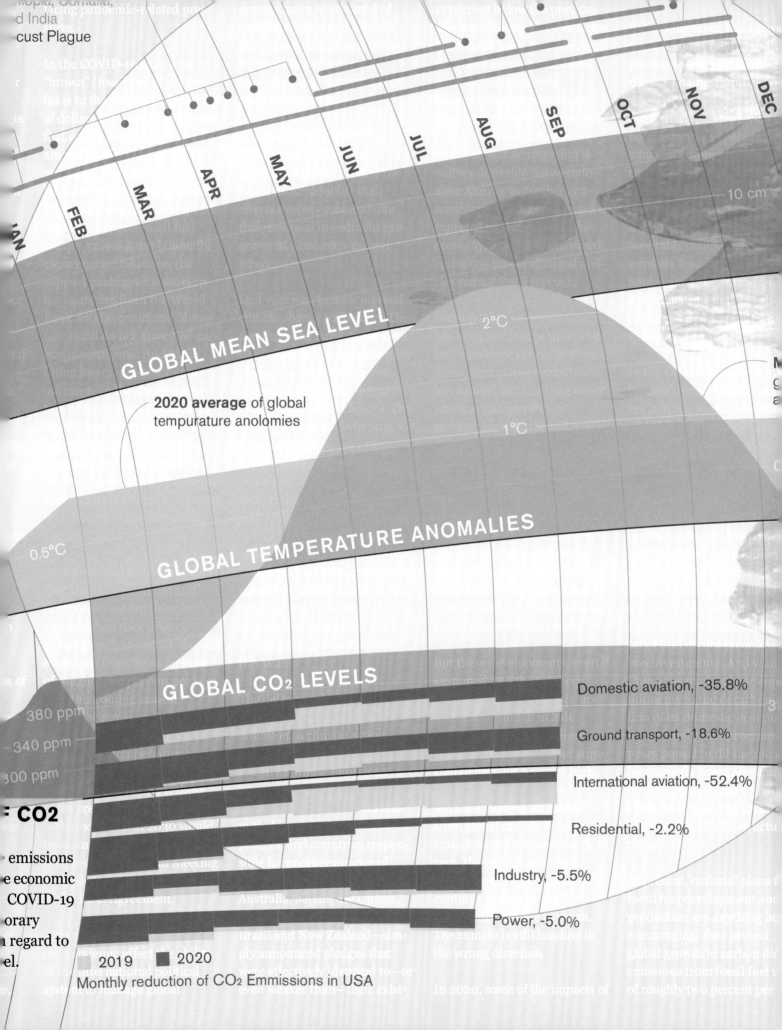

GLOBAL MEAN SEA LEVEL

10 cm

2°C

2020 average of global tempurature anolomies

1°C

0.5°C

GLOBAL TEMPERATURE ANOMALIES

JAN FEB MAR APR MAY JUN JUL AUG SEP OCT NOV DEC

GLOBAL CO₂ LEVELS

380 ppm

340 ppm

300 ppm

Domestic aviation, -35.8%

Ground transport, -18.6%

International aviation, -52.4%

Residential, -2.2%

F CO2

emissions
e economic
COVID-19
orary
n regard to
el.

Industry, -5.5%

Power, -5.0%

■ 2019 ■ 2020

Monthly reduction of CO₂ Emmissions in USA

Nuclear Risk

An Expanding Concern

The number of nuclear warheads has fallen from Cold War highs and nuclear testing has all but ceased. Still, nuclear risk is rising as arms control treaties wither and die, the potential for accidental nuclear war remains under-appreciated despite decades of nuclear mishaps, and nuclear weapons countries devote billions of dollars to nuclear modernization. Has the world come full circle and begun a new nuclear arms race?

Information on nuclear warheads, countries possessing or seeking nuclear weapons, nuclear testing, and nuclear diplomatic agreements is arrayed on a circular timeline that starts in 1940 (lower left) and moves clockwise toward the present.

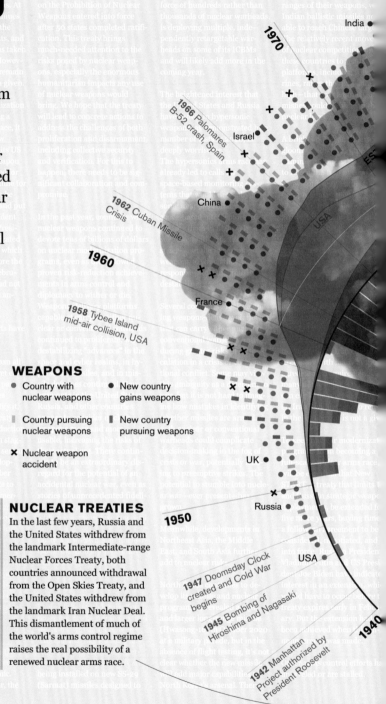

WEAPONS

- Country with nuclear weapons
- New country gains weapons
- Country pursuing nuclear weapons
- New country pursuing weapons
- ✕ Nuclear weapon accident

NUCLEAR TREATIES

In the last few years, Russia and the United States withdrew from the landmark Intermediate-range Nuclear Forces Treaty, both countries announced withdrawal from the Open Skies Treaty, and the United States withdrew from the landmark Iran Nuclear Deal. This dismantlement of much of the world's arms control regime raises the real possibility of a renewed nuclear arms race.

Timeline labels:
- 1970
- 1966 Palomares B-52 crash, Spain
- 1962 Cuban Missile Crisis
- 1960
- 1958 Tybee Island mid-air collision, USA
- 1950
- 1947 Doomsday Clock created and Cold War begins
- 1945 Bombing of Hiroshima and Nagasaki
- 1942 Manhattan Project authorized by President Roosevelt
- 1940

Country labels: India, Israel, China, France, UK, Russia, USA

Sources
Bulletin of the Atomic Scientists; "Status of World Nuclear Forces," Federation of American Scientists; "Number of Nuclear Weapons Tests", Oklahoma Geological Survey Observatory/Our World in Data; "List of nuclear weapons tests," Wikipedia; "Treaties and Agreements," Arms Control Association; "Broken Arrows: Nuclear Weapons Accidents," atomicarchive.com; Data analysis of countries with or pursuing nuclear weapons by Scott Sagan, Stanford University.

Designed by Pentagram
Giorgia Lupi, Sarah Kay Miller, Phil Cox, Ting Fang Cheng, Talia Cotton

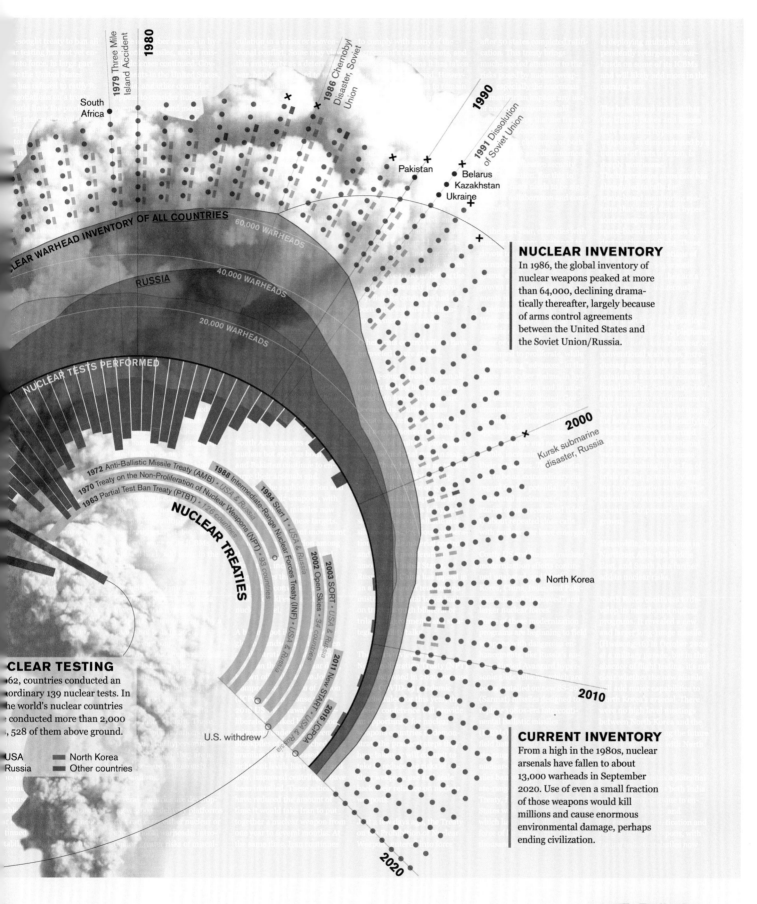

1980

1979 Three Mile Island Accident

1986 Chernobyl Disaster, Soviet Union

1990

1991 Dissolution of Soviet Union

South Africa

Pakistan

Belarus
Kazakhstan
Ukraine

NUCLEAR WARHEAD INVENTORY OF ALL COUNTRIES

60,000 WARHEADS

RUSSIA

40,000 WARHEADS

20,000 WARHEADS

NUCLEAR TESTS PERFORMED

1972 Anti-Ballistic Missile Treaty (AMB)
1970 Treaty on the Non-Proliferation of Nuclear Weapons (NPT) • 136 countries
1963 Partial Test Ban Treaty (PTBT)
1988 Intermediate-Range Nuclear Forces (INF) • USA & Russia
1994 Start 1 • USA & Russia

NUCLEAR TREATIES

2002 Open Skies • 34 countries
2003 SORT • USA & Russia
2011 New START • USA & Russia
2015 JCPOA • USA & Russia

U.S. withdrew

NUCLEAR INVENTORY

In 1986, the global inventory of nuclear weapons peaked at more than 64,000, declining dramatically thereafter, largely because of arms control agreements between the United States and the Soviet Union/Russia.

2000

Kursk submarine disaster, Russia

North Korea

2010

CURRENT INVENTORY

From a high in the 1980s, nuclear arsenals have fallen to about 13,000 warheads in September 2020. Use of even a small fraction of those weapons would kill millions and cause enormous environmental damage, perhaps ending civilization.

2020

NUCLEAR TESTING

[19]62, countries conducted an [extra]ordinary 139 nuclear tests. In [t]he world's nuclear countries [hav]e conducted more than 2,000 [tests], 528 of them above ground.

USA
Russia
North Korea
Other countries

Climate Change

A Warming Planet

In 2020, one of the two warmest years on record, governments around the world failed to take sufficient action to address the carbon dioxide emissions that cause climate change.

Changes in sea level, changes in temperature, and changes in atmospheric carbon dioxide—are shown across time. At left, the graphic shows changes from the year 1000 through 2019; the circle in the center shows changes in 2020; and at right are projections of changes from 2021 through the year 2100.

2020 CLIMATE DISASTERS

The world's failure to come s[...] ciently to grip with climate c[...] was underscored in 2020 by [...] of environmental disasters.

Australia
Bushfires

Ethiopia, Somalia, and India
Locust Plague

USA
Sever[...]

A SUDDEN INCREASE

Since the industrial age, global carbon dioxide levels have increased, leading to rising temperatures and sea levels in recent decades.

REDUCTION OF CO2 EMMISSIONS

In 2020, carbon dioxide emissions fell temporarily due to the economic slowdown caused by the COVID-19 pandemic. But the temporary reduction meant little in regard to temperature and sea level.

GLOBAL MEAN SEA LEVEL

GLOBAL TEMPERATURE ANOMALIES

GLOBAL CO2 LEVELS

Baseline begins at 260 ppm

1100 1200 1300 1400 1500 1600 1700 1800 1900 2000

JAN FEB MAR

10 cm

0.5°C

-0.5°C

380 ppm
340 ppm
300 ppm

2019 202[...]
Monthly reduction [...]

GLOBA[...]
GLC[...]
GLC[...]

2020 [...]
tempu[...]

Sources

Bulletin of the Atomic Scientists; "GISTEMP Seasonal Cycle since 1880," NASA Goddard Institute for Space Studies; "2100 Climate Warming Projections," Climate Action Tracker; "Trends in Atmospheric Carbon Dioxide,"

NOAA Global Monitoring Laboratory; "Sea Level Satellite Data: 1993-Present," NASA Global Climate Change; "Climate Change: Global Sea Level" NOAA Climate.gov; The Two Degrees Institute; "Net Zero Tracker," Energy & Climate

Intelligence Unit; Liu, Z., Ciais, P., Deng, Z. et al. "Near-real-time monitoring of global CO2 emissions reveals the effects of the COVID-19 pandemic," Nature Communications; Disasters," Center for Disaster Philanthropy"

Designed by Pentagram
Giorgia Lupi, Sarah Kay Miller, Phil Cox, Ting Fang Cheng, Talia Cotton

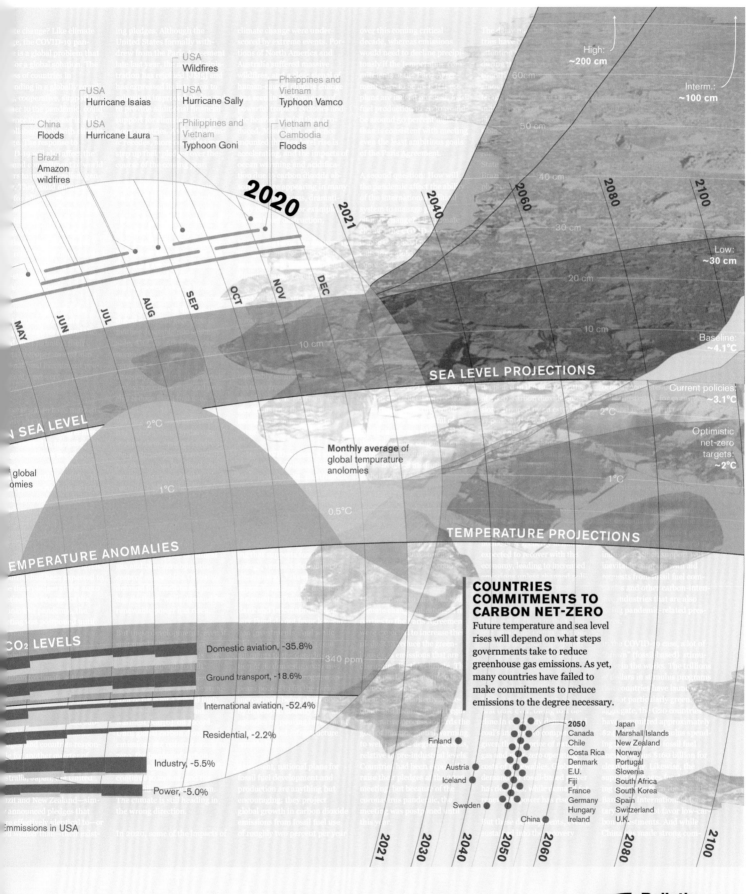

Disruptive Technology

Trust and the Pandemic

The COVID-19 pandemic has spawned what the W.H.O. has called an "infodemic" of mis- and disinformation. Widespread dysfunction in today's information ecosystem is a threat multiplier that undermines public trust and complicates society's ability to address major threats of all types.

Below, trends in public trust of institutions are charted leading up to 2020. Beginning in January of 2020, global COVID-19 case counts are shown at bottom along a timeline. Additional public opinion data is also plotted based on when surveys were fielded: perceptions of the W.H.O., willingness to be vaccinated, and trust in various U.S. public individuals.

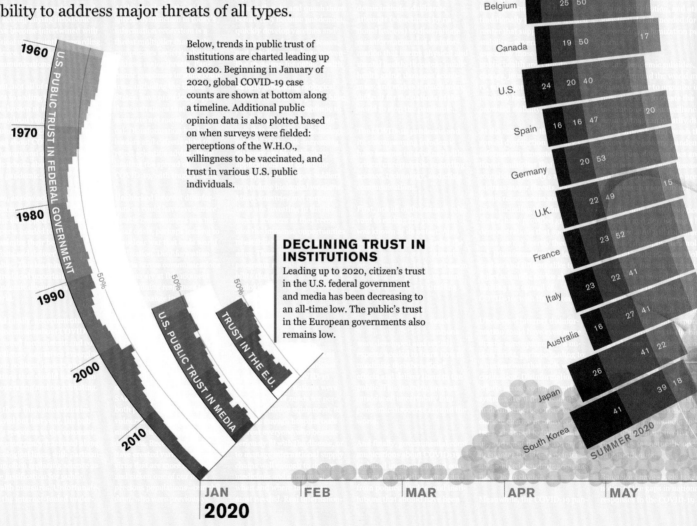

VARYING OPINIONS ON THE W.H.O.

Public perception of the World Health Organization's COVID-19 response is generally positive, but not by everyone.

% who agree: "The W.H.O. has done a ___ job dealing with the COVID outbreak"

	Very bad	Somewhat bad	Somewhat good	Very good
Sweden		19	59	
Denmark		20	61	
Netherlands		21	54	
Belgium		25	50	
Canada		19	50	17
U.S.	24	20	40	
Spain	16 16	47		20
Germany		20	53	15
U.K.		22	49	
France		23	52	
Italy	23	22	41	
Australia	16	27	41	
Japan	26		41	22
South Korea	41		39	18

SUMMER 2020

DECLINING TRUST IN INSTITUTIONS

Leading up to 2020, citizen's trust in the U.S. federal government and media has been decreasing to an all-time low. The public's trust in the European governments also remains low.

U.S. PUBLIC TRUST IN FEDERAL GOVERNMENT

50%

U.S. PUBLIC TRUST IN MEDIA

50%

TRUST IN THE E.U.

50%

1960
1970
1980
1990
2000
2010

JAN **2020** FEB MAR APR MAY

Sources
"Public trust in federal government near historic lows for more than a decade", Pew Research Center; "Trust in EU at its highest in five years, new poll shows," Euro News/Eurobarometer; "Americans Remain Distrustful of Mass Media",

Gallup; "World Health Organization's handling of COVID-19 gets positive marks in most countries polled," Pew Research Center; "Fewer people say they would take a COVID-19 vaccine now than 3 months ago" World Economic

Forum/Ipsos; "About four-in-ten Americans have a great deal of confidence in medical scientists, scientists," Pew Research Center; "Coronavirus World Map: Tracking the Global Outbreak" The New York Times. Numbers approximate.

Designed by Pentagram
Giorgia Lupi, Sarah Kay Miller, Phil Cox, Ting Fang Cheng, Talia Cotton

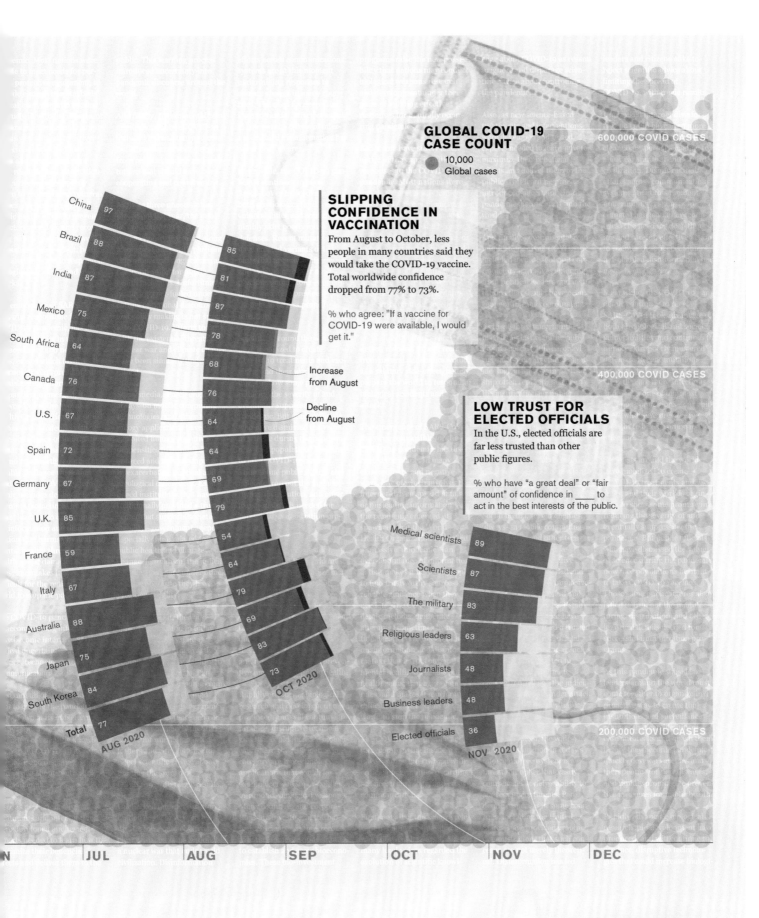

GLOBAL COVID-19 CASE COUNT

● 10,000 Global cases

600,000 COVID CASES

SLIPPING CONFIDENCE IN VACCINATION

From August to October, less people in many countries said they would take the COVID-19 vaccine. Total worldwide confidence dropped from 77% to 73%.

% who agree: "If a vaccine for COVID-19 were available, I would get it."

400,000 COVID CASES

Increase from August

Decline from August

LOW TRUST FOR ELECTED OFFICIALS

In the U.S., elected officials are far less trusted than other public figures.

% who have "a great deal" or "fair amount" of confidence in ____ to act in the best interests of the public.

Country	AUG 2020	OCT 2020
China	97	85
Brazil	88	81
India	87	87
Mexico	75	78
South Africa	64	68
Canada	76	76
U.S.	67	64
Spain	72	64
Germany	67	69
U.K.	85	79
France	59	54
Italy	67	64
Australia	88	79
Japan	75	69
South Korea	84	83
Total	77	73

NOV 2020

Medical scientists	89
Scientists	87
The military	83
Religious leaders	63
Journalists	48
Business leaders	48
Elected officials	36

200,000 COVID CASES

| N | JUL | AUG | SEP | OCT | NOV | DEC |

Bulletin of the Atomic Scientists

The Bulletin has reset the minute
hand on the Doomsday Clock
24 times since its debut in 1947,
most recently in 2021 when
the hands were again set at 100
seconds to midnight.

Every Clock
change, all 24
positions,
since its debut
in 1947

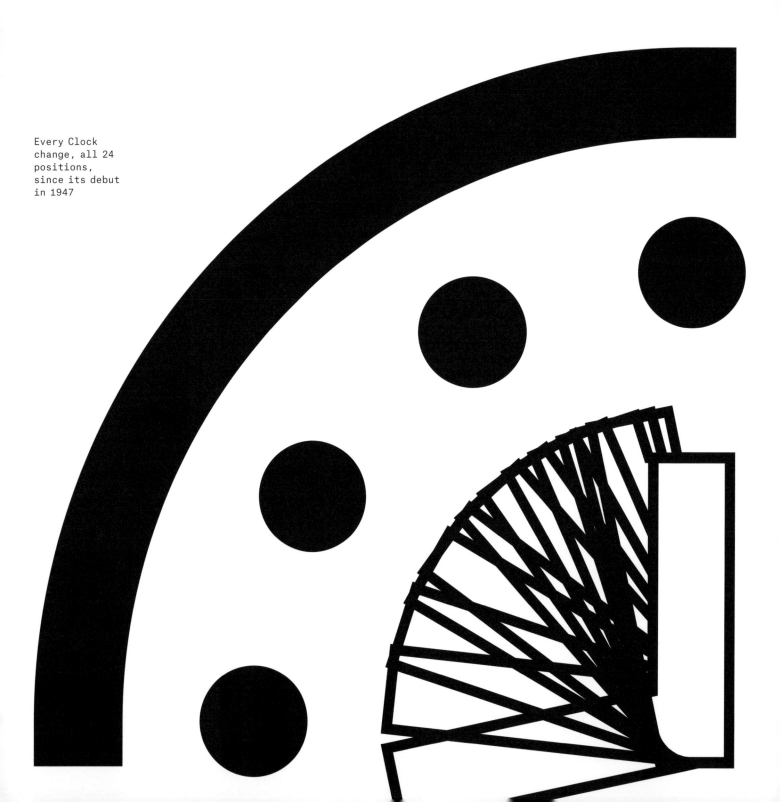

Clock Changes Over Time

By Kennette
Benedict,
Publisher and
Executive
Director of
the Bulletin,
2005-2015

Every time the Doomsday Clock is reset, the Bulletin is flooded with questions about the internationally recognized symbol. Key among them is: Who decides what time it is?

In the early days, *Bulletin* editor Eugene Rabinowitch decided whether the hand should be moved. A scientist himself, fluent in Russian, and a leader in the international disarmament movement, he was in constant conversation with scientists and experts within and outside governments in many parts of the world. Based on these discussions, he decided where the Clock hand should be set and explained his thinking in the *Bulletin*'s pages.

When Rabinowitch died in 1973, the Bulletin's Board of Directors took over the responsibility. A vote in 2008 restructured the Board of Directors into the Governing Board and the Science and Security Board (SASB), the latter of which meets twice a year to discuss world events and to reset the Clock as necessary. The board is made up of scientists and other experts with deep knowledge of nuclear technology and climate science, who often provide expert advice to governments and international agencies. They consult widely with their colleagues across a range of disciplines and also seek the views of the Bulletin's Board of Sponsors, which has historically included 40 Nobel Laureates.

Another common question: When were the hands set farthest from midnight? In 1991, with the end of the Cold War, the United States and the Soviet Union signed the Strategic Arms Reduction Treaty, the first treaty to provide for deep cuts to the two countries' strategic nuclear weapons arsenals, prompting the Bulletin to set the Clock hand to 17 minutes to midnight.

Perhaps the most pressing question? When were the hands set closest to midnight? The answer is right now, and that's where we start the timeline on the following pages, going back in time from 2021 as we survey the various Clock settings over the past 75 years.

In 2020, the Science and Security Board set the time to 100 seconds to midnight, largely because of worldwide governmental dysfunction in dealing with global threats.

Before 2020, the closest the hand was set to midnight was two minutes: in 1953, after the United States and the Soviet Union each tested their first thermonuclear weapons within six months of one another, and in 2018, largely due to nuclear risk and the rising threat of climate change

2020
It is 100 Seconds
to Midnight

The global security situation is unsustainable and extremely dangerous, but that situation can be improved, if leaders seek change and citizens demand it. There is no reason the Doomsday Clock cannot move away from midnight. It has done so in the past when wise leaders acted, under pressure from informed and engaged citizens around the world. We believe that mass civic engagement will be necessary to compel the change the world needs. Citizens around the world have the power to unmask social media disinformation and improve the long-term prospects of their children and grandchildren. They can insist on facts, and discount nonsense. They can demand—through public protest, at the ballot box, and in many other creative ways—that their leaders take immediate steps to reduce the existential threats of nuclear war and climate change. It is now 100 seconds to midnight, the most dangerous situation that humanity has ever faced. Now is the time to unite—and act.

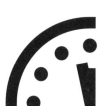

2019
It is Still 2 Minutes
to Midnight

The "new abnormal" that we describe, and that the world now inhabits, is unsustainable and extremely dangerous. The world security situation can be improved, if leaders seek change and citizens demand it. It is two minutes to midnight, but there is no reason the Doomsday Clock cannot move away from catastrophe. It has done so in the past, because wise leaders acted—under pressure from informed and engaged citizens around the world. Today, citizens in every country can use the power of the internet to fight against social media disinformation and improve the long-term prospects of their children and grandchildren. They can insist on

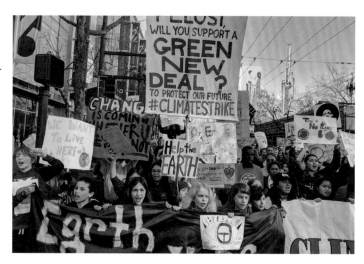

Youth Climate Strike, San Francisco, March 2019

facts, and discount nonsense. They can demand action to reduce the existential threat of nuclear war and unchecked climate change. Given the inaction of their leaders to date, citizens of the world should make a loud and clear demand: #RewindTheDoomsdayClock.

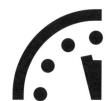

2018
It is 2 Minutes
to Midnight

The failure of world leaders to address the largest threats to humanity's future is lamentable—but that failure can be reversed. It is two minutes to midnight, but the Doomsday Clock has ticked away from midnight in the past, and

Hydrogen bomb testing, North Korea, 2018

during the next year, the world can again move it further from apocalypse. The warning the Science and Security Board now sends is clear, the danger obvious and imminent. The opportunity to reduce the danger is equally clear. The world has seen the threat posed by the misuse of information technology and witnessed the vulnerability of democracies to dis-information. But there is a flip side to the abuse of social media. Leaders react when citizens insist they do so, and citizens around the world can use the power of the internet to improve the long-term prospects of their children and grand-children. They can insist on facts, and discount nonsense. They can demand action to reduce the existential threat of nuclear war and unchecked climate change. They can seize the opportunity to make a safer and saner world.

Donald Trump
sworn in as
US president,
January 20, 2017

is very high, and the actions needed to reduce the risks of disaster must be taken very soon." In 2017, we find the danger to be even greater, the need for action more urgent. It is two and a half minutes to midnight, the Clock is ticking, global danger looms. Wise public officials should act immediately, guiding humanity away from the brink. If they do not, wise citizens must step forward and lead the way.

Unchecked
climate change,
2017

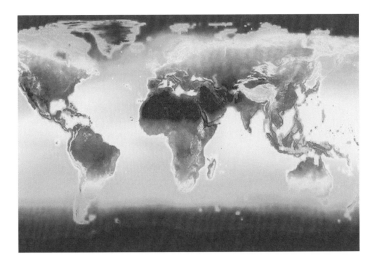

2016
It is Still 3 Minutes
to Midnight

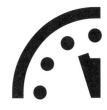

Last year, the Science and Security Board moved the Doomsday Clock forward to three minutes to midnight, noting: "The probability of global catastrophe is very high, and the actions needed to reduce the risks of disaster must be taken very soon." That probability has not been reduced. The Clock ticks. Global danger looms. Wise leaders should act— immediately."

2017
It is Two and a Half Minutes
to Midnight

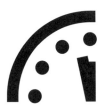

For the last two years, the minute hand of the Doomsday Clock stayed set at three minutes before the hour, the closest it had been to midnight since the early 1980s. In its two most recent annual announcements on the Clock, the Science and Security Board warned: "The probability of global catastrophe

2015
It is 3 Minutes
to Midnight

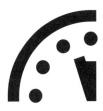

Unchecked climate change, global nu-clear weapons modernizations, and outsized nuclear weapons arsenals pose extraordinary and undeniable threats to

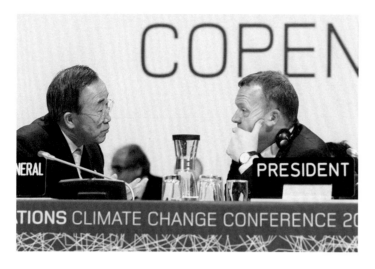

UN Secretary-General Ban Ki-moon consulting with Danish Prime Minister Lars Løkke Rasmussen, Climate Change Conference, Copenhagen, 2009

the continued existence of humanity, and world leaders have failed to act with the speed or on the scale required to protect citizens from potential catastrophe. These failures of political leadership endanger every person on Earth. Despite some modestly positive developments in the climate change arena, current efforts are entirely insufficient to prevent a catastrophic warming of Earth. Meanwhile, the United States and Russia have embarked on massive programs to modernize their nuclear triads—thereby undermining existing nuclear weapons treaties. "The Clock ticks now at just three minutes to midnight because international leaders are failing to perform their most important duty—ensuring and preserving the health and vitality of human civilization."

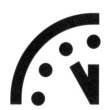

2012
It is 5 Minutes to Midnight

The challenges to rid the world of nuclear weapons, harness nuclear power, and meet the nearly inexorable climate disruptions from global warming are complex and interconnected. In the face of such complex problems, it is difficult to see where the capacity lies to address these challenges. Political processes

seem wholly inadequate; the potential for nuclear weapons use in regional conflicts in the Middle East, Northeast Asia, and South Asia is alarming; safer nuclear reactors need to be developed and built, and more stringent oversight and training is needed to prevent future disasters; the pace of technological solutions addressing climate change may not be adequate to meet the hardships from large-scale climate disruption.

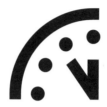

2010
It is 6 Minutes to Midnight

International cooperation rules the day. Talks between Washington and Moscow for a follow-on agreement to the Strategic Arms Reduction Treaty are nearly complete, and more negotiations for further reductions in the US and Russian nuclear arsenals are already planned. Additionally, Barack Obama becomes the first US president to publicly call for a nuclear-weapon-free world. The dangers posed by climate change are still great, but there are pockets of progress. Most notably: At Copenhagen, developing and industrialized countries agree to take responsibility for carbon emissions and to limit global temperature rise to 2 degrees Celsius.

President Obama signs New START, a nuclear arms reduction treaty between the US and the Russian Federation, in the Oval Office, Feb. 2, 2011

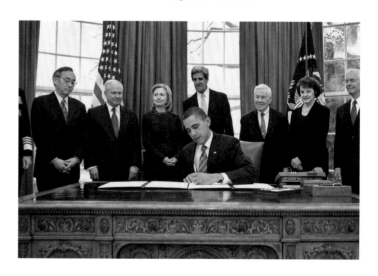

2007
It is 5 Minutes
to Midnight

The world stands at the brink of a second nuclear age. The United States and Russia remain ready to stage a nuclear attack within minutes, North Korea conducts a nuclear test, and many in the international community worry that Iran plans to acquire the Bomb. Climate change also presents a dire challenge to humanity. Damage to ecosystems is already taking place; flooding, destructive storms, increased drought, and polar ice melt are causing loss of life and property.

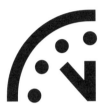

2002
It is 7 Minutes
to Midnight

Concerns regarding a nuclear terrorist attack underscore the enormous amount of unsecured—and sometimes unaccounted for—weapon-grade nuclear materials located throughout the world. Meanwhile, the United States expresses a desire to design new nuclear weapons, with an emphasis on those able to destroy hardened and deeply buried targets. It also rejects a series of arms control treaties and announces it will withdraw from the Anti-Ballistic Missile Treaty.

President Bush announces US withdrawal from the 1972 Anti-Ballistic Missile Treaty, December, 2001

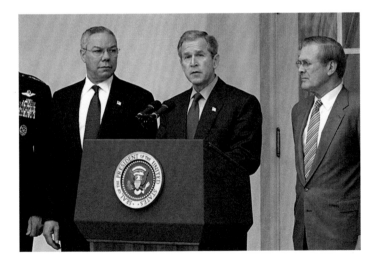

1998
It is 9 Minutes
to Midnight

India and Pakistan stage nuclear weapons tests only three weeks apart. "The tests are a symptom of the failure of the international community to fully commit itself to control the spread of nuclear weapons—and to work toward substantial reductions in the numbers of these weapons," a dismayed *Bulletin* reports. Russia and the United States continue to serve as poor examples to the rest of the world. Together, they still maintain 7,000 warheads ready to fire at each other within 15 minutes.

Anti-nuclear weapon protests, India, 1998

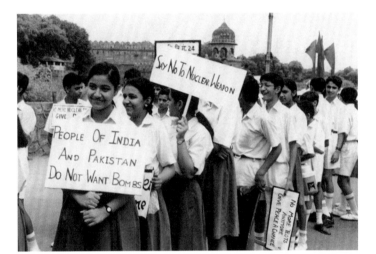

1995
It is 14 Minutes
to Midnight

Hopes for a large post-Cold War peace dividend and a renouncing of nuclear weapons fade. Particularly in the United States, hard-liners seem reluctant to soften their rhetoric or actions, as they claim that a resurgent Russia could provide as much of a threat as the Soviet Union. Such talk slows the rollback in global nuclear forces; more than 40,000 nuclear weapons remain worldwide. There is also concern that terrorists could exploit poorly secured nuclear facilities in the former Soviet Union.

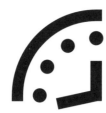

1991
It is 17 Minutes
to Midnight

With the Cold War officially over, the United States and Russia begin making deep cuts to their nuclear arsenals. The Strategic Arms Reduction Treaty greatly reduces the number of strategic nuclear weapons deployed by the two former adversaries. Better still, a series of unilateral initiatives removes most of the intercontinental ballistic missiles and bombers in both countries from hair-trigger alert. "The illusion that tens of thousands of nuclear weapons are a guarantor of national security has been stripped away," the *Bulletin* declares.

Fall of the Berlin Wall, 1989

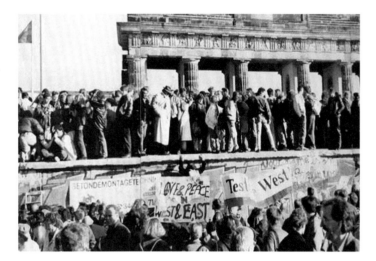

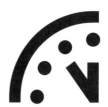

1988
It is 6 Minutes
to Midnight

The United States and Soviet Union sign the historic Intermediate-Range Nuclear Forces Treaty, the first agreement to actually ban a whole category of nuclear weapons. The leadership shown by President Ronald Reagan and Soviet Premier Mikhail Gorbachev makes the treaty a reality, but public opposition to US nuclear weapons in Western Europe inspires it. For years, such intermediate-range missiles had kept Western Europe in the crosshairs of the two superpowers.

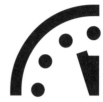

1984
It is 3 Minutes
to Midnight

US-Soviet relations reach their iciest point in decades. Dialogue between the two superpowers virtually stops. "Every channel of communications has been constricted or shut down; every form of contact has been attenuated or cut off. And arms control negotiations have been reduced to a species of propaganda," a concerned *Bulletin* informs readers. The United States seems to flout the few arms control agreements in place by seeking an expansive, space-based antiballistic missile capability, raising worries that a new arms race will begin.

1990
It is 10 Minutes
to Midnight

As one Eastern European country after another (Poland, Czechoslovakia, Hungary, Romania) frees itself from Soviet control, Mikhail Gorbachev refuses to intervene, halting the ideological battle for Europe and significantly diminishing the risk of all-out nuclear war. In late 1989, the Berlin Wall falls, symbolically ending the Cold War. "Forty-four years after Winston Churchill's 'Iron Curtain' speech, the myth of monolithic communism has been shattered for all to see," the *Bulletin* proclaims.

President Reagan announces the Strategic Defense Initiative—later dubbed "Star Wars" by the press—in a televised address, March 1983.

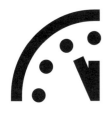

1981
It is 4 Minutes
to Midnight

The Soviet invasion of Afghanistan hardens the US nuclear posture. Before he leaves office, President Jimmy Carter pulls the United States from the Olympic Games in Moscow and considers ways in which the United States could win a nuclear war. The rhetoric only intensifies with the election of Ronald Reagan as president. Reagan scraps any talk of arms control and proposes that the best way to end the Cold War is for the United States to win it.

In response to the December 1979 Soviet invasion of Afghanistan, President Jimmy Carter announced that the US would not participate in the 1980 Moscow Olympic Games.

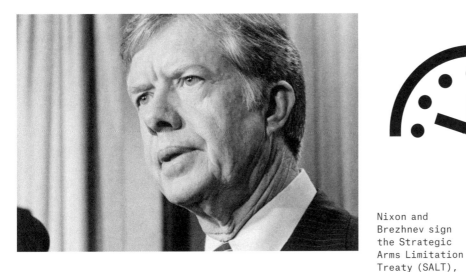

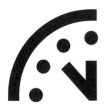

1980
It is 7 Minutes
to Midnight

Thirty-five years after the start of the nuclear age and after some promising disarmament gains, the United States and the Soviet Union still view nuclear weapons as an integral component of their national security. This stalled progress discouraged the Bulletin: "[The Soviet Union and United States have] been behaving like what may best be described as 'nucleoholics'—drunks who continue to insist that the drink being consumed is positively 'the last one,' but who can always find a good excuse for 'just one more round.'"

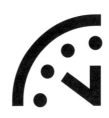

1974
It is 9 Minutes
to Midnight

South Asia gets the Bomb, as India tests its first nuclear device. And any gains in previous arms control agreements seem like a mirage. The United States and Soviet Union appear to be modernizing their nuclear forces, not reducing them. Thanks to the deployment of multiple independently targetable reentry vehicles (MIRVs), both countries can now load their intercontinental ballistic missiles with more nuclear warheads than before.

1972
It is 12 Minutes
to Midnight

The United States and Soviet Union attempt to curb the race for nuclear superiority by signing the Strategic Arms Limitation Treaty (SALT) and the Anti-Ballistic Missile (ABM) Treaty. The two treaties force a nuclear parity of sorts. SALT limits the number of ballistic missile launchers either country can possess, and the ABM Treaty stops an arms race in defensive weaponry from developing.

Nixon and Brezhnev sign the Strategic Arms Limitation Treaty (SALT), Moscow, 1972

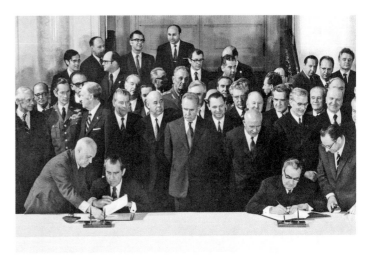

future of our society on the world scale," the *Bulletin* laments. "There is a mass revulsion against war, yes; but no sign of conscious intellectual leadership in a rebellion against the deadly heritage of international anarchy."

1963
It is 12 Minutes
to Midnight

After a decade of almost nonstop nuclear tests, the United States and Soviet Union sign the Partial Test Ban Treaty, which ends all atmospheric nuclear testing. While it does not outlaw underground testing, the treaty represents progress in at least slowing the arms race. It also signals awareness among the Soviets and United States that they need to work together to prevent nuclear annihilation.

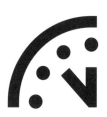

1969
It is 10 Minutes
to Midnight

Nearly all of the world's nations come together to sign the Nuclear Non-Proliferation Treaty. The deal is simple—the nuclear weapon states vow to help the treaty's non-nuclear weapon signatories develop nuclear power if they promise to forego producing nuclear weapons. The nuclear weapon states also pledge to abolish their own arsenals when political conditions allow for it. Although Israel, India, and Pakistan refuse to sign the treaty, the *Bulletin* is cautiously optimistic: "The great powers have made the first step. They must proceed without delay to the next one—the dismantling, gradually, of their own oversized military establishments."

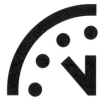

1960
It is 7 Minutes
to Midnight

Political actions belie the tough talk of "massive retaliation." For the first time, the United States and Soviet Union appear eager to avoid direct confrontation in regional conflicts such as the 1956 Egyptian-Israeli dispute. Joint projects that build trust and constructive dialogue between third parties

1968
It is 7 Minutes
to Midnight

Regional wars rage. US involvement in Vietnam intensifies, India and Pakistan battle in 1965, and Israel and its Arab neighbors renew hostilities in 1967. Worse yet, France and China develop nuclear weapons to assert themselves as global players. "There is little reason to feel sanguine about the

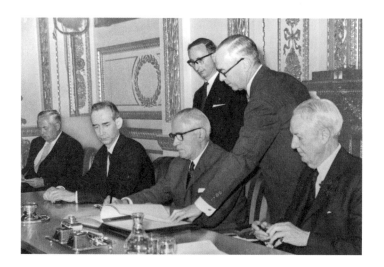

Cloud from XX-58 Ivy Mike, the first full-scale test of an experimental thermonuclear device, above the Enewetak Atoll, Marshall Islands, November 1952

also quell diplomatic hostilities. Scientists initiate many of these measures, helping establish the International Geophysical Year, a series of coordinated, worldwide scientific observations, and the Pugwash Conferences, which allow Soviet and American scientists to interact.

their first nuclear device, officially starting the arms race. "We do not advise Americans that doomsday is near and that they can expect atomic bombs to start falling on their heads a month or year from now," the *Bulletin* explains. "But we think they have reason to be deeply alarmed and to be prepared for grave decisions."

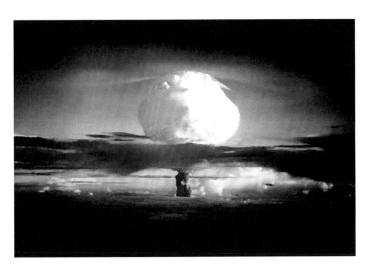

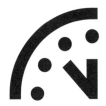

1947
It is 7 Minutes to Midnight

As the *Bulletin* evolves from a newsletter into a magazine, the Clock appears on the cover for the first time. It symbolizes the urgency of the nuclear dangers that the magazine's founders—and the broader scientific community—are trying to convey to the public and political leaders around the world.

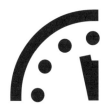

1953
It is 2 Minutes to Midnight

After much debate, the United States decides to pursue the hydrogen bomb, a weapon far more powerful than any atomic bomb. In October 1952, the United States tests its first thermonuclear device, obliterating a Pacific Ocean islet in the process; nine months later, the Soviets test an H-bomb of their own. "The hands of the Clock of Doom have moved again," the *Bulletin* announces. "Only a few more swings of the pendulum, and, from Moscow to Chicago, atomic explosions will strike midnight for Western civilization."

Photograph of early atomic experiment taken by Harold Edgerton with his rapatronic camera, early 1950s

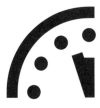

1949
It is 3 Minutes to Midnight

The Soviet Union denies it, but in the fall, President Harry Truman tells the American public that the Soviets tested

The *Bulletin of the Atomic Scientists* may be the only outlet whose approach to climate change is explicitly existential.

Panic Time: The Clock and the Climate Crisis

By E. Tammy Kim, freelance reporter and essayist

This article was originally published in the Spring 2020 issue of the *Columbia Journalism Review*

Illustration: Gaby D'Alessandro

In November, just before I went to see Jerry Brown at the annual meeting of the Bulletin of the Atomic Scientists, some 11,000 climate experts signed a statement declaring "clearly and unequivocally that planet Earth is facing a climate emergency." At 81, Brown, the former governor of California, was retired, but not really, having committed himself to fending off environmental disaster. Recently, he had testified before a House subcommittee, calling an attack by President Trump on California's auto emissions rules "just plain dumb, if not commercially suicidal." A month before that, he'd announced the creation of the California-China Climate Institute, a bilateral research and training initiative "to spur further climate action." And just before finishing his last term as governor, he'd signed on as the Executive Chair of the Bulletin, which was eager to stake out territory in the climate fight.

I'd arranged to interview Brown about his choice to join the *Bulletin*, a nonprofit magazine founded in Chicago in 1945 by conscience-stricken alumni of the Manhattan Project. The *Bulletin* covers all things nuclear and is best known for its annual Doomsday Clock announcement, which draws on expert opinion to report just how close we are to the "midnight" of man-made apocalypse. But the publication's original remit—to help "formulate the opinion and responsibilities of scientists" and "educate the public" about the many "problems arising from the release of nuclear energy"—has broadened considerably. It now devotes equal attention to the threat of the climate crisis, including in the setting of the Clock.

In this regard, the Bulletin and a post-gubernatorial Brown were an ideal match. The meeting I attended, at the regal University Club in downtown Chicago, was Brown's second with the Science and Security Board, a group of subject-matter experts who set the Clock and advise the editorial staff. (The Bulletin also has two other boards: The Governing Board, a corporate and philanthropic fundraising body, and the Board of Sponsors, which boasts 13 Nobel laureates.) A few hundred people arrived, palling around and getting ready to talk all things apocalypse. The dress code for the event had called for business attire, but Brown turned up in crumpled slacks and a navy-blue sweater—a suitcase screw-up, he explained.

Why the Bulletin? I asked. "Number one is, of course, the reduction of the nuclear

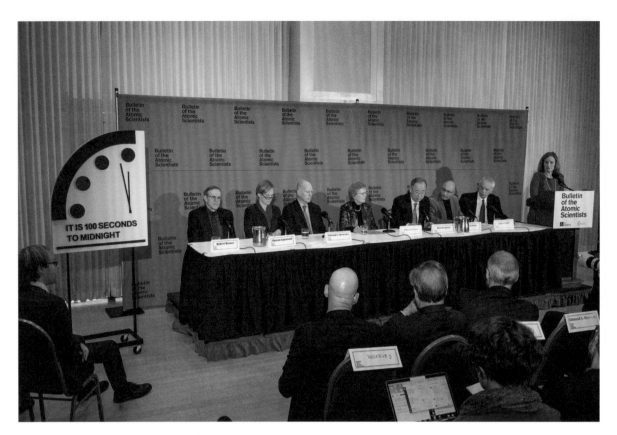

What time is it? At the 2020 announcement of the Doomsday Clock, the Bulletin's leaders declared us closer than ever to midnight.

threat, but climate is another huge threat to humanity," he said. "And the Bulletin, by linking the two threats, can increase public awareness, get people thinking about the big threats that humanity faces." Brown complained, in his jocular, pugnacious way, that the American news media's "servitude to the concept of the news of the day" is partly to blame for public ignorance about climate change. He asked me repeatedly, "How can journalism cover something as diffuse and general and gradual as climate change?" As we chatted, searching for answers, I thought of the untold amount of carbon we'd all combusted to get to Chicago.

I next saw Brown at the opening luncheon, in the buffet line among Bulletin funders and fans. The crowd resembled that of a classical-music concert: old, white, intellectual. The day included three sets of workshops, led by eminent scientists and policy wonks, then a closing plenary session and dinner banquet at Chicago's Palmer House, a grand hotel dating to the late 19th century. At the

dinner, Brown delivered an energetic, free-flowing speech. "The worse it is, the more excited I am," he said, the it being our current geopolitical, nuclear, and climate morass. "Let's get it done!"

That second it—the avoidance of total destruction—aptly distilled the Bulletin's mission. Since the atrocities of Hiroshima and Nagasaki, the magazine has tried to convey the grave danger we've imposed on ourselves. Today, though the possibility of nuclear war remains real, the climate crisis feels just as daunting and consequential. Environmental scientists know this, as do journalists who report on global warming. Yet the *Bulletin of the Atomic Scientists* may be the only publication to cover climate change with an approach that is explicitly existential.

●

In 2017, during a seemingly endless, ever-escalating row between President Trump and North Korean leader Kim Jong-un, the *Bulletin of the*

Atomic Scientists was permanently tabbed in my browser window. What some were calling a new "North Korean nuclear crisis" wasn't really new or even a crisis so much as the crackling of a rather constant fire. Still, as a Korea watcher with family on the peninsula, and given the "statesmen" involved, I felt frightened and looked to the *Bulletin* as a vital source of news and commentary. The magazine had, after all, invented the nuclear beat.

From the very first issue, a slight, mimeographed newsletter published on the fourth anniversary of the attack on Pearl Harbor, the *Bulletin* appealed to America and the rest of the world to eliminate nuclear weapons and establish "efficient international control" of atomic energy. Progress "will be useless if our nation is to live in continuous dread of sudden annihilation," the editors said at a conference in Moscow. "We can afford compromises, disagreements, or delays in other fields—but not in this one, where our very survival is at stake." A few years on, the *Bulletin* published the text of a speech by Albert Einstein, delivered to journalists at the United Nations, in which he asked why global cooperation hadn't yet staved off the threat of apocalypse. Perhaps it would be different, he suggested, if the atom bomb were not "one of the things made by Man himself." Einstein later founded the Bulletin's Board of Sponsors.

The *Bulletin* evolved from a newsletter into a magazine, headquartered at the University of Chicago, and Martyl Langsdorf, a landscape painter and the wife of a Manhattan Project alumnus, designed a symbolic cover: an analog clock, set at 11:53 pm, to represent the imminence of our self-destruction. In 1949, when the Soviet Union tested its first nuclear device, Eugene Rabinowitch, the *Bulletin*'s coeditor, decided to animate Langsdorf's Clock, winding it four minutes closer to midnight. It has ticked forward and backward ever since—through the proliferation of ballistic missiles; the catastrophes at Three Mile Island, Chernobyl, and Fukushima; and the adoption of and American withdrawal from the Intermediate-Range Nuclear Forces (INF) Treaty. The Nuclear Notebook, a research column of hair-raising erudition, has appeared in every issue since May 1987 and is second only to the Doomsday Clock in *Bulletin* influence. Each Notebook installment analyzes a category of stockpile—tactical nuclear weapons, for instance, or the Chinese nuclear arsenal—down to the quantity and types and locations of various arms and fissile materials.

The interests of the magazine have always overlapped with those of environmentalists. Early Bulletin scientists expressed a desire to make atomic energy a clean, limitless alternative to fossil fuels. That did not, of course, come to pass; more apparent were various kinds of long-term damage, from nuclear tests to plant meltdowns to radioactive waste buried on- and offshore, all of it documented in the *Bulletin*. There's still no consensus on nuclear power. At the annual meeting, Robert Socolow, a member of the Science and Security Board and a Princeton professor emeritus, said in a presentation, "I'm still going back and forth on nuclear energy, because of the coupling of nuclear power and nuclear weapons." There is always "some probability" of disaster, he added.

Atomic energy, in any case, never came close to rivaling fossil fuels, and the subject of climate change appeared in the *Bulletin* as early as November 1961. "Climate to Order," an article-cum–thought experiment by H.E. Landsberg, a German climatologist, described geoengineering—that is, hacking the atmosphere (reflecting sunlight, injecting chemicals into the stratosphere, etc.)—avant la lettre. In theory, Landsberg wrote, it would be great to customize our environment, but "When we are changing the climate of the whole world, a mistake could be disastrous." In 1970, the *Bulletin* ran another piece on geoengineering, this time in relation to "polar ice" and "man's inadvertent influences on global climate." By 1972, a long, poetic account of the loss of forests and arable land would warn, "There is plenty of evidence that man is the principal cause of this change."

When I visited Rachel Bronson, the CEO and president of the Bulletin, in the magazine's Chicago offices, she plucked a bound library volume from her shelf and opened it to February 1978. "Is mankind warming the Earth?" William W. Kellogg, a meteorologist, queried in the magazine's first climate-change cover story. "The answer is, I believe, an unqualified 'yes.'" Kellogg's article might have been written today, so salient are its arguments against delayed action and the conflating of extreme weather and atmospheric

transformation. He included a message to colleagues who "maintain that we should not publish any conclusions about the response of the climate to anthropogenic influences until we have done more homework," expressing his disagreement "with such a conservative and noncommunicative attitude because the stakes are so great, the issues so fundamental to the future of society and most of all because some decisions are upon us that depend on every scrap of insight we can muster."

By the end of the Cold War, most scientists were aware of the dangers of climate change and its relation to atomic and geopolitical concerns. Around the time Bill McKibben published *The End of Nature*, the first mass-market account of global warming, in 1989, the *Bulletin* was running pieces on the science of climate change "side by side with heated denials that global warming posed any threat at all," historians David Kaiser and Benjamin Wilson observe in a special 70th-anniversary issue of the *Bulletin*. The magazine also recast the debate over nuclear energy "amid new apprehension about greenhouse gas emissions and implications for global warming." Len Ackland, the editor from 1984 to 1991, told me that it became clear "we needed to address longer-term environmental dangers." To that end, he commissioned new artwork from Langsdorf: in her cover illustration for the October 1989 issue, the circle of the Clock encloses a blue-and-white map of the world, the minute and hour hands radiating out from the North Pole. In 1992, the *Bulletin* published a major speech by Mikhail Gorbachev that set out environmental priorities for a post-Soviet world: "The prospect of catastrophic climatic changes—more

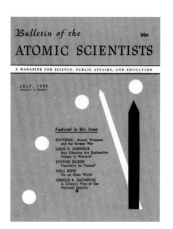

July 1950

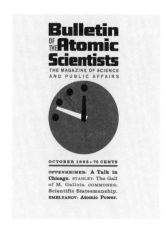

October 1963

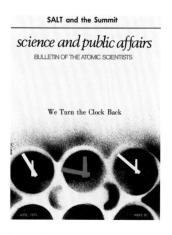

June 1972

Ticktock: Martyl Langsdorf, a landscape painter and the wife of a Manhattan Project alumnus, designed a symbolic Bulletin cover: an analog clock that would represent the imminence of our self-destruction. That clock would become the magazine's visual touchstone.

April 1990

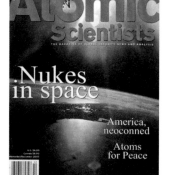

November/December 2003

November 2019

frequent droughts, floods, hunger, epidemics, national-ethnic conflicts, and other similar catastrophes—compels governments to adopt a world perspective and seek generally applicable solutions."

The *Bulletin* has vacillated in style over time, toggling between academic journal and science magazine, but has always maintained a certain seriousness. When I spoke to Bronson, she told me that tradition and expertise are no longer enough. "In the moment of populism in which we're now operating, we'd better inform the populace," she said. "Our power will come from having an educated and devoted following that's larger than it is right now." Recently, the *Bulletin* has adjusted its idioms; leaned more on interviews, explainers, personal essays, and multimedia; and stretched beyond an author base of older white male technocrats from Europe and the United States. There's the Voices of Tomorrow column, which ran a moving essay by four teenage activists, including Isra Hirsi, Congresswoman Ilhan Omar's daughter: "Adults won't take climate change seriously. So we, the youth, are forced to strike." There's elegant multimedia reportage, such as deputy editor Dan Drollette's "Tilting toward windmills," about a test wind farm on Block Island, Rhode Island. And there's refined polemic: for example, "Let science be science again," by Yangyang Cheng, a Chinese physicist based in Chicago, on science advocacy in the age of Donald Trump. A popular video series, "Say What? A clear-eyed look at fuzzy policy," produced by multimedia editor Thomas Gaulkin, demonstrates that, even though the *Bulletin* is nonpartisan, it's religiously pro-science.

●

In recent years, the *Bulletin* website has more than quintupled its traffic, from about 42,000 visits per month in 2013 to 372,000 per month today. The audience remains small but is also—judging from the comments section and social media— well connected and atypically informed: scientists, graduate students, journalists, the kinds of people who subscribe to *Scientific American* and *Foreign Affairs*. In response to a recent article on the Intergovernmental Panel on Climate Change that debunked the supposed coming of a "little

ice age," commenter Cjones1 wrote: "You forgot to mention that less solar radiation allows more cosmic radiation which effects [sic] cloud cover. The IPCC predictions have been less accurate than a bone-throwing shaman." Fifty-five people responded to this with a thumbs-up.

The *Bulletin* discontinued its print edition in 2008 but maintains a distinction between its paywalled bimonthly magazine and other articles. A yearly subscription costs sixty dollars. Since 2011, John Mecklin has served as the *Bulletin*'s editor in chief. He supervises six editors, spread out across the United States, who commission and write; seven other staff members handle administration, public relations, and fundraising. Collectively, they aim to grow the magazine's readership, assign more illustrations, and invest in narrative and investigative journalism. "I'm in the process of commissioning a story right now, paying somebody two to three dollars a word," Mecklin told me. "The *Bulletin* is doing well financially, but I can't pay what the *New Yorker* pays somebody, or I can't do it for very many stories a year." Most pieces are written for nothing—"donated," as Mecklin put it—by experts with day jobs. One of Mecklin's predecessors, Mark Strauss, recalled compensating at least one contributor with a Bulletin T-shirt.

When Mecklin took the job, climate represented just "a quarter or 30 percent" of the magazine, he told me; it's now "more like 40 percent nuclear, 40 percent climate." As he explained, "What has evolved and changed since I've been editor is that there are now three areas of focus: it's nuclear, climate change, and this area we call disruptive technologies"—such as artificial intelligence and disinformation—a sort of "threat multiplier of the first two." Both Mecklin and Bronson described this expanded mission as logical and necessary, and in line with the *Bulletin*'s history of tackling the impacts of cutting-edge science.

When I listened in on a recent editorial meeting, via Skype, I was struck by the magazine's simultaneously banal and illustrious character. The editors did what all editors do: They evaluated pitches and commissions, reviewed social media statistics (e.g., an "SUV shaming" story, by contributing editor Dawn Stover, that was "doing well on the interwebs"), brainstormed story ideas, and

planned coverage. But every so often, someone would refer to a famous politician or scientist (e.g., Siegfried Hecker, a Stanford physicist who has personally inspected North Korea's nuclear arsenal) not as a dream subject or occasional source, but as a friend and adviser to the magazine. On questions of climate, for instance, they might consult Elizabeth Kolbert, a Pulitzer Prize–winning *New Yorker* writer who sits on the Science and Security Board. This is a publication with extraordinary history and reach. I thought of something Mecklin told me when we first spoke: "We want to be read in the White House, at the Kremlin, and at the kitchen table."

Among the prominent scientists closely involved with the *Bulletin* is Raymond Pierrehumbert, a lavishly bearded and tweeded physicist, not of the nuclear sort. He joined the magazine's Science and Security Board while across campus at the University of Chicago. He has since moved to Oxford, but remains heavily involved. In his work on "the early Earth" and planets around other stars, he applies the "same physics we use to quantify the greenhouse effect on Earth," he told me. "If you're a climate scientist or paleontologist, you've studied the role of carbon dioxide in the Earth's past history—you know that what humans are doing to the Earth's climate is truly disturbing." For his part, he said, "It would be irresponsible to stay in the lab." Pierrehumbert once wrote a lively column on science and politics for *Slate*; he also contributed to the website RealClimate and appeared in a well-intentioned rap video titled "We are climate scientists, Chicago style." (He's better as a folk musician.)

In a recent cover story for the *Bulletin*, "There is no Plan B for dealing with the climate crisis," Pierrehumbert argues in dramatic language against geoengineering. To pursue that strategy, he writes, would commit "generations yet unborn to continuously run a mechanical process, over a time-span longer than the age of the pyramids.... And if our offspring don't, or simply can't, do so at some point in the future, then they will suffer the consequences of an unimaginably huge climate shock, accumulated over vast amounts of time."

When I saw Pierrehumbert at the annual meeting, he was sheepish about the sin of his flight to get to Illinois. Yet he seemed energized by the company of his colleagues: fellow physicists, national-security experts, and politicians, including Jerry Brown, whom he admires. A few years ago, Pierrehumbert told me, he'd raised concerns with Brown about coal exports. If California allowed a proposed coal export terminal to be built, Pierrehumbert had said, it would increase demand in China, putting all of our carbon reduction goals in jeopardy. The problems were confounding, the answer frustratingly simple: "We need to put fossil fuel companies out of business, or at least their traditional business," Pierrehumbert told me. "We will need to write down carbon to zero." Brown heard him out, Pierrehumbert recalled, but "it was not on his radar."

In November, Pierrehumbert had California's cap-and-trade program on his mind. A flaw of that and related markets, he told me, is that they apply an inaccurate equivalence "standard, mass for mass," to methane and carbon dioxide, thereby exaggerating the role of methane in global warming. But "if we reopen the debate"—that is, rejigger the math of cap-and-trade—"we could lose the benefit on carbon dioxide. It's politically complicated. I'm not sure it's worth the risk," he explained. "It's too bad that Jerry Brown is no longer governor." Even if he didn't act on everything Pierrehumbert told him about, he had, at least, listened. Gavin Newsom, the new guy in Sacramento, has yet to show up to a Bulletin meeting.

●

At the start of 2020, Bronson and her staff flew to Washington, DC, as they do every January, to announce to the world what time it is. At the press conference, livestreamed to maximize virality, Bronson wore a scarlet dress and stood at a podium bearing the Bulletin's somber black-and-white logo. In 2018 and 2019, the Clock was set at 11:58, the direst assessment by the Science and Security Board since 1953, after both the United States and the Soviet Union tested hydrogen bombs. This year, alongside Brown; Mary Robinson, a former president of Ireland; and Ban Ki-moon, a former UN secretary-general, Bronson delivered an even grimmer report: The world was now a hundred seconds from apocalypse—"closer than ever to midnight," as CNN would write.

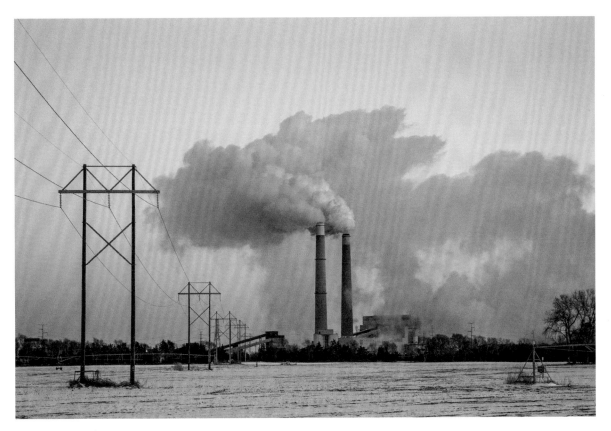

Xcel Energy's
Sherburne County
Generating
Station, a coal-
fired power plant,
near Becker,
Minnesota

The *Bulletin*'s accompanying statement, authored by Mecklin and addressed to the "leaders and citizens of the world," is a seven-page, reader-friendly recitation of man-made horrors and suggested mitigations. Humanity is facing "a state of emergency that requires the immediate, focused, and unrelenting attention of the entire world," it reads. The reasons are many. On the nuclear side, the United States, Russia, and China retain their stockpiles; Iran retreated from international cooperation, in response to America's withdrawal from their nuclear deal and its assassination of a top Iranian military commander; the INF Treaty is no more and other arms agreements are soon to expire. In terms of climate change, the US officially left the Paris Agreement; Brazil is allowing its precious rain forests to be destroyed; and greenhouse gas emissions are on the rise, zero-carbon rhetoric be damned. All this is made worse by a "corrupted and manipulated media environment" in which truth, let alone scientific reality, becomes increasingly unknowable.

Still, the *Bulletin* statement offers shards of hope. "Climate change has catalyzed a wave of youth engagement, activism, and protest," it observes. If we multiply this "mass civic engagement," it states, "there is no reason the Doomsday Clock cannot move away from midnight."

If the Clock announcement invites sober reflection, it's also an occasion to push for political action. Throughout its history, the *Bulletin* has balanced its journalistic mission with various forms of advocacy. As soon as the atomic scientists in Chicago founded the *Bulletin*, they joined with colleagues in Los Alamos, Oak Ridge, and Manhattan to lease an office in Washington, forming a Beltway collaboration that eventually became the Federation of American Scientists. Last year, just after the Clock announcement, Bronson, Brown, and former defense secretary William Perry, who now chairs the Bulletin's Board of Sponsors, met with House Speaker Nancy Pelosi and Senate Minority Leader Charles Schumer—to lobby not for a specific candidate or bill, but for arms control, diplomacy,

and nuclear and climate policies rooted in science. *Bulletin* staff transmitted the ominous details of the Clock statement: North Korean nuclear proliferation, increasing carbon dioxide emissions, and information warfare. This year, alas, Congress was busy with impeachment proceedings.

There is a tension, in such conversations, between fear and hope. How much is too much apocalypse talk? "It's very hard to find the words, even, to express the moment we now are in," Brown said, during the Clock announcement. "I myself am a person of limitless words, but I can't find how to say it in such a way that it can be heard." Back in November, at the end of the closing plenary session, a tall, bespectacled woman in the audience raised her hand: Elizabeth Talerman, a strategic-communications expert, who offered some advice on framing. It's best to avoid phrases like "existential threat," she said, because they bum people out. The Doomsday Clock certainly has its skeptics, mostly on the right. See: "Just skip the doomsday predictions, guys" (the *National Review*); "Goose eggs: No climate change doomsday warning has come true" (the *Washington Examiner*); "The Climate Doomsday Trap" (the Cato Institute). Strauss, the former editor, told me that the *Bulletin* has played just as important a role in debunking "overhyped threats"—for example, "fears that terrorists might start massive forest fires"—as it has in playing up actual perils.

When I asked Brown how the *Bulletin* should convey the urgency of the climate crisis, he didn't have an easy answer. He brought up a document from 1992, a one-page "Warning to Humanity" published by the Union of Concerned Scientists, a nonprofit whose members and staff often write for the *Bulletin*. "A great change in our stewardship of the earth and the life on it is required, if vast human misery is to be avoided and our global home on this planet is not to be irretrievably mutilated," the statement reads. Brown's point was that every climate messenger, not just at the *Bulletin*, struggles to balance gloom and motivation. Meaghan Parker, executive director of the Society of Environmental Journalists, told me, "It's not so much about the emotion—are you a doom writer or a solutions-and-hope writer?—but talking about the specific, lived changes of real people."

Some *Bulletin* articles punch and flail; others coax. Many do both, traipsing from seemingly intractable problems to optimistic solutions. In its March 2019 issue, the *Bulletin* examined "climate change action—from the right," including an interview with Christine Todd Whitman, the former governor of New Jersey and head of the Environmental Protection Agency under George W. Bush, and an article about a Christian group, Young Evangelicals for Climate Action. Mecklin's editor's note offered practical guidance to "ungenerous corners" of the American left: "Republican officeholders are not likely to agree to substantive action on climate change until they feel it is clearly in their best political interest to do so. The best people to explain those best interests to Republican congressmen and women? Republicans who believe in climate action and vote their beliefs." Recently, when I sat down to read a tall stack of *Bulletin* articles, I felt a confusing combination of terror, depletion, and productive rage.

Perhaps this is how the original atomic scientists felt, trembling from guilt, trying to pull us away from the abyss. Nuclear war, so overwhelming a concept, once needed its own metaphors to be understood. When the *Bulletin* first took on climate change as an area of focus, it might have seemed an odd fit. "As they say, nuclear can do us in in an afternoon; climate change will take much longer," Kennette Benedict, the *Bulletin*'s former director and publisher, who oversaw the inclusion of climate change in the Clock-setting, told me. But the two crises are now an inseparable apocalyptic pair. If memories of fallout shelters and air raid drills make rising sea levels and extreme temperatures feel more pressing, then so be it.

The Bulletin of the Atomic Scientists has been a longtime supporter and collaborator on arts projects that align with its mission to educate the public about man-made threats to human existence.

Ellen Sandor and (art)n: Chris Kemp, Diana Torres, Azadeh Gholizadeh, and Janine Fron, *Have a Nice Day II*, 2017 (Detail I).

In Memory of Martyl, 42 × 32 × 72 in. Digital PHSCologram sculpture, Duratrans, Kodalith, and Plexiglas

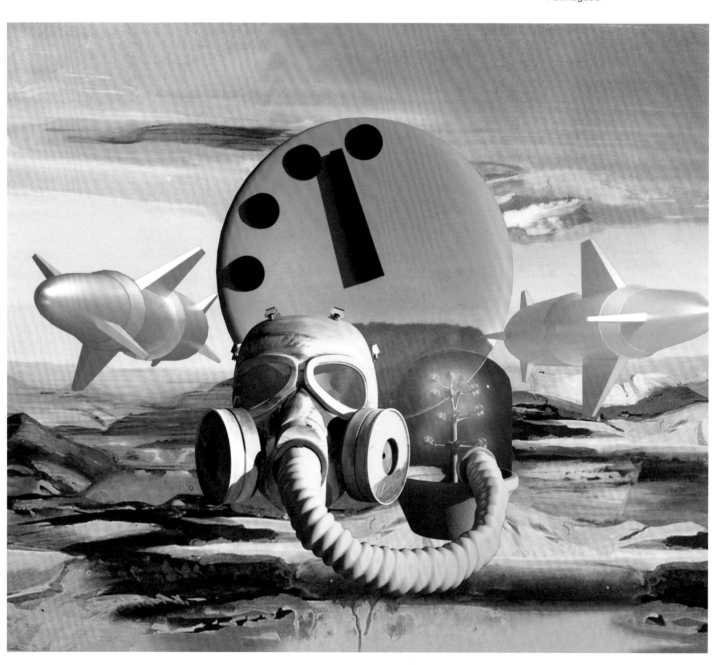

The Doomsday Clock and the Arts

By Robert K. Elder

From its earliest days, the Bulletin of the Atomic Scientists has featured both science and the visual arts in its publishing, recognizing that art can move people and ideas in ways that are often more powerful than published scientific research alone. Over its history, the magazine regularly incorporated paintings, photographs, and as importantly, cartoons. Art has long been featured in the Bulletin's publications, social media streams, branding, and annual reports.

The Bulletin has continued to partner with major museums and arts leaders to advance the conversation around art and science.

The organization has also partnered with the Hirshhorn Museum in Washington, DC, the School of the Art Institute of Chicago, and the Museum of Science and Industry on exhibits. The Bulletin regularly collaborates with artists, musicians, and cutting-edge new media artists to create new work.

By working together with leading contemporary artists, designers, and creative communicators, the Bulletin seeks to broaden the conversation, generating innovative ways of framing crucial issues around peace and security.

In this section, we'll showcase a few of the Bulletin's collaborations—with the promise of more to come.

New Media and the Doomsday Clock

In 2002, Martyl teamed up with new media artist Ellen Sandor and the (art)n collective to create artwork that combined her landscape paintings and elements of the Doomsday Clock. These works were called PHSColograms (pronounced *skol-o-gram*)—a term coined by Sandor in 1983.

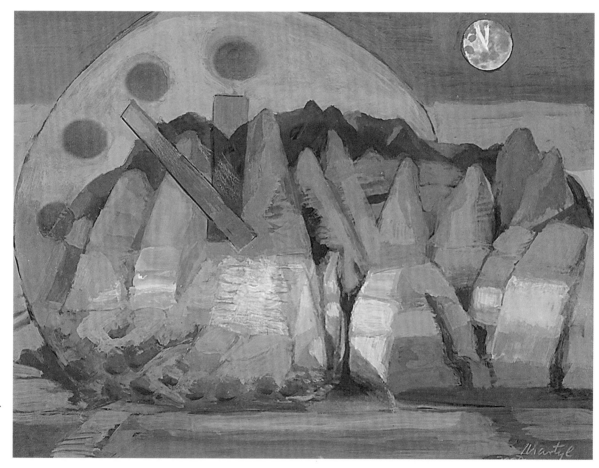

Martyl, *Doomsday Clock: Have a Nice Day*, 2002, 9 × 7 in. Gouache on Mylar, from the Richard and Ellen Sandor Family Collection

PHSCologram is an acronym for photography, holography, sculpture, and computer graphics.

These digital 3D hard copy images of multidimensional photography, which are viewed through rear lighting, have a sculptural quality. Presented here in two dimensions, these pieces brought Martyl's work to a new generation of multimedia artists.

After Martyl's death in 2013, Sandor and her (art)ⁿ team worked with Carolina Cruz, the mother of virtual reality (VR), to create an interactive VR tour of Doomsday Clock history from 1947 to 2019.

In homage to the original *Have a Nice Day* PHSCologram collaboration with the late artist and Doomsday Clock designer, Martyl, Ellen Sandor and (art)ⁿ created a PHSCologram sculpture with three additional panels to complement the original, addressing more in-depth factors that have led and continue to push humanity toward midnight. —Robert K. Elder

Martyl, *Have a Nice Day*, 2002.
Ellen Sandor and (art)ⁿ:
Keith Miller, Pete Latrofa,
and Janine Fron, 40 × 30
in., Virtual Photograph/
PHSCologram: Duratrans,
Kodalith, Plexiglas

I met my dear friend Martyl in the 1980s, when she asked me to show my 3D PHSColograms at Fermilab's Art Gallery. Martyl's authentic vision reflected the importance of art, science, and technology to evolve our society. What a blessing it was to later work with her and the (art)ⁿ team in 2002 on a PHSCologram that incorporated her iconic Doomsday Clock with her exquisite landscape art. She was thrilled to see her aesthetic juxtaposed with the Doomsday Clock in digital 3D, which we recently made into a sculpture with additional PHSCologram panels inspired by events in the Bulletin's timeline.

After Martyl passed in 2013, in her memory, I had the privilege of working with Rachel Bronson, my (art)ⁿ team, and Carolina Cruz's team on a VR tour of the Doomsday Clock from 1947–2019. Rachel Bronson's detailed historical perspective in her narration and Carolina Cruz, being the mother of VR, made this work a transcendent artistic experience. All of the textures we included in the piece feature Martyl's poetic landscapes, and we were all moved and inspired by her unique vision.
—Ellen Sandor, Founding Artist & Director, (art)ⁿ

Have a Nice Day II, 2017
(Detail II).

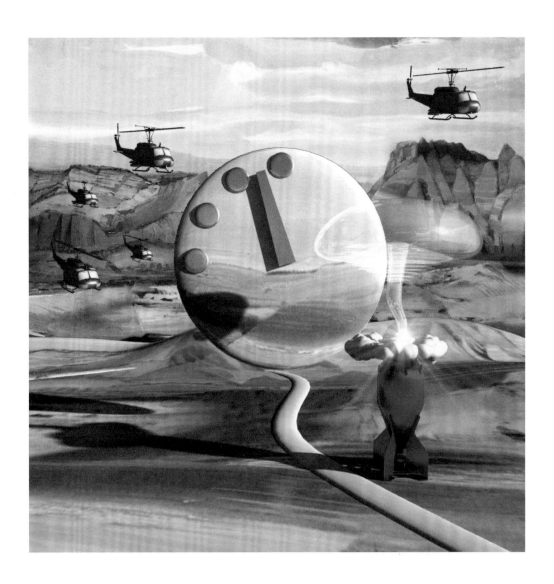

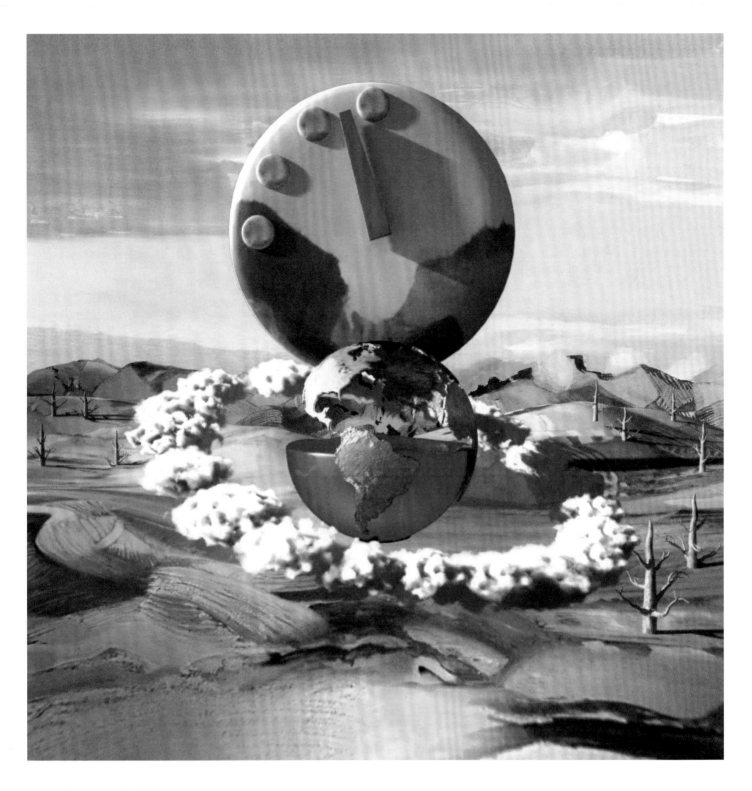

Have a Nice Day II, 2017
(Detail III).

Produced 15 years after the original *Have a Nice Day*, this body of work reveals heightened threats of nuclear warfare, growing tensions between nations, and environmental factors of climate change, along with positive scientific discoveries that could improve medicine and have many more beneficial applications.

In this reimagined virtual landscape the player explores the Los Alamos desert site of Project Y and navigates through the Doomsday Clock timeline from 1947 to 2019. All the vignettes of the landscape textures are painterly montages of Martyl's dramatic landscape paintings of mountains and rocky terrain. Each station contains visual cues that symbolize major events that occurred in a specific year. The tour is narrated by Rachel Bronson, president and CEO of the Bulletin of the Atomic Scientists.

Virtual Reality Tour Through the Doomsday Clock, 2018/19. Ellen Sandor & (art)ⁿ: Diana Torres and Azadeh Gholizadeh, Carolina Cruz-Neira, Jason Zak, Tanner Marshall, and Jaimes Krutz, George W. Donaghey Emerging Analytics Center, University of Arkansas at Little Rock, William Robertson, Co-Founder/CTO Digital Museum of Digital Art. Special thanks to Janine Fron. Voiceover by Rachel Bronson, President and CEO of the Bulletin of the Atomic Scientists. In Memory of Martyl.

Amnesia Atomica

At the crossroads of sculpture and performance, *Amnesia Atomica* aims to remind people about the dangers of nuclear annihilation.

By Gayle Spinazze and Robert K. Elder, Bulletin staff

In February 2020, artist Pedro Reyes and the Mexican Ministry of Foreign Affairs unveiled *Amnesia Atomica*, a three-story inflatable mushroom cloud. The project was commissioned by the Bulletin of the Atomic Scientists with support and inspiration from the NSquare Collaborative "to raise public awareness, revitalize the once vibrant anti-nuclear community, and most importantly put pressure on political leaders, policymakers, and global citizens by reminding them of the consequences of inaction," according to curator Pedro Alonzo.

The sculpture served as a central component of a three-day commemoration of the 53rd anniversary of the Treaty of Tlatelolco, a historic agreement that created a nuclear-weapon-free zone for Latin America and the Caribbean.

"NO ONE SHOULD HAVE THE POWER TO KILL US ALL!!!" Reyes wrote in 2021, reflecting on the piece. "The Bulletin of the Atomic Scientists and curator Alonzo commissioned me to work on a campaign to renew interest in this threat. The answer was *Amnesia Atomica*, an effort to remember not only nuclear dangers but also the activism, slogans, graphics, and tactics that led to a massive reduction of nuclear warheads from over 60,000 to under 14,000. It's meant to provide persuasive resources and share them with generations that grew up unaware of this problem."

Bulletin CEO Rachel Bronson was in Mexico City for the event and spoke as part of the panel discussion, "Relevance and validity of the Treaty of Tlatelolco."

"The Doomsday Clock and *Amnesia Atomica* share the legacy of visual arts and science working together to convey complex ideas. Unfortunately, scientific facts and data often numb the public but the right visual can transform obtuse science and policies into a compelling narrative that individuals can comprehend and get behind," said curator Alonzo. "Working with Pedro Reyes and the Bulletin of the Atomic Scientists is an ideal situation that brings these disciplines together."

Events surrounding the Treaty commemoration also included a new performance by Mexican dance company Nohbords, as well as a concert by punk band Vyctoria and a weekend-long film festival.

Amnesia Atomica was slated to travel with the Bulletin to New York City to draw public attention to the 50th anniversary of the Treaty on the Non-Proliferation of Nuclear Weapons (NPT), the bedrock of the global nuclear arms control landscape—although the event was postponed due to COVID-19 concerns and the United Nations' changed schedule.

Amnesia Atomica is a continuation of Reyes' work on disarmament. As the title implies, the project spotlights the public's disconnect to issues of nuclear threat and the failure of experts and leaders to contain it.

Reyes juxtaposes the horrific symbol of nuclear Armageddon with a medium traditionally associated with advertising, the Macy's Thanksgiving Day Parade, and bouncy houses. The cloud will serve as a centerpiece for events around the world, allowing community organizations and civic actors to bring their voices and talents to reducing the nuclear threat.

"I love the idea of the expert and the storyteller working together to create compelling narratives. We need both the scientist and the artist to unpack and properly address the complex and intransigent issues facing humanity," said curator Alonzo.

Pedro Reyes, *Amnesia Atomica*, February 2020, Mexico City

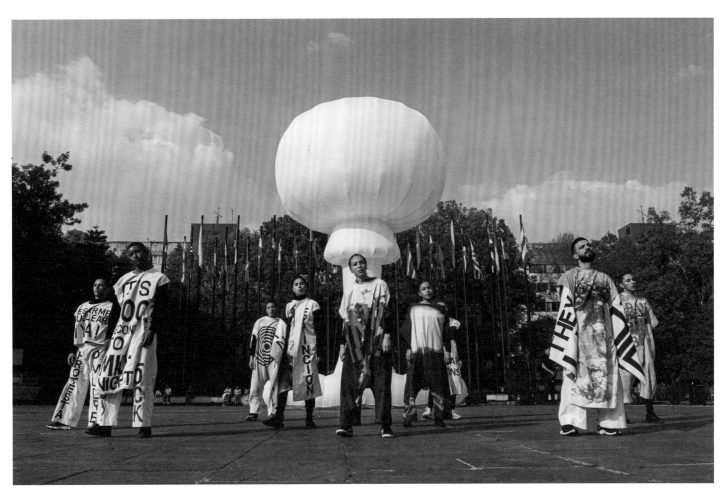

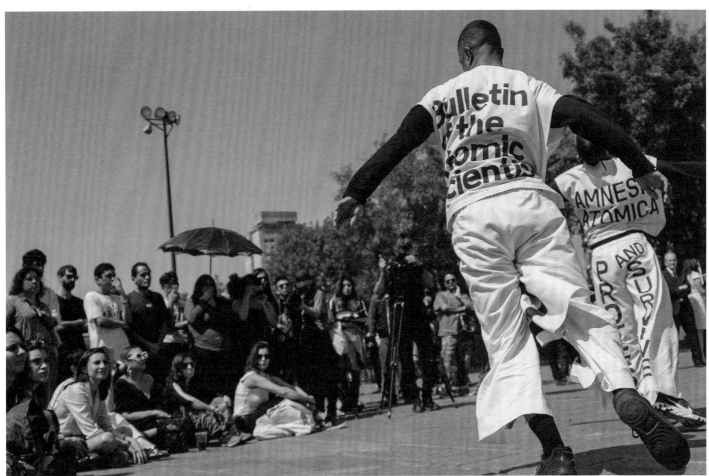

Statement from the Artist

The fall of the Berlin Wall and the end of the Soviet Union created the false illusion that the threat of thermonuclear war was a thing of the past. However, in the present, there are still over 13,000 nuclear warheads ready to be used. Previous hard-fought international nuclear treaties and accords have recently collapsed, and every major nuclear-armed state is investing heavily in their nuclear arsenal. Relations between the United States and Russia, countries that control 90 percent of the world's nuclear weapons, have deteriorated significantly. New "low-yield" weapons are being deployed under the illusion that the area of damages inflicted by a nuclear explosion could be "limited." A nuclear exchange, either by accident or by design, would inflict extreme destruction and likely lead to the end of life on the planet.

For those concerned about climate change bringing the world to an end in the next 30 years, we're sorry to tell you that a nuclear exchange could happen at any minute. Danger is high and there's no margin for error. Are you worried yet? Let our leaders know!!! —Pedro Reyes

Pedro Reyes, *Amnesia Atomica*, February 2020, Mexico City

The Doomsday Clock as Art

The Doomsdai Clock

The Bulletin has always been on the bleeding edge of art and science, collaborating with new visions and new technologies on evolving artforms. Obvious—a French collective of artists and researchers in machine learning—is exploring the creative features of artificial intelligence.

By Robert K. Elder

In 2018, Obvious created *The Doomsdai Clock*, a work of art featuring a built-in screen within a unique representation of the Bulletin's Doomsday Clock.

The screen displays a video loop created by Obvious using artificial intelligence algorithms that create new and unique visuals based on aerial photos from Russian photographer Stas Bartnikas. The photos were taken during his trips to some of the most remote places on Earth. *The Doomsdai Clock* reminds us to address urgent ecological issues. By combining this AI-generated background with the most recognizable elements of the Clock, Obvious offers a new vision of the Bulletin's Doomsday Clock, which sits at the crossroads of nature and technology.

"The aim of this collaboration is to ignite a conversation about our planet and the impact we have on it," said Obvious. "The underlying question is: How do we responsibly manage the tools at our disposal, recognizing both the beauty and disaster they are capable of creating?"

This project aims to send a warning about the urgency of building a framework for both the use of new technologies and the global behavior regarding climate change. It achieves this by combining the widely recognized visual of the Doomsday Clock with AI-generated visuals from some of the wildest nature on earth.

Obvious, *The Doomsdai Clock*, 2018

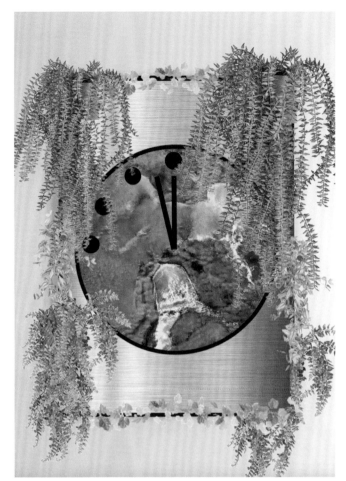
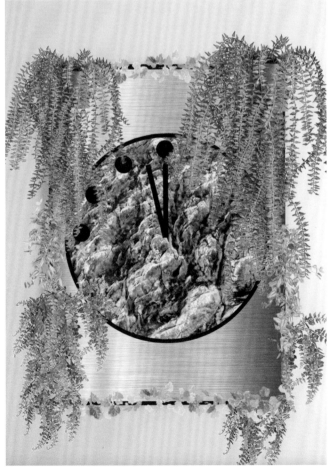
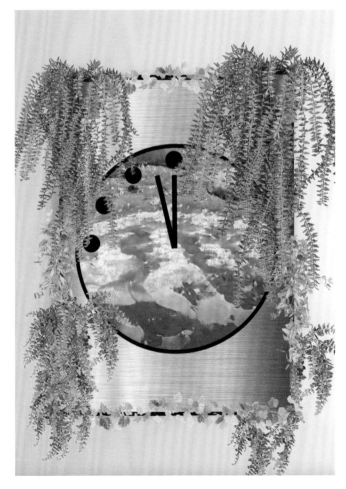

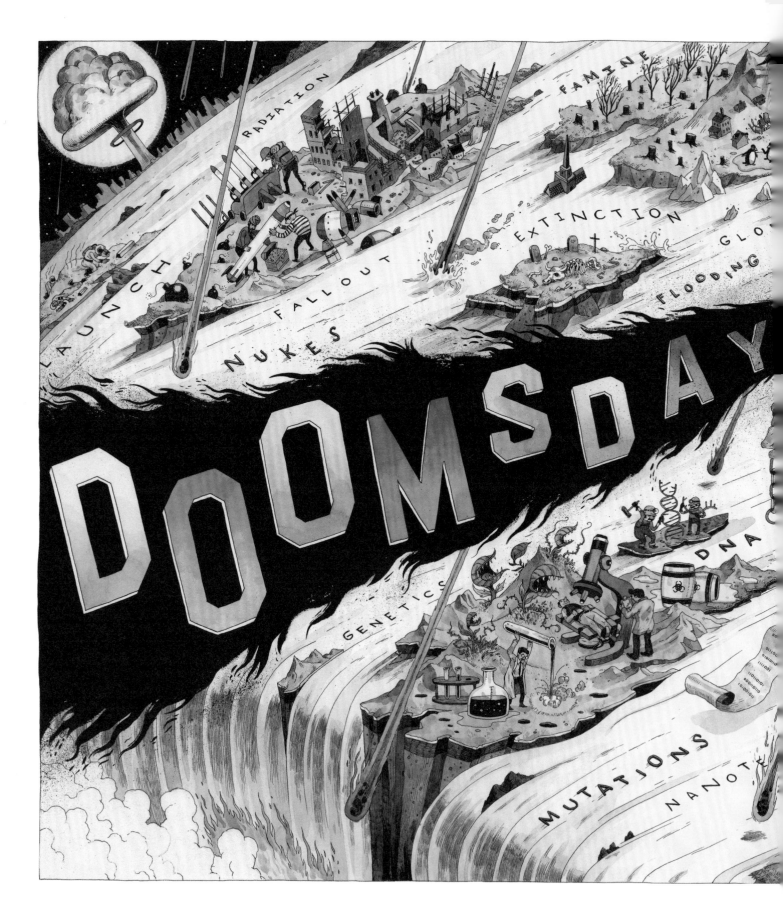

Doomsday

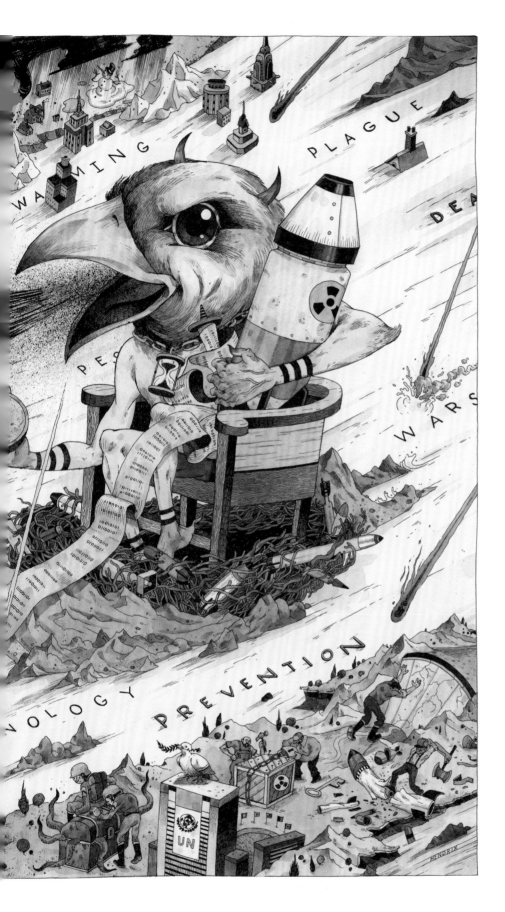

John Hendrix's illustration *Doomsday* was featured in the January/February 2007 issue of *Bulletin of the Atomic Scientists*.

Doomsday was also one of 500 illustrations chosen by the Society of Illustrators to be featured in their newest compilation, *Icons & Images: 50 Years of Extraordinary Illustration*. The images for the collection were chosen by a committee from a pool of 25,000 images featured in annual magazines since 1958.

"Drawing for a living is always enjoyable, but being able to make a bizarre and imaginative drawing while also serving the greater mission of the *Bulletin* is really as good as it gets in our business," said Hendrix. "Since publication, the image has been often referenced by other art directors, calling about new potential disasters."

John Hendrix, *Doomsday*, 2007

"We tend to act like the
Doomsday Clock has
a snooze button." —Batman

The Doomsday Clock in Pop Culture

By Robert K. Elder

Ben Affleck as
Bruce Wayne/Batman
in *Justice League*,
Warner Bros., 2017

How do you know that you're an indelible part of pop culture?

When Batman talks about you.

That's what happened in 2017's *Justice League* movie, when Ben Affleck—as Bruce Wayne/Batman—tells Wonder Woman, "We tend to act like the Doomsday Clock has a snooze button."

The "we" in question is humanity, of course.

The Doomsday Clock has been name-checked all over—as the answer in both a *New York Times* crossword puzzle and in the original Trivial Pursuit board game.

There was even a Doomsday Clock in a 1988 episode of the cartoon *Adventures of the Gummi Bears*, and it was used in punchlines for Canadian comedies *Kim's Convenience* (2017) and *Baroness von Sketch Show* (2018). Notably, the Clock received an unofficial digital redesign in *The Simpsons Movie* (2007, see page 21). In this section, we explore some of the weird, wonderful ways that the Doomsday Clock and its pop culture homages appear in music, movies, comics, television, literature, board games, and beyond.

The Clash: The Call Up

The Clash, "The Call Up,"
Sandinista!, **CBS, 1980**

This single off The Clash's *Sandinista!* triple album features the Doomsday Clock reference:

> At 55 minutes past eleven
> There is a rose

This anti-draft, anti-war song also featured the anti-nuclear B-side "Stop the World" from the British rockers.

Wah! Heat: Seven Minutes to Midnight

Wah! Heat, "Seven Minutes to Midnight," Inevitable Records, 1980

This 1980 single by Wah! Heat was released during an atmosphere of increasing nuclear paranoia and failing detente over Soviet involvement in Afghanistan, when the Bulletin moved the Clock forward two minutes, to the eponymous seven minutes to midnight.

Music

The Who: Why Did I Fall for That?

The Who, "Why Did I Fall for That?,"
***It's Hard*, Polydor, 1982**

The Who's album *It's Hard* taps into early 1980s nuclear anxiety. This song mentions the Doomsday Clock specifically.

```
Four minutes to midnight
on a sunny day
maybe if we smile
the clock'll fade away
maybe we can force
the hands to just reverse
```

Pink Floyd: Two Suns in the Sunset

Pink Floyd, "Two Suns in the Sunset,"
***The Final Cut*, Harvest, 1983**

This song is the closing track of Pink Floyd's album *The Final Cut* and was written by Roger Waters who was a songwriter, singer, bassist, and composer for the band. In June 2020, Waters released an updated, solo cover of this song in a series of "lockdown" sessions. The music video for this song starts off with a reference to the Doomsday Clock:

```
We're at one hundred seconds to
midnight on the doomsday clock.
This is the closest the Human Race
has ever been to nuclear catastrophe
```

Iron Maiden: 2 Minutes to Midnight

Iron Maiden, "2 Minutes to Midnight," EMI, 1984

British heavy metal band Iron Maiden released this song in 1984. The song rose to number 11 on the UK singles chart. Contrary to popular belief, it doesn't mention either 1980s Cold War tensions or the Cuban Missile Crisis but was instead inspired by hydrogen bomb tests in the 1950s.

```
2 minutes to midnight
The hands that threaten doom
2 minutes to midnight
To kill the unborn in the womb
```

Midnight Oil: Minutes to Midnight

Midnight Oil, "Minutes to Midnight,"
***Red Sails in the Sunset*, Columbia, 1984**

Midnight Oil's 1984 LP *Red Sails in the Sunset*, the cover of which shows an aerial view of Sydney after a nuclear strike, includes a song called "Minutes to Midnight."

```
I look at the clock on the wall
It says three minutes to midnight
Faith is blind when we're so near
```

"We had decamped to Japan to record our fifth album with the primal scream of the Cold War in full swing. There were literally tens of thousands of nuclear warheads primed to wipe humans off the face of the earth, so the record had a very strong anti-nuclear focus. One of the key tracks was 'Minutes to Midnight,' which, whilst summing up the stupidity of mutually assured destruction, exits with choruses proclaiming hope is our best weapon. Some of us visited Hiroshima, and what we saw there—unimaginable random destruction, followed by nuclear illness which lasted for generations—makes the current Treaty on the Prohibition of Nuclear Weapons a must-sign for all nations. Hopefully songs like this one can ring the bell loudly for a nuclear-free planet." —Peter Garrett, lead singer, Midnight Oil, 2021

Sting: Russians

Sting, "Russians," *The Dream of the Blue Turtles*, A&M Records, 1985

A foreboding clock, reminiscent of the Doomsday Clock, appears throughout the 1985 music video for this song from Sting's debut solo album, *The Dream of the Blue Turtles*.

> There's no such thing as a winnable war
> It's a lie we don't believe anymore
> Mister Reagan says,
> "We will protect you"
> I don't subscribe to this point of view
> Believe me when I say to you
> I hope the Russians love
> their children too

Bright Eyes: Easy/Lucky/Free

Bright Eyes, "Easy/Lucky/Free," *Digital Ash in a Digital Urn*, Saddle Creek, 2005

In 2005, Bright Eyes released this song, which references a symbolic "atomic clock."

> I set my watch to the atomic clock
> I hear the crowd count down
> 'til the bomb gets dropped
> I always figured that
> there'd be time enough
> I never let it get me down

Smashing Pumpkins: Doomsday Clock

Smashing Pumpkins, "Doomsday Clock," *Zeitgeist*, **Martha's/Reprise, 2007**

This is the opening track on Smashing Pumpkins' album *Zeitgeist*. Billy Corgan, the lead singer, primary songwriter, and guitarist of the band, explained why the song was inspired by the Doomsday Clock.

"If you want to understand the Doomsday Clock inspiration, it's simple ... I'm an American. Being an American right now, that is my experience. I feel like I'm watching something ticking down ... I don't know what's ticking down, I don't know why it's ticking down, I don't know who is moving the hands on the Clock ... but I certainly feel like an observer."
—Billy Corgan, AT&T Blue Room, July 2007

Linkin Park: Minutes to Midnight

Linkin Park, *Minutes to Midnight*, **Warner Bros. Records, 2007**

The title of Linkin Park's third studio album, *Minutes to Midnight*, is a reference to the hands of the Doomsday Clock. At the time the album was released in 2007, the Clock stood at 5 minutes to midnight.

"Hoping to continue its colossal success, the group spent more than a year working on *Minutes to Midnight*— a reference to the Doomsday Clock—writing over 100 demos and eventually settling on 12 tracks that [Mike] Shinoda describes as a 'breakthrough in the development of the band's sound,'" wrote Dana Rodriguez in a 2007 article for *Broadcast Music*.

Flobots: The Circle in the Square

Flobots, "The Circle in the Square," Shanachie, 2012

In 2012, Flobots released this song, which referenced the Doomsday Clock's setting that year.

> Whatever time it was when you began
> The clock is now 11:55 on the big hand
> So you're invited into the
> circle that we sleep in
> Invited to depend on friendships
> we deepen
> To uncover the secrets in the
> [breath] that we're bleepin'
> The treasure maps we pretend
> we do not believe in

Hozier: Wasteland, Baby!

Hozier, "Wasteland, Baby!," Rubyworks/Island, 2019

Hozier explained at a concert in Reno that this song—as well as the entire 2019 album of the same name—was inspired by the Doomsday Clock moving to two minutes to midnight.

"[I] was writing much of this album in mid-2016... it was kind of a funny time... I'm not sure if you're familiar with the Doomsday Clock... but it moved forward two minutes to midnight, which is generally considered not a good thing. So, for the hell of it, I was writing a few love songs for the end of the world." —Hozier, December 2019

Bastille: Quarter Past Midnight

Bastille, "Quarter Past Midnight," *Doom Days*, Virgin EMI, 2019

Not only did this British band call its third album *Doom Days*, its concert tour poster also evokes the Doomsday Clock design. Lyrics include:

> Tick tock
> You're running out of time
> 12 o'clock is check out time
> Time to get out
> To run and hide
> Or turn around
> And hold your ground

Snowy ft. Jason Williamson: Effed

Snowy ft. Jason Williamson, "EFFED," *Doom Days*, Virgin EMI, 2019

One minute to midnight on the Doomsday Clock is heavily referenced in this song by Snowy and Jason Williamson. This track was later championed by a number of BBC Radio DJs, including Iggy Pop.

> I can tell something ain't right
> It's one minute to midnight

Editor's note: the Clock has not been moved to one minute to midnight in its 75-year history.

Bastille's "Still Avoiding Tomorrow Tour" poster from 2019 evokes the Doomsday Clock.

International Composition: In Our Time

Cras, *In Our Time*, January 2020, Copenhagen, Denmark

"Art should hold up a mirror to the world and make us think about ourselves in new ways," said Henrik Bay Hansen, one of the six members of CRAS. "That is exactly what the Doomsday Clock does."

CRAS is an ensemble of six guitarists from Copenhagen, who found inspiration in the 2019 announcement that the Doomsday Clock remained at two minutes to midnight.

"Listening to the news on the radio and learning about the Doomsday Clock, we realized that in a way the Clock itself is the 'perfect' piece of art: It is simple and recognizable, and it tackles its topic in the most direct manner," Hansen said.

Weeks before, someone in the ensemble suggested the idea of developing an "endless" piece of music, and "while the concept in itself sounded interesting from an artistic point of view, we thought that it would never work, because how do you play music that never ends without making it boring and disengaging to the audience?"

The Doomsday Clock announcement in 2019 offered a solution. Hansen explains: "We immediately felt that this was a great opportunity to do a project where our music could interpret the times we live in and the challenges that we face as human beings. That day our ongoing and potentially endless musical endeavour, *In Our Time*, became a reality. The core of the project is that, since taking care of our planet should be a transnational collaboration, different composers from all over the world would write new pieces of music (we call them chapters) whenever the time changes. Every chapter should continue right where the previous one ended, making it sort of an artistic relay race, where the composers find inspiration in the current state of the world."

Wanting to start the project at "the birthplace of the bomb," CRAS chose the New Mexico-based composer, José-Luis Hurtado, to write the first chapter. That piece, titled "Two Minutes to Midnight on the Doomsday Clock," was performed in January 2020 in an old Cold War bunker just outside of Copenhagen.

In 2020, CRAS turned to the former Eastern Bloc and Lithuanian composer Rūta Vitkauskaitė, whose piece "BYOYOMI (100 Seconds to Midnight)" was performed on Hiroshima Day 2020 as a tribute to the victims of the first nuclear bomb.

"The Doomsday Clock was an inspiration to us as both human beings and artists," Hansen said. "*In Our Time* is all about merging science and art, and in doing so we hope to touch people, to inspire, and to bring a new perspective on the things that are relevant to anyone."

Moving forward, Hansen said, every time the Bulletin of the Atomic Scientists sets the Doomsday Clock, a new musical "chapter" will be added to this ongoing creative process. Over time, different composers from every part of the world will contribute to *In Our Time*, each one taking over where the previous one ended, Hansen said, "so that ultimately we'll have one long, uninterrupted piece of music that goes on forever." — Robert K. Elder

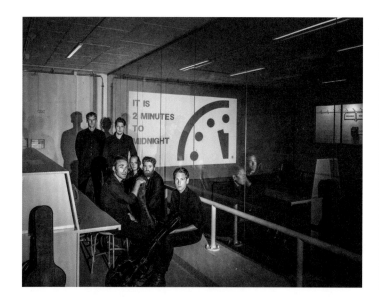

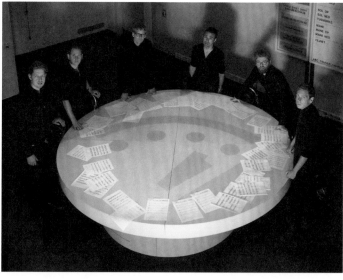

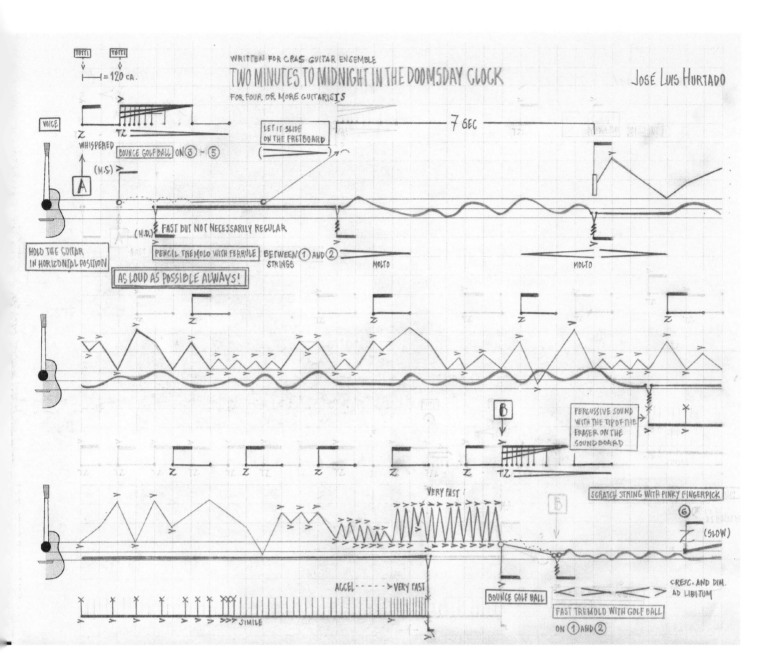

José-Luis Hurtado,
"Two Minutes to Midnight
on the Doomsday Clock,"
Manuscript, 2020

Performance location in
a Cold War bunker just
outside of Copenhagen.

Dr. Strangelove

Stanley Kubrick (dir.), *Dr. Strangelove or: How I Learned to Stop Worrying and Love the Bomb*, Columbia Pictures, 1964

By Robert K. Elder

In 1960, as nuclear-armed B-52 bombers continuously flew on high alert above the US, film director Stanley Kubrick read about the dangers of nuclear proliferation as a subscriber to the *Bulletin of the Atomic Scientists*.

That year, the *Bulletin* reviewed author Peter George's novel *Red Alert*, a novel about a rogue US Air Force general who launches a solo nuclear attack on Russia.

"*Red Alert*," the *Bulletin* declared, is "one of the niftiest little analyses" of real-world nuclear strategy and mishaps. "If an accident, or a bit of mischief, or a false alarm, or a misunderstanding, can lead to war but not necessarily, what makes the difference, if anything, other than luck?"

Red Alert inspired Kubrick to make *Dr. Strangelove or: How I Learned to Stop Worrying and Love the Bomb* (1964), a dark comedy about all-out war triggered by human folly. Kubrick's irreverent approach helped millions of viewers to confront their fears, and to talk and think about the unthinkable.

Kubrick's dark satire *Dr. Strangelove* follows a psychotic US Air Force general who deliberately sets out to start a nuclear war. In the film, American leaders are unable to reverse the fictional General Jack D. Ripper's order to bomb Russia. Russian leaders, meanwhile, can't deactivate their "doomsday machine," a giant bomb that automatically explodes when incoming missiles are detected. Each side follows the logic of mutually assured destruction; neither can prevent a global catastrophe.

"The most realistic things are the funniest. Laughter can only make people a little more thoughtful," Kubrick said in 1964.

But there was a darker edge, as well. Kubrick wasn't comforted by the turning back of the Doomsday Clock (from two, then seven, then 12 minutes to midnight) in the early 1960s, observed Peter Kramer in his 2014 book about the production for the British Film Institute's Film Classics series.

Kramer observed that, even though the Doomsday Clock was moving in a hopeful direction, Kubrick highlighted in his production notes that "many scientists, politicians, and philosophers continued to predict humanity's nuclear self-destruction 'by 1970.'"

Kubrick explained this worldview to *Cosmopolitan* magazine in 1963, talking about his worry that an accident or inadvertent use of a nuclear weapon posed a great risk to humanity.

"If the system was safe 99.99 percent of the days of the year, given average luck, it would fail in 30 years," Kubrick said.

Dr. Strangelove—powerful, zany, and perfectly in sync with the times—quickly caught fire in the public's imagination. Its influence even extended to the 1964 presidential election.

While *Dr. Strangelove* played in US movie theaters, US President Lyndon B. Johnson ran for re-election. Earlier in the campaign, his opponent Barry Goldwater suggested using low-yield nuclear weapons to defoliate forests and destroy supply lines in the war against North Vietnam.

In response, Johnson framed the election as a vote about nuclear policy and highlighted Goldwater's views in campaign ads. Suddenly, voters began to view Goldwater in a much darker light, and Johnson won by one of the biggest landslides in US history.

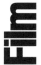
Film

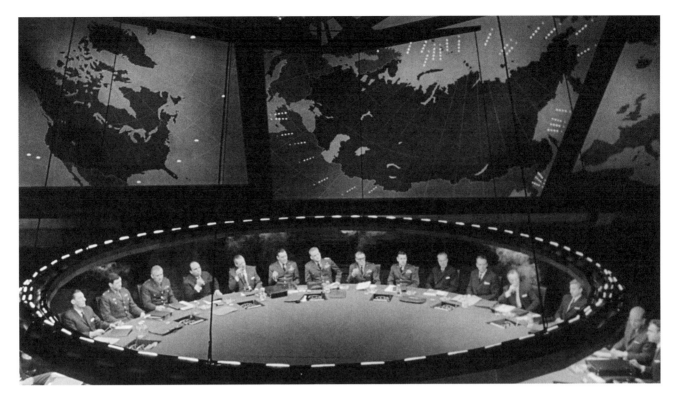

The War Room in *Dr. Strangelove*

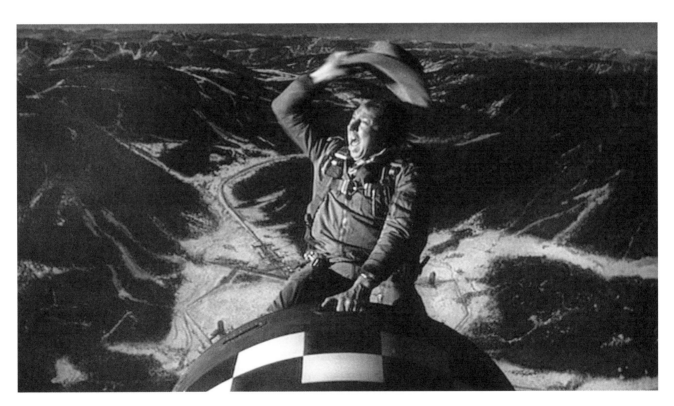

Slim Pickens riding a nuclear bomb in the
final moment of *Dr. Strangelove*

Jimmy Kimmel Live!

Jimmy Kimmel Live!, ABC, January 24, 2020

Televison

On late-night TV, *Jimmy Kimmel Live!*—in both 2020 and 2021—produced comedy segments after the new Doomsday Clock time was announced.

"Oh my God, someone stole three-quarters of the Clock!" Kimmel quipped in 2020, making reference to the quarter-clock design. "It's more like a Doomsday Speedometer. Why is it still analog?" Kimmel continued offering advice: "If you want to raise awareness of the fact that we are on the verge of extinction, you have to do more. Like why not make it a live television event?"

He then rolled tape on a proposed "Rockin' Doomsday Eve" with musical guests Post Malone, BTS, and Kim Jong-un, among others. "As the Clock strikes midnight, the ball drops on everyone!" says the announcer, over images of a mushroom cloud and a tornado.

Thanks for the advice, Jimmy. We're trying. We really are. Keep the advice coming.

The Late Show
with Stephen Colbert

The Late Show with Stephen Colbert, CBS, 2016

On Jan. 28, 2016, the Doomsday Clock made it into the opening monologue of *The Late Show with Stephen Colbert*. "It is the only clock more terrifying than the one that wakes you up in the morning," said Colbert. Colbert was commenting on the Doomsday Clock's time, which remained at three minutes to midnight.

"Three minutes: Not good. Three minutes only leaves you enough time to brush your teeth and throw on last night's pants before the world ends," he said. But then Colbert changed tactics and offered a comedic ray of hope:

"Now the end of the world is scary, admittedly, but I just want to remind everybody that Doomsday— the Clock—is just based on tensions between people. And we can all do something to reduce tensions and help move the Clock back next year," Colbert said.

After which he encouraged everyone in his studio audience, and everyone watching at home, to "hug it out. It's about love."

"Because we're only here together on this planet for the blink of an eye," Colbert said. "And that was beautiful, what you just did. And now that we've made an intimate human connection, even if we don't affect the Doomsday Clock—I can now move the Late Show Orgy Clock to one minute closer to midnight."

Madame Secretary: "On the Clock"

Television

Zetna Fuentes (dir.), "On the Clock,"
***Madame Secretary*, CBS, 2016**

By John Mecklin,
Editor-in-Chief,
*Bulletin of the
Atomic Scientists*

In the early 2000s, David Grae was looking for ideas. He'd been trying to break into television writing and needed a "spec script"—a sample episode he could send to producers, agents, and other Hollywood gatekeepers to show what he could do. He'd been playing around with plots for *West Wing*, the NBC White House drama then beloved by viewers, critics, and most of the country's political commentariat, when he got a phone call from his brother, Seth. An attorney and an energy expert, Seth advised governments around the world on the financing and operation of nuclear power plants. He also sat on the governing board for the Bulletin of the Atomic Scientists.

During their conversation, David said, his brother mentioned something called the Doomsday Clock. Each year, a group of Bulletin experts decides where to set the Clock's minute hand, based on their evaluation of the world security situation, particularly in regard to nuclear war and climate change. It was the first David Grae had heard of the Bulletin or its Clock.

"I thought it was an interesting, cool thing, this idea of a Doomsday Clock. How close are we to utter nuclear Armageddon, or any kind of Armageddon? So I used it in that spec script, which did well for me," Grae said. "I ended up getting work off it. But then I kind of forgot about it."

Spec scripts are seldom produced, and Grae's Doomsday Clock script never became a

West Wing episode. Still, it helped him start and build a television career that has included work on a series of prominent shows, the first of which was *Joan of Arcadia*, a fantasy drama that had a Maryland teenager executing assignments from God and thereby improving the world in some unpredictable (except by God) way. David was hired onto *Joan* by its creator, Barbara Hall.

Some 12 years later, Grae was again working with Hall, this time on the hit CBS drama *Madam Secretary*, which plays out the daunting public and private dramas that an extraordinarily honorable female US Secretary of State must confront, it seems, on a weekly basis. Grae and Hall had teamed up to write an episode with a main storyline that involved a Pakistani military aircraft that had crashed inside India—with a hydrogen bomb on board. The Pakistani prime minister wanted a technical team from his country to disarm the bomb and bring it home. The Indian prime minister wanted a team from his country to disarm the bomb and not even consider giving it back to the Pakistanis. Secretary of State Elizabeth McCord (aka actress Téa Leoni) wanted to broker a solution.

But this episode of *Madam Secretary* needed something more than India-Pakistan compromise; it needed subplots. As with many "serious" television series, each episode of *Madam Secretary* ordinarily includes three subplots—story A, story B, and story C, in television lingo—twined around one another in a way that pulls viewers along through the whole of the episode. In this case, the Pakistan-India faceoff was story A; a continuing tale about

The Doomsday Clock in Pop Culture 140

terrorism was story C. Hall and Grae needed a B story. "So again, that story—which you know my brother suggested, 'Why don't you do something with the Doomsday Clock?,' all those years ago—it made perfect sense to us," Grae said. "It was easy to weave into this larger story that we had conceived."

The episode that eventually resulted was called "On the Clock"; in its 42 minutes of airtime, the Pakistan-India story and a terrorism subplot circle an unlikely conceit: President Conrad Dalton (Keith Carradine) has gotten word that the Bulletin of the Atomic Scientists intends to move the Doomsday Clock's minute hand closer to midnight, indicating the world had gotten more dangerous, which could hurt the president politically. And President Dalton is entering an election year.

So he assigns the Secretary of State the task of persuading the Bulletin's scientists not to move the Clock (as she also, of course, brokers a deal resolving the Pakistani nuclear bomb stranded in India).

When "On the Clock" aired in March 2016, Bulletin staffers were of course happy with the publicity it provided the organization. In real-world terms, however, the episode was as flagrantly preposterous as network television often can be. It is unrealistic, at the least, to think that State Department officials would spend great amounts of time and effort lobbying a small nonprofit magazine about the setting of a metaphorical clock. To have the climax of that lobbying take place at a Bulletin party full of dancing atomic scientists—a party described as a "rager," no less—is fantasy of epic proportions, even for Hollywood.

Doctor Who: "Four to Doomsday"

Televison

John Black (dir.), "Four to Doomsday,"
***Doctor Who*, British Broadcasting Corporation, 1982**

Peter Davison, the fifth actor to play the epony-mous Doctor, made his debut in this four-episode alien invasion story arc. Here, the ticking-clock narrative is fueled by the frog-like alien Urbankan Monarch, who threatens to exterminate humanity with a lethal toxin—all so he can steal minerals and repopulate the Earth with his own race of aliens. The "four" in the title is the number of days left until Monarch reaches our planet, which will mark "doomsday" for humans. Oh, and there's an interstellar dance party at the climax of the episode, which the Doctor uses as a distraction to save mankind. Longtime *Doctor Who* writer Terrance Dicks would also release a novelization of the story in 1983, published by Target Books.

John Bellairs, *The House with a Clock in Its Walls*, Puffin, 1973

This Gothic mystery novel featured illustrations by Edward Gorey and was aimed at juvenile readers. The book follows a 10-year-old boy named Lewis, who discovers that a "doomsday clock" is hidden in his Uncle Jonathan's creaky Michigan house. Lewis learns that this magical clock could destroy the world—so he must find and smash the clock first.

 The House with a Clock in Its Walls was the first of 12 eventual books in a series and would later be adapted for television (*Once Upon a Midnight Scary*, an anthology show hosted by Vincent Price in 1979), and as a full-scale movie in 2018, directed by Eli Roth and starring Jack Black, Kyle MacLachlan, and Cate Blanchett.

Helen McCloy, *The Imposter*, Mead, 1977

In this tale of espionage and laser weapons, a young woman wakes up in a psychiatric clinic after surviving a near-fatal car crash. The Doomsday Clock becomes an integral part of the plot—and is even used to decode a secret message, all while serving as a symbol of Cold War tensions.

 McCloy's protagonist is haunted by the possibility the world has already ended, that "Midnight has already struck."

 But she ultimately decides to be more hopeful: "There was nothing to worry about. Midnight was not going to strike on the Doomsday Clock or any other cosmic timepiece. The world has lived for a generation since Hiroshima. The survival instinct was too stubborn to permit species suicide. Human beings were not going to throw away something it had taken four million years to build."

Piers Anthony, *Wielding a Red Sword*, Del Rey Books, 1986

In this fourth installment in Piers Anthony's *Incarnations of Immortality* book series, an Indian prince runs away to join the circus to escape an arranged marriage. Mym, our Indian hero, falls in love, is tempted by Satan and becomes the living incarnation of War, which makes him a very busy man. One of the tools of his office, in addition to the time-stopping Red Sword, is the Doomsday Clock—a giant clock that predicts the upcoming, and possibly preventable, apocalypse.

Books

The Tommyknockers

Stephen King, *The Tommyknockers*, Putnam, 1987

In Stephen King's paranoia- and alien-infused 1987 sci-fi novel *The Tommyknockers*, a twisted version of the Doomsday Clock shows up as the "Black Clock," an invention of The Union of Concerned Scientists—not the Bulletin of the Atomic Scientists.

It still serves the same function, as protagonist James "Gard" Gardener finds himself immune to the effects of a mysterious object in the woods (read: a buried spaceship). The steel plate in Gard's head protects him as his small-town neighbors are slowly being turned into something more than human.

All the while, Gard watches the geopolitical situation on Earth get worse: "In spite of his dull fury at the insanity of nuclear power and the energy-swilling technocratic pigs who had created it and underwritten it and refused to see its dangers even in the wake of Chernobyl, in spite of his depression at the AP wire photo of the scientists advancing the Black Clock to two minutes before midnight, he fully recognized the possibility that destroying the ship might be the best thing he could possibly do."

Elsewhere in the 558-page book, King writes, "The Mideast was getting ready to explode again, and if there was shooting this time, some of it might be nuclear. The Union of Concerned Scientists, those happy folks who kept the Black Clock, had advanced the hands to two minutes to nuclear midnight yesterday, the paper reported."

In 1987, the hands of the Doomsday Clock stood at three minutes to midnight.

The novel was adapted into a two-part TV movie on ABC starring Jimmy Smits (*L.A. Law, NYPD Blue*) as Gard, which aired in 1993.

Books

Goodnight Trump

Erich Origen and Gan Golan,
***Goodnight Trump: A Parody*, Little,**
Brown and Company, 2018

The Doomsday Clock makes a cameo in Gan Golan and Erich Origen's *Goodnight Trump*, (2018) a parody of the bestselling children's book *Goodnight Moon*.

"The Doomsday Clock has infiltrated such a broad array of cultural spaces over the last seven decades," said Golan. "It is a perfect example of how one can translate science into compelling public messaging, which can then be inserted into popular culture and political discourse. It was a meme before we knew what memes were."

Origen isn't entirely sure when they decided to include the Doomsday Clock in *Goodnight Trump*, but he said, in hindsight, it makes sense for a few reasons.

1 "There is a clock in *Goodnight Moon*, and its hands move as the reader moves through the book," Origen said.

2 "With *Goodnight Trump*, the Doomsday Clock seemed appropriate because we (and Trump) were suddenly talking about nuking people again, as if it were a game we could win," Origen said.

3 "Pairing Doomsday Clock with the words 'global climate shock' seemed like a good way to remind people that amidst the daily onslaught of outrage, a more serious threat to our survival loomed in the background," Origen said. "In a strange way, the Doomsday Clock brings that story full circle, to the point where the only way we can comprehend what's happening within nature is to see it represented as a clock."

For Golan, the connection is even more direct, as he also serves as the creative director of the Climate Clock, which "melds art, science, technology, and grassroots organizing to get the world to #ActInTime" according to the project's website, climateclock.world.

"[The Doomsday Clock] served as inspiration for the Climate Clock, although we often have to convince people ours is NOT a doomsday clock (which speaks to the enduring power of the Bulletin's Clock)," Golan said.

The Doomsday Clock and its imagery have appeared throughout multiple incarnations of DC Comics' seminal *Watchmen* property—not only the original 1986–1987 comic book series, but also a movie adaptation, a TV series and a sequel comic book series titled, aptly enough, *Doomsday Clock*.

The Doomsday Clock makes headline news in *Watchmen* #1, 1986.

The Doomsday Clock in Watchmen

By Robert K. Elder

From the start, the Doomsday Clock was an explicit part of the *Watchmen* universe.

"If the Doomsday Clock in our own world stands at five minutes to twelve, then in the world we're talking about the big hand is just a fraction of a second away from midnight," wrote Alan Moore in his original script for the ground-breaking *Watchmen* comic book series, which debuted in 1986.

The series, a post-modern meditation on superheroes and humanity's penchant for self-destruction, would spawn a movie adaptation (2009), an HBO miniseries (2019), and several spin-off comics, including DC Comics' *Doomsday Clock* (2017–2019).

Yet it all begins with that first issue, in *Watchmen* #1—when the murder of a former costumed hero coincides with international tensions that are leading the US and Soviet Union into an atomic war. On one page, a newspaper headline reads, "Nuclear Doomsday Clock stands at five to twelve."

Dave Gibbons, who illustrated the original comics, remembers the very real Cold War tensions that fueled the story. "The question of nuclear war being quite imminent, it was a real concern. I—and a lot of people I knew—worried about it."

Gibbons continued, "I didn't do any particular research into the Clock. But sadly, it fit brilliantly into the narrative that we had."

Leslie S. Klinger, author of *The Annotated Watchmen*, said that those worries permeated the series and its iconography.

Doomsday Clock cover, DC Comics, 2019

Watchmen movie teaser poster, Paramount Pictures, 2009, featuring the iconic smiley button with its blood spatter that, if viewed as a clock face, roughly marks five minutes to midnight, an implied echo of the Doomsday Clock

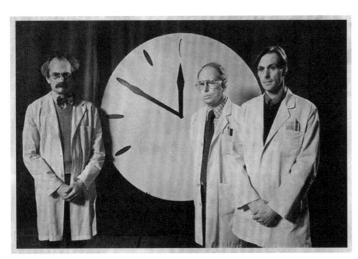

Above:
Watchmen movie promotional material, Zack Snyder, 2009

Left:
The Doomsday Clock makes an appearance in issue #2 of DC Comics' *Doomsday Clock*, 2017

"They were writing this at a time when the Clock was at about three minutes to midnight. People were very aware of doom hanging over our heads. And the Clock was a beautiful way to symbolize that. And so they grabbed the image. There are explicit references to the Doomsday Clock in *Watchmen*. And yes, they use the Clock repeatedly in the book without necessarily mentioning that it's the Doomsday Clock, because there's a lot of images of clocks," Klinger said.

The original series even adopted a clock face motif on its back covers, as the 12-issue series counted down to a cataclysmic event, symbolized by blood running down the page and dripping onto a clock approaching midnight.

Imagery of the Doomsday Clock is even more prominent in subsequent versions of *Watchmen*. Zack Snyder's movie adaptation, and its marketing materials, feature forlorn scientists in white lab coats in front of a physical Doomsday Clock—which references the *Bulletin*'s annual press conference

Watchmen promotional poster, HBO, 2019

148

FROM THE VISIONARY DIRECTOR OF '300'

WATCHMEN

WARNER BROS. PICTURES AND PARAMOUNT PICTURES PRESENT

IN ASSOCIATION WITH LEGENDARY PICTURES A LAWRENCE GORDON/LLOYD LEVIN PRODUCTION A ZACK SNYDER FILM "WATCHMEN" MALIN AKERMAN BILLY CRUDUP MATTHEW GOODE CARLA GUGINO
JACKIE EARLE HALEY JEFFREY DEAN MORGAN PATRICK WILSON MUSIC BY TYLER BATES EDITED BY WILLIAM HOY A.C.E. PRODUCTION ALEX McDOWELL RDI DIRECTOR OF PHOTOGRAPHY LARRY FONG EXECUTIVE PRODUCERS HERBERT W. GAINS THOMAS TULL
BASED ON THE GRAPHIC NOVEL DAVE GIBBONS AND PUBLISHED BY DC COMICS SCREENPLAY BY DAVID HAYTER AND ALEX TSE PRODUCED BY LAWRENCE GORDON LLOYD LEVIN DEBORAH SNYDER DIRECTED BY ZACK SNYDER

03.06.09

WWW.WATCHMENMOVIE.COM

announcing the time (minus the lab coats). That image is later updated in the *Doomsday Clock* #2 comic book. The HBO series would also prominently feature a yellow clock in its poster and marketing images. The Doomsday Clock resonates in *Watchmen* stories perfectly, given the themes of time and existential dread throughout the different adaptations.

Even stranger, Gibbons says, are the historical echoes of the series. For this we should issue a spoiler alert, because the original *Watchmen* series culminates in a villain engineering a fake alien invasion—and an attack that kills millions in New York City—which halts the United States and Soviet Union from engaging in nuclear war. While some critics recognize a similar plot for an episode from TV's *Outer Limits* (1963's "Architects of Fear"), Gibbons was also shocked to hear that President Ronald Reagan and Soviet Premier Mikhail Gorbachev discussed an alien invasion in 1985.

On a 2009 episode of the talk show *Charlie Rose*, Gorbachev recounted this story from the Lake Geneva summit:

> "From the fireside house, President Reagan suddenly said to me, 'What would you do if the United States were suddenly attacked by someone from outer space? Would you help us?'

> "I said, 'No doubt about it.'"

> "He said, 'We too.'"

> "So that's interesting," said Gorbachev, who laughed after recounting the story.

"I think there's all these resonances," Gibbons says. "And the more you look at *Watchmen*, the more you will find resonances, the more clocks you will find."

Watchmen No. 12, September, 1986. "When we had the smiley face, we wanted to have some blood on it. And I thought, 'Wouldn't it be great if that echoed how close the clock was to midnight?'" said artist Dave Gibbons.

Far right: The back cover of *Watchmen* #11, the penultimate issue of the original series.

In addition to the Doomsday Clock's impact on the *Watchmen* series, the Clock also shows up in other comics.

Detective Comics

Detective Comics #685, February 1995
In this issue, which writer Chuck Dixon titled "The Doomsday Clock," Bruce Wayne tries to regain his hold on Wayne Enterprises and his role as Batman after an injury. At the climax of the story, the big baddie—Soviet master assassin KGBeast—threatens to blow up Gotham City with a baseball-size nuclear bomb.

The title of the story, says Dixon, "was just a direct reference to a nuclear threat. It seemed evocative of what was going on in the story."

Dixon, a prolific writer of the Batman family of titles and co-creator of the villain Bane, grew up during the Cuban Missile Crisis, so the Doomsday Clock has personal resonance with him.

"We were all aware of what we felt was going to be an inevitable nuclear exchange with the Soviet Union," Dixon remembers. "There were drills and air raid shelters, and we were constantly being reminded in magazines, newspapers and television that we were living under this threat. All the kids I grew up with had nightmares about this happening. And so we lived with it."

"The Doomsday Clock," *Detective Comics* #682, February 1995

Comics

Title page from
"The Doomsday
Clock," *Detective
Comics* #682,
February 1995

Metamorpho

Metamorpho #2, October 1965

In this Cold War story, "Terror from the Telstar," Metamorpho—the Element Man—fights the nefarious Nicholas Balkan and his three sons. Balkan has constructed a planet-shaking Doomsday Clock, which turns out to be an actual Rube Goldberg-like clock whose ticking vibration will disrupt the Earth's magnetic field.

"I had intended to use it for global blackmail, but now I activated it to make sure you never make Nicholas Balkan face justice!" the villain explains. "We—and the whole world—die together ... ha, ha, ha!"

With quick thinking, Metamorpho transforms himself into a cobalt-tipped drill and burrows to the center of the Earth. He gums up this Doomsday Clock by becoming a "sulphur-calcium-carbon cocktail."

"It's stopping ... I've beaten it," Metamorpho says. "Old Earth's reprieved for a few more million years!"

Mind you, this was written in the years before climate change was a major concern.

Stranger in a Strange Land #2, 1990

Bruce Bolinger, best known for his work in *Cracked* magazine, published this series with Rip Off Press in the late 1980s and early 1990s.

Billed as "More stupid tales from that aging hippie lost ... somewhere ... deep in the Bible belt," this second issue opens with a full-page story titled "The Doomsday Clock."

Here, two friends decry the destruction of their favorite fishing hole by forest clear-cuts, pollution, acid rain, and global warming. These particular hundred acres of forest were used to make toilet paper for Toledo, Ohio. The punchline of the story is funny, ironic, and completely unprintable here.

Stranger in a Strange Land

Stormwatch

Stormwatch: Post Human Division #4, April 2007

In this story by Christos Gage, illustrated by Doug Manke, the villainous Ferryman attacks the Stormwatch team before he's bested by the sorceress Black Betty. It seems that the barrier between worlds has been weakened, prompting the Ferryman—a supernatural being who feeds on death—to search for the original Doomsday Clock.

"Over the decades, this Clock became the focus of so much primal fear that it acquired power," explains Betty. "If the hands were forcibly moved to midnight, it would cause a nuclear war."

She hands the Clock to Stormwatch leader John Doran, saying, "So put that somewhere safe, hmm?"

Writer Christos Gage said that he'd known about the Doomsday Clock growing up "during the Cold War," but "Watchmen definitely seared it into my memory."

The Clock ended up in his run on Stormwatch when he thought "about the idea of mass belief in something giving it power."

He says, "So, if enough people believe the Doomsday Clock striking 12 equals nuclear annihilation, that's actually what happens if you make it strike twelve—nuclear war. It seemed like a cool threat/MacGuffin."

For the uninitiated, the MacGuffin is a term popularized by Alfred Hitchcock. The MacGuffin is a plot device or object that drives the action and character motivation, much like the Infinity Gauntlet in the Avengers movies or Maltese Falcon in the Humphrey Bogart classic of the same name.

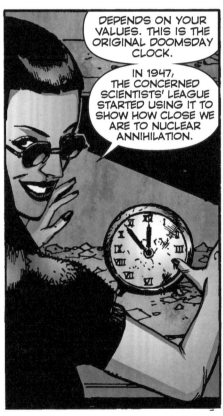

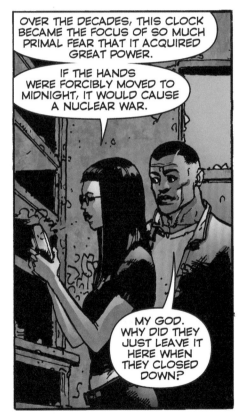

Batman: The Dark Knight Returns

**Batman: The Dark Knight Returns—
The Game, Cryptozoic Entertainment, 2021**

In 2021, game maker Cryptozoic Entertainment crowdfunded about $400,000 to launch *Batman: The Dark Knight Returns—The Game*, based on the famous story by artist and writer Frank Miller.

The Doomsday Clock is an integral part of the board and gameplay.

"As a Gen Xer, I grew up under the specter of nuclear destruction. The Doomsday Clock was the clearest, most iconographic representation of how close to the edge our society was pushing itself," said Morgan Dontanville, who co-designed the game with Daryl Andrews.

"By the end of Frank Miller's graphic novel, which the game is based on, the world is literally pushed to the brink of destruction," Andrews added. "They set off the bomb and it wreaks havoc worldwide."

Graphic designer Larry Strauss, part of the Cryptozoic creative team, said that they took a minimalist approaching in crafting the game's Doomsday Clock look to better complement, and stay out of the way of, the artistic styles of the original creators Miller, inker Klaus Janson, and colorist Lynn Varley.

"In designing the Doomsday Clock that plays such a prominent role in gameplay, the aesthetic needed to reflect the darkness and grit of the source material, as well as retain functionality within the game," said Strauss.

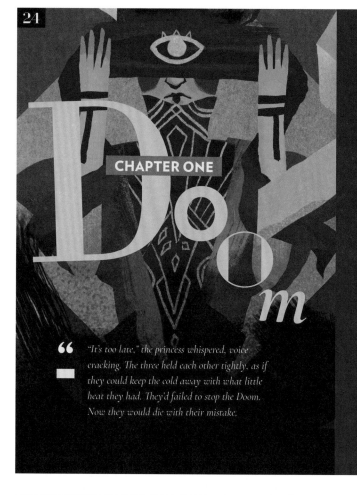

CHAPTER ONE

Doom

> ❝ *"It's too late," the princess whispered, voice cracking. The three held each other tightly, as if they could keep the cold away with what little heat they had. They'd failed to stop the Doom. Now they would die with their mistake.*

The **Doom** is a cataclysmic event threatening to upend the safety or comfort of the heroes or their people. In ARC, the heroes' goal is preventing this apocalypse.

The **DOOM** is determined by the **GUIDE** and players. It can be large in scope—for example, a world-sundering earthquake triggered by a goddess' death—or more intimate—a small village about to be overrun by blind, humanoid parasites.

DOOMS ADVANCE AT A TERRIFYING PACE EVEN WITHOUT PLAYER INTERVENTION: WAITING FOR NO ONE AND ALWAYS MOVING FORWARD.

C.
Building the
DOOMSDAY CLOCK

The **DOOMSDAY CLOCK** charts the apocalypse's inevitable approach, advancing every set time interval. Once it reaches its end the **DOOM** is unleashed.

The **DOOMSDAY CLOCK** is made up of discrete **MOMENTS**. Its speed and number depend on how long you intend to run the game.

NUMBER OF SESSIONS	NUMBER OF MOMENTS	DOOMSDAY CLOCK ADVANCES EVERY...
1	3 per hour of play	30 minutes
	Example: *for a 4-hour session, the DOOMSDAY CLOCK has 12 moments (4 x 3) and advances every 30 minutes.*	
2-3	1.5 per hour of play (round up)	hour
	Example: *for two 5-hour sessions, the DOOMSDAY CLOCK has 15 moments (10 x 1.5) and advances every 30 minutes.*	
4+	1.5 per session (round up)	session
	Example: *for 7 sessions, the DOOMSDAY CLOCK has 11 moments (7 x 1.5) and advances every session.*	

Every time the **DOOMSDAY CLOCK** advances **one moment** is consumed.

Afterwards, roll d6 equal to the number of **OMENS** still in play, advancing the clock once for every **5 or 6.**

> **For example,** let's say you're playing a one-session game. Thirty minutes after the game starts, you advance the **DOOMSDAY CLOCK** by one moment. If there are 3 **OMENS** left you then roll 3 dice. Let's say you roll 3, 4, and 5—you advance the **DOOMSDAY CLOCK** an additional moment for a total of 2 this instance.

A sample **DOOMSDAY CLOCK** for a 3-hour, single-session game. 2 moments have been consumed.

Draw the **DOOMSDAY CLOCK** on a large, dedicated sheet of paper or digital canvas. Make sure it is front and center so everybody can see the time slowly running out.

See **Appendix 4: Sample Doom** to see how the **DOOMSDAY CLOCK** is used.

ARC

Bianca Canoza, ARC, momatoes, 2021

The Doomsday Clock has a key role in ARC, a tabletop role-playing game (RPG) created by Manila-based designer Bianca Canoza. In 2021, she surpassed her Kickstarter goal and raised $89,563 from international backers to produce the game.

ARC players attempt to stave off the apocalypse before the Doomsday Clock expires and signals the end of the game. ARC utilizes a vividly designed character and storyline booklet to guide the experience.

"The Doomsday Clock in ARC serves as a mechanical indicator of time as well as an absolute and perhaps even moral imperative to act before all is lost," said Canoza, who designs games through her company, momatoes (which is creatively not capitalized).

In the ramp-up to the Clock's 75th anniversary, the Bulletin of the Atomic Scientists joined Threadless in asking artists for their own take. We were interested in designs that reimagine or redesign the Doomsday Clock, tell people how to "Turn Back the Clock," and incorporate our three areas of focus: Nuclear Risk, Climate Change, and Disruptive Technology.

Wearing the Doomsday Clock

By Robert K. Elder

In 2021, the Bulletin ran a Doomsday Clock T-shirt design contest hosted by Threadless.com, in an effort to reimagine the Clock and shed light on our issues of nuclear risk, climate change, and disruptive technologies.

Winner Nathan Doyle's design, *Time is Running Out*, was chosen from 353 submissions. The Bulletin received designs from all over the world, including entries from Indonesia, Costa Rica, the United Kingdom, the Philippines, India, and even Peoria, Illinois.

Doyle, a naval architect in Adelaide, Australia, said his image attempts to capture the "severity of man-made threats to our existence, and the ray of color aims to draw the viewer's attention, expressing hope."

The T-shirt design competition encouraged artists from around the world to either:

1 Reimagine or redesign the Doomsday Clock
2 Tell people how to Turn Back the Clock
3 Incorporate the Bulletin's three areas of focus: Nuclear Risk, Climate Change, and Disruptive Technology

Doyle won $1,000 for his design, plus a $250 Threadless gift certificate. He was invited to the Bulletin's virtual annual event.

"Thank you to the Bulletin of the Atomic Scientists and Threadless for running this competition and encouraging artists around the world," said Doyle. "I am extremely grateful that this design was selected from such a wide variety of thought-provoking designs to help commemorate the 75th anniversary of the Doomsday Clock."

What follows are some of the other submissions from the contest.

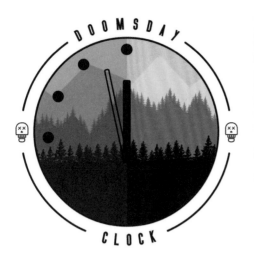

Doomsday Clock Forest
Dennis Vargas Calderón, Costa Rica

75 Years and Counting
Mulyana Yusuf, Indonesia

2 Clicks to Inferno
Vivek Akhani, India

Clock is Ticking
Evan Hatch, USA

Apocalypse in 100 Seconds
Sergi Morales, Uruguay

We Can Stop The Doom Clock
Enan Sunarya, Indonesia

DOOMSDAY CLOCK
for *Beginners*

DOOMSDAY CLOCK
EXPLAINED:

1. NUCLEAR ANNILATION
2. GLOBAL TECHNOLOGICAL DESTRUCTION
3. CATASTROPHIC CLIMATE CHANGE.

Not... Zombie Apocalypse . Alien Invasion . Continental Shift

Doctor Doomsday Robert Dale, USA

Doomsday Clock

100 Seconds To Death COVID-19
Apip Saepul Akbar, Indonesia

75 Years of Doom
Jeremy Martinez, USA

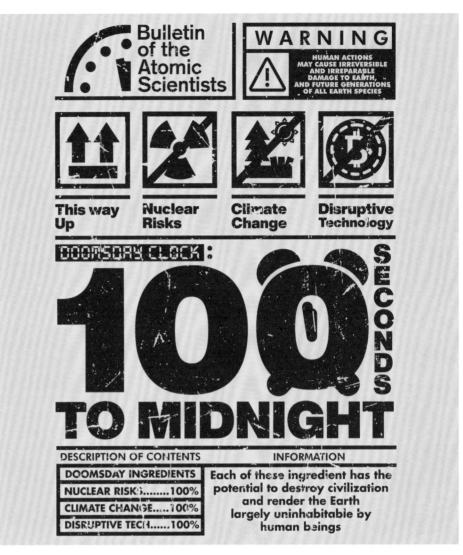

Warning From The Future
Aldrich Agdon / BVRDTO, Philippines

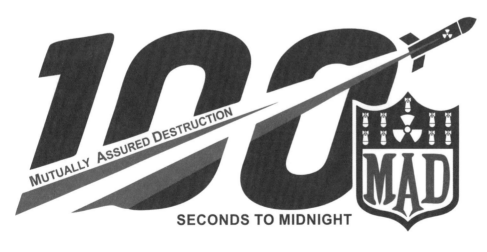

MAD
JurgisX, Mexico

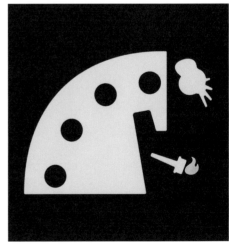

Big Shots
Eric Atkins, USA

By a Thread
Roy Spensley, United Kingdom

How's the temperature?

Testing the Water
Eric Atkins, USA

Wait... What?!
Justyn Charles, Antigua and Barbuda

Stop It!
Agum Gum, Indonesia

10 Degrees
Dave Barry, United Kingdom

Apocalypse Watch
John Tibbott, United Kingdom

Only Time Agus Hari Mulyanto, Indonesia

Earth Falling Roy Spensley, United Kingdom

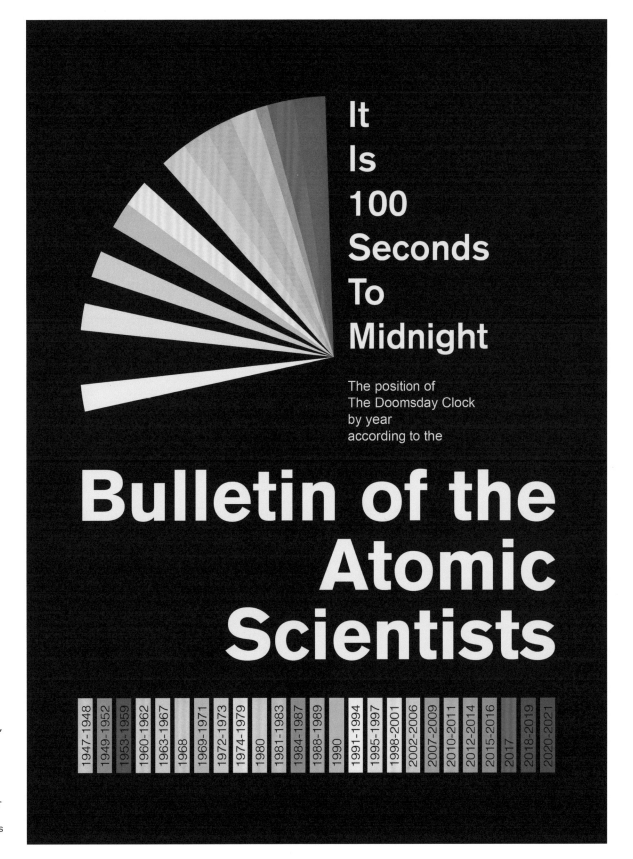

Phil Dodd,
*Doomsday Clock
Times*, 2020

Though not originally a T-shirt,
Dodd adapted his
design for the
Bulletin's merchandising shop.
Dodd's design is
an example of our
ongoing partnership with artists
and designers.

The Doomsday Clock is set every year by the Bulletin's Science and Security Board in consultation with its Board of Sponsors, which has included 40 Nobel laureates. The Clock has become a universally recognized indicator of the world's vulnerability to catastrophe from nuclear weapons, climate change, and disruptive technologies in other domains.

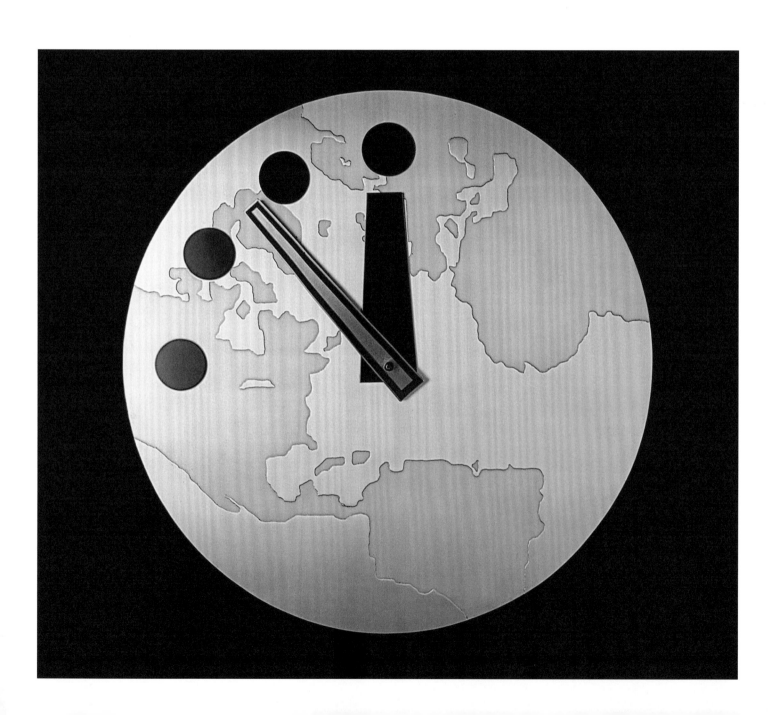

The Physical Doomsday Clock

By Robert K. Elder

For much of its history, the Doomsday Clock hasn't been a physical object. It's a metaphor that started as a magazine cover.

That's changed over the years, as the Clock has been used for the Bulletin of the Atomic Scientists' annual announcement of how close humanity is to self-annihilation. In the mid-2000s, poster board images of Pentagram and Michael Bierut's powerful redesign were employed.

The latest incarnation of the physical Doomsday Clock, complete with hands that move, is housed near the Bulletin's offices at the University of Chicago's Harris School of Public Policy.

Stephen Schwartz, the Bulletin's publisher and executive director from 1998 to 2005, remembers two versions of the physical Clock. One was a wooden, square replica of the Clock modeled on Martyl's original design. The other was a redesigned, circular, copper-colored Clock with a map of the world superimposed on its face.

"Martyl never liked this representation ... the US was too prominent or something like that. She didn't like it at all," Schwartz says. "She was never consulted about it. And I mean, the Clock wasn't hers at that point."

Although lost now, this metal Clock was 18 to 20 inches in diameter and weighed 15 to 20 pounds.

"If you dropped it, you could break your foot," Schwartz remembers.

Both of these early physical Clocks hung in the boardroom of the Bulletin's offices at 6042 S. Kimbark Ave. in Chicago, and were used for TV appearances, news conferences, and educational tours.

In 1999, Schwartz even traveled with the metal Clock—cradled in bubble wrap and carried in a shopping bag—for a History Channel segment in New York City. Sure enough, he was stopped by security when it went through the X-ray machine.

Schwartz introduced himself and gave a quick public tutorial about the Bulletin and the history of the Doomsday Clock.

"They could see, obviously, that it wasn't anything dangerous, but it was different looking. They listened and they said, 'Okay, thank you,' and they let me go on my way," Schwartz says.

Not all reactions were as subdued.

During one public tour, a junior high student asked, "Why couldn't you just move the hands further away from midnight and make the world safer?"

Schwartz says, "I wish it were that simple. But unfortunately, [it] simply reflects reality."

This circular copper-colored Doomsday Clock, used at the turn of the millennium, was one of two original physical representations of the Clock.

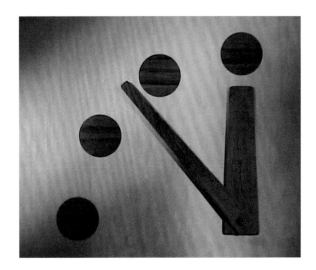

This wooden, square replica of the Doomsday Clock, modeled on Martyl Langsdorf's design, was one of two original physical representations of the Clock.

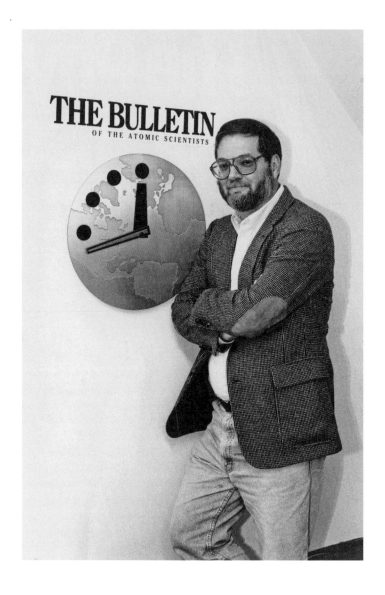

Mike Moore, editor of the *Bulletin of the Atomic Scientists* from 1991– 2000, at the University of Chicago in 1991 with a replica of the Doomsday Clock set at 17 minutes to midnight.

Physics Nobel Prize winner Leon M. Lederman, for- mer director of the Fermi National Accelerator Laboratory and Chair Emeritus of the Bulletin's Board of Sponsors, sets the Doomsday Clock to seven minutes to midnight in 2002.

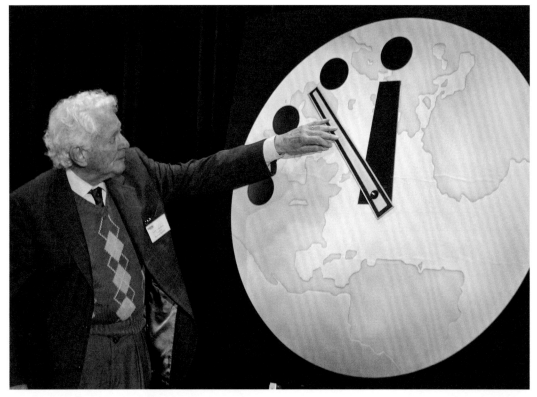

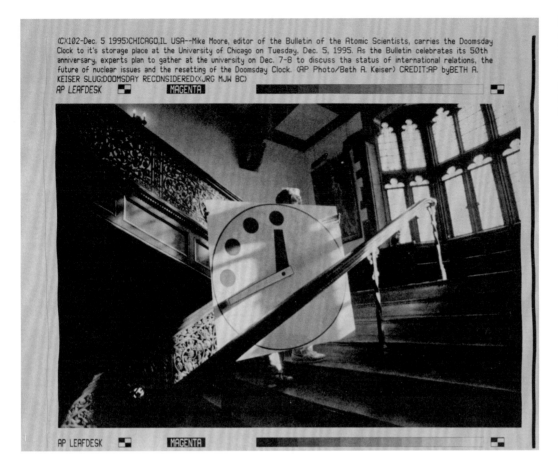

(CX102-Dec. 5 1995)CHICAGO,IL USA--Mike Moore, editor of the Bulletin of the Atomic Scientists, carries the Doomsday Clock to it's storage place at the University of Chicago on Tuesday, Dec. 5, 1995. As the Bulletin celebrates its 50th anniversary, experts plan to gather at the university on Dec. 7-8 to discuss tha status of international relations, the future of nuclear issues and the resetting of the Doomsday Clock. (AP Photo/Beth A. Keiser) CREDIT:AP byBETH A. KEISER SLUG:DOOMSDAY RECONSIDERED(XJRG MJW BC)
AP LEAFDESK MAGENTA

AP LEAFDESK MAGENTA

Mike Moore, *Bulletin of the Atomic Scientists* editor from 1991–2000, carries one of the first physical representations of the Doomsday Clock, a wooden replica, to a storage place in the University of Chicago in 1995.

Bulletin of the Atomic Scientists board chair and Manhattan Project member Leonard Rieser sets the Doomsday Clock to nine minutes to midnight in June 1998.

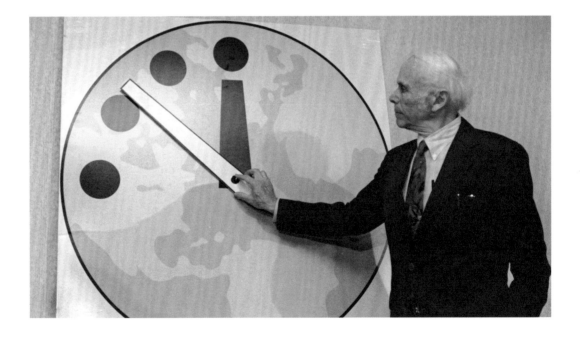

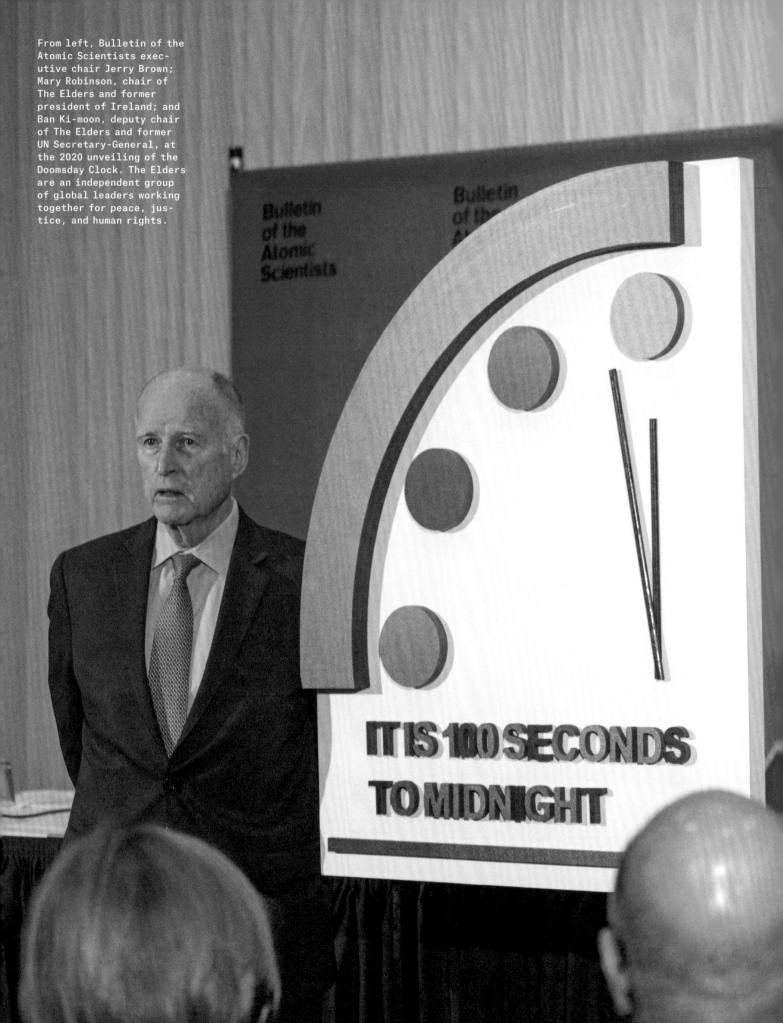

From left, Bulletin of the Atomic Scientists executive chair Jerry Brown; Mary Robinson, chair of The Elders and former president of Ireland; and Ban Ki-moon, deputy chair of The Elders and former UN Secretary-General, at the 2020 unveiling of the Doomsday Clock. The Elders are an independent group of global leaders working together for peace, justice, and human rights.

IT IS 100 SECONDS TO MIDNIGHT

Cosmologist and theoretical physicist Stephen Hawking at the 2007 Doomsday Clock press conference. Hawking, author of *A Brief History of Time*, participated in the international event from the Royal Society in London, held jointly with members of the Bulletin at the American Association for the Advancement of Science in Washington, DC.

That year, the Doomsday Clock moved from 7 to 5 minutes to midnight, the first time the time changed in five years.

"As scientists, we understand the dangers of nuclear weapons and their devastating effects, and we are learning how human activities and technologies are affecting climate systems in ways that may forever change life on Earth," Hawking said. "As citizens of the world, we have a duty to alert the public to the unnecessary risks that we live with every day, and to the perils we foresee if governments and societies do not take action now to render nuclear weapons obsolete and to prevent further climate change."

From left, Bulletin of the Atomic Scientists' Science and Security Board chair Robert Rosner, founding director of the Energy Policy Institute at the University of Chicago, and Science and Security Board member Suzet McKinney, then CEO/Executive Director of the Illinois Medical District, reveal the 2021 Doomsday Clock on Jan. 27, 2021. The time remained at 100 seconds to midnight.

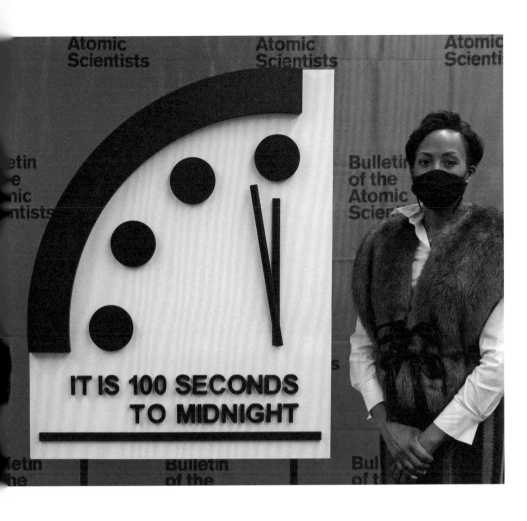

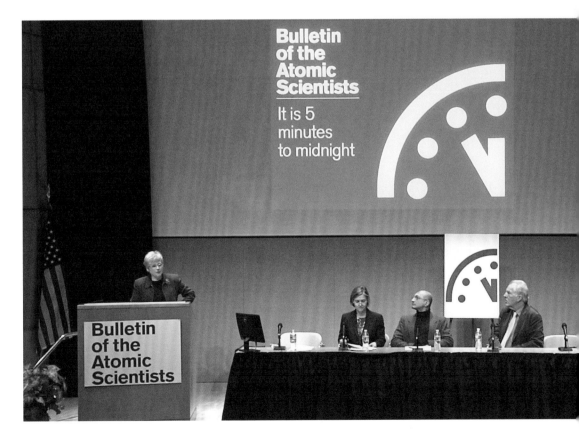

Bulletin executive director Kennette Benedict speaks at the 2015 setting of the Doomsday Clock from five minutes to midnight to three minutes to midnight.

She is joined by Science and Security Board members, from left, Sharon Squassoni, research professor at the Institute for International Science and Technology Policy; Sivan Kartha, senior scientist at the Stockholm Environment Institute; and Richard Somerville, climate scientist and distinguished professor emeritus at Scripps Institution of Oceanography.

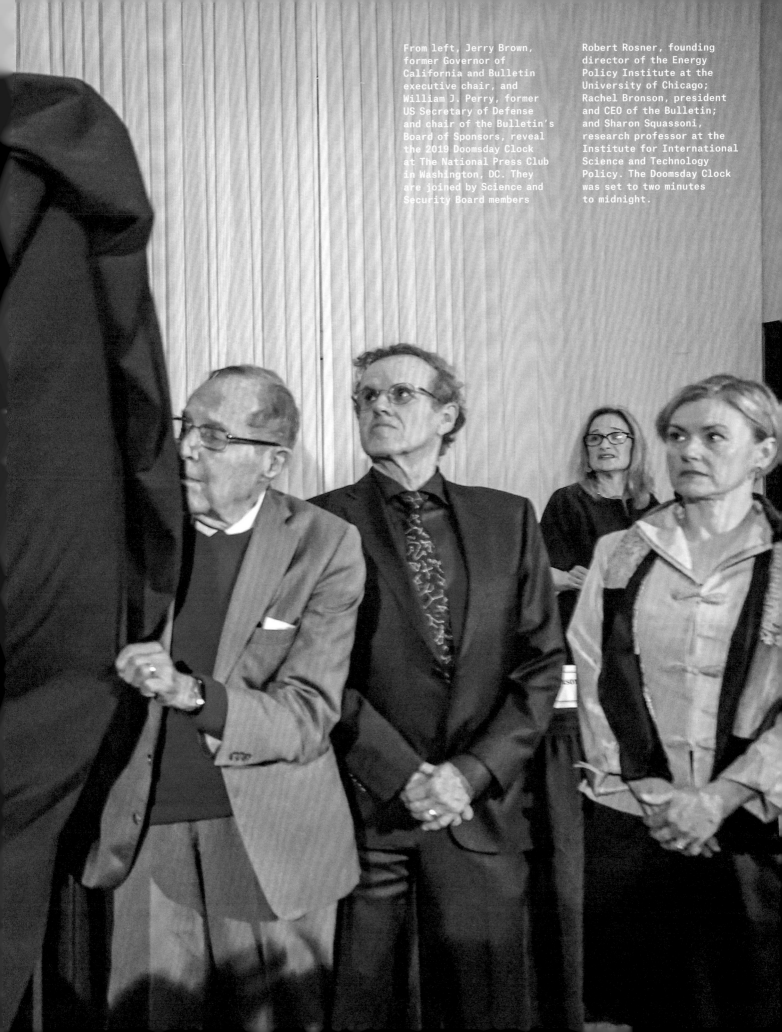

From left, Jerry Brown, former Governor of California and Bulletin executive chair, and William J. Perry, former US Secretary of Defense and chair of the Bulletin's Board of Sponsors, reveal the 2019 Doomsday Clock at The National Press Club in Washington, DC. They are joined by Science and Security Board members Robert Rosner, founding director of the Energy Policy Institute at the University of Chicago; Rachel Bronson, president and CEO of the Bulletin; and Sharon Squassoni, research professor at the Institute for International Science and Technology Policy. The Doomsday Clock was set to two minutes to midnight.

This book went to press at the end of 2021, with the Doomsday Clock at 100 seconds to midnight—the closest humanity has ever been to self-destruction. Yet with each new year, each unveiling, there's hope that we can turn back the Clock, that there's time to take action and influence policymakers to make our world more secure. Because we've created these threats, it's our responsibility to resolve them and make the planet safe for future generations.

Thank You

Martyl Langsdorf (1917-2013)

Acknowledgments

The authors would like to thank the daughters of Martyl Langsdorf, Sandie Shoemaker and Suzanne Langsdorf, who championed this long-simmering project.

This book would not have been possible without the support of Rachel Bronson, the President and CEO of the Bulletin of the Atomic Scientists, and the Bulletin staff. Special thanks to the Bulletin's Chief Advancement Officer, Colleen McElligott, for all of her work and advice. Thanks to Alexa Shoemaker Brooks for her fundraising efforts.

Eagle-eyed copyediting and additional writing were provided by Dawn Stover, Lorene Yue, Gayle Spinazze, Sarah Starkey and CFO Lisa McCabe. Editor-in-chief John Mecklin and his team were invaluable for their insights and never-ending editorial work. Thanks to Bulletin staff members: Susan D'Agostino, Dan Drollette Jr, Matt Field, Thomas Gaulkin, Delilah Marto, Jessica McKenzie, Halley Posner and Brandon Powell.

Kennette Benedict, former Executive Director and Publisher of the Bulletin (2005–2015), was a fount of helpful information, as was Stephen I. Schwartz, who served in those roles 1998–2005.

Thanks to all the authors, artists and musicians who gave permission for us to publish their materials, and to all the contributors—particularly Michael Bierut and Pentagram—for their vision and collaboration.

Dave Gibbons, illustrator and co-creator of *Watchmen*, was an absolute joy to work with and we thank him for his kindness and good grace.

Others who contributed permissions or supported the book include: John Sepenuk, Co-Founder and CEO Cryptozoic Entertainment; University of Chicago Librarian Jenny Hart; scholar Leslie S. Klinger; Hector Cantu; Andy Broome; and Sara W. Duke, Curator, Popular & Applied Graphic Art, Library of Congress.

Our superstar designer is James Goggin, and everyone should be so lucky to work with such a talented, innovative, and patient saint.

The Bulletin is thankful for support for this publication provided in part by a grant from Carnegie Corporation of New York, Holthues Trust, John D. and Catherine T. MacArthur Foundation, Ploughshares Fund and its many donors and friends for their continued support and commitment to its mission.

The Bulletin is honored to have your continued support and commitment to its mission.

Rob would like to thank his wife, Betsy Edgerton, and his children, Eva and Dylan, who gave him time to complete this labor of love. Betsy meticulously read and edited the final version of this book before it went to press, and her contributions were invaluable.

JC would like to personally acknowledge Martyl and her daughters, Sandie Shoemaker and Suzanne Langsdorf, for their years of friendship and championing of this project, as well as his wife, Sybil Perez, and two boys, Xander and Leo, for their enduring support.

Donors

This book was made possible through the generosity of Martyl Langsdorf's friends and family.

Robert Atcher
Kennette Benedict and Robert Michael
Wayne and Susan Benjamin
Marjorie Craig Benton
Charles and Jennifer Clark
Henry and Priscilla Frisch
Kendal and Kenneth Gladish
Alexander Hasha
Peter and Nancy Hildebrand
John Mark Horton
David Kamen and Eileen Hsu
Denny Lane
Suzanne Langsdorf
Ellen Lederman
Terrie Liberman
Catherine Marshall
Tanera Marshall
Helen H. Mills
Robert and Sandra Morgan
Vaia Papadimitriou
Judith Pieper
Irene Pritzker
Emily Pulitzer
Alexander and Janet Rabinowitch
Mary Rabinowitch
William and Eleanor Revelle
Anne Rorimer
Lowell Sachnoff and Fay Clayton
Judy Schramm
Terri and Paul Schroeder
Todd Schwebel
Aimee Shoemaker
Alexandra and F. Wells Shoemaker
Sara Shoemaker
Anne Terry Straus
Tanya Sugarman
Sally Thompson
Janine Tollestrup

Board of Sponsors

The Bulletin's Board of Sponsors was first established in December 1948 by Albert Einstein, with J. Robert Oppenheimer as its first chair. Members of the Board of Sponsors are recruited by their peers from the world's most accomplished science and security leaders to reinforce the importance of the Bulletin's activities and publications. The Board grew out of the Emergency Committee of Atomic Scientists, which Einstein wrote, "was organized in August 1946 to support the educational activities undertaken by the various groups of atomic scientists."

Members of the Board of Sponsors are consulted on key issues, including the setting of the Bulletin's Doomsday Clock. Members, which have counted 40 Nobel laureates over the years, are welcome to attend all meetings.

Albert Einstein (1879-1955)
1921 Nobel Laureate in Physics,
Board of Sponsors founder